William Blake

The Creation of the *Songs*

From Manuscript to Illuminated Printing

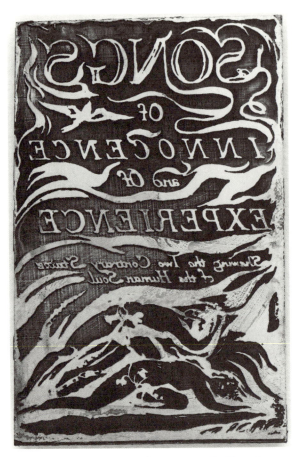

General title-page, *Songs of Innocence and of Experience*, 1794. First step relief etched copper plate by Michael Phillips. Reproduced actual size 114 × 71 mm.

William Blake

The Creation of the *Songs*

From Manuscript to Illuminated Printing

MICHAEL PHILLIPS

PRINCETON UNIVERSITY PRESS

First published 2000 by
The British Library
96 Euston Road
London NW1 2DB

Published in North America in 2000 by
Princeton University Press
41 William Street
Princeton, NJ 08540

Library of Congress Catalog Card Number: 00–103817

ISBN 0-691-05720-6 (cased edition)
ISBN 0-691-05721-4 (paperback edition)

Designed by Bob Elliott
Printed and bound in England at the
University Press, Cambridge

To
Yves Bonnefoy & Martin Butlin

Contents

Preface

How Blake wrote and then produced his poems in what he called Illuminated Printing has always fascinated me, as of course why he did so. In 1978, Martin Butlin, formerly keeper of the Historic British Collection at the Tate Gallery, gave me the opportunity to share this enthusiasm, in a lecture at the Tate Gallery given on the occasion of the major Blake exhibition that he curated that year. This was the beginning of this book. I chose to focus upon the manuscript drafts of the *Songs*, contemporary accounts of the method Blake used to produce them and the significance of his move to Lambeth in the winter of 1790–91. With a small research grant from the British Academy I consolidated these preliminary investigations and published the results the following year.[1] I then began research into Blake's life to try to learn more, beginning in the 1770s and concluding with his circumstances in Lambeth during the early 1790s. It was during this period that Blake served his apprenticeship as an engraver, experimented as poet, painter and graphic artist and beginning in 1789 entered the most innovative and productive period in his life as printmaker and publisher of his own books. I felt that it was essential to try to see as many examples of his original illuminated books and prints as possible, particularly the first examples that he produced shortly before moving to Lambeth and during the first years that he lived there. But outside of London and Cambridge, the greatest collections and many isolated examples of importance were in North America.

For the academic sessions 1984–1986, I combined unpaid and sabbatical leave from my post at Edinburgh University with visiting professorships in the United States within reach of major holdings of Blake's original published works and related unpublished materials. In Austin, New Haven, Boston and New York I was able to see many examples for the first time. While teaching at Williams College I met the second great friend of this book, Yves Bonnefoy, Chaire D'Etudes Comparées de la Fonction Póetique at the Collège de France. In the years that followed, Yves Bonnefoy invited me to Paris to lecture at the Collège de France on Blake's method of illuminated printing and about my search into the circumstances of his life in Lambeth. He made it possible for me to visit the great printmaking Atelier Lacourière et Frélaut in Montmartre. There I observed the registration and printing of colour-printed plates and how, alone, with ink-smudged hands, Blake could have inked his plates, handled and printed impression after impression without touching the paper and keeping every sheet pristine.

Returning to Edinburgh, for the next two years I trained in the evenings in traditional etching techniques with Marcus Rees Roberts at Edinburgh College of Art. Later, I became a member of the professional Edinburgh Printmakers Workshop where, with expert help and advice from Alfons Bytautas and others, I carried out further experiments recreating Blake's processes. Lectures given at the Collège de France in Paris and the Bibliographical Society in London followed, on the printing of the *Songs* and the development of Blake's method of colour-printing.[2] It was now clear that a biography that focused upon Blake's struggle and craft in forming his poems, and that took full account of his invention and experiments in developing the methods used to reproduce them, was the way forward. The only work where the evidence survived to trace this creative progress from its origins to publication was the *Songs*.

With the advantage of my training and experiments in duplicating Blake's graphic processes, it was essential to return to North America to see again the copies of the *Songs* and other illuminated books and prints and those it had not been possible to see before. With further help from the British Academy, I was able to see nearly all of the thirty five copies in public and private collections then in

America and Canada and, eventually, all but two of the fifty copies that are recorded. Many examples were photographed and notes taken on all, establishing common factors that identified print runs, colouring and sequence, as well as what rendered each copy unique. Especially valuable was the opportunity to study a variety of examples in laboratory conditions, under magnification, raking light and ultra-violet light, where I established that Blake's colour-printing process involved more than one printing stage. In this research, I was helped at the National Gallery of Canada by Geoffrey Morrow and Douglas Schoenherr, and at the Yale Center for British Art by Theresa Fairchild and Patrick Noon. More recently, Shelly Fletcher, Head of Paper Conservation, and Rebecca Donnan, Mellon Fellow in Advanced Paper Conservation at the National Gallery of Art, Washington, D.C., have given generously of their time and expertise while I was working in the Lessing J. Rosenwald collections at the National Gallery and the Library of Congress. At the Pierpont Morgan Library, New York, Anna Lou Ashby, Deborah Evetts, and Reba F. Snyder welcomed me and helped with my enquiries. In correspondence, Vincent Daniels, of the Conservation Research Group of the British Museum, provided expert assistance when I found that Blake had problems using lead white pigment in his colour-printed plates. At the Houghton Library, Eleanor M. Garvey and later Anne Anninger, at Wellesley College Library, Ruth Rogers, and at the H. E. Huntington Library, Thomas V. Lange, all helped to advance my research. The pioneering work in Blake's graphic techniques by Robert N. Essick has been invaluable, as has his friendship and support. The more recent work of Joseph Viscomi has also been a frequent source of reference. If, ultimately, I differ from several of their conclusions, I have built upon their contributions.

No investigation into the creation of the *Songs* can be carried out without studying the manuscripts containing Blake's working drafts of many of the poems. Again, my understanding is founded upon the earlier work of others, most notably John Sampson, Joseph Wicksteed, Sir Geoffrey Keynes,

and David V. Erdman and Donald K. Moore.[3] For the present study, I have drawn upon and expanded my earlier work on the manuscript of *An Island in the Moon*, including reproducing in facsimile the folios containing Blake's drafts of three of the *Songs of Innocence*.[4] The edition of the *Manuscript Notebook* by Erdman and Moore has been a constant companion. But, until now, only by turning the pages of the *Manuscript Notebook* itself was it possible to get close to living the writing of these wonderful and often haunting poems. In order to see and transcribe how each poem evolved, to work out when and how words, lines and sometimes whole stanzas were written, rejected and rewritten, the manuscripts have been studied at different times of the year, in different natural and artificial lights. This has revealed the different colours and shades of ink, nib sizes and pencil that he used that are recorded here. Now, seeing the pages in colour facsimile, we can more easily imagine Blake writing them at No.13 Hercules Buildings in Lambeth during 1792 and 1793, in the penumbra of events in France and reaction to them in London. In our mind's eye, see him bringing to mind the damp, narrow streets and alleyways near the Thames at Lambeth where he walked, and what he saw and heard there as recorded in these pages.

For years, the *Manuscript Notebook*, one of the great treasures of the British Library, has been restricted. Had permission not been granted by successive Manuscripts Librarians, including D. P. Waley, M. A. F. Borrie and most recently Ann Payne, this crucial part of my study would not have been possible. No one has been more helpful and generous in this regard than Sally Brown, Senior Curator of Modern Literary Manuscripts at the British Library. Indeed, it was her suggestion that this book should be proposed for publication by the British Library. David Way, head of publications, has most marvellously obliged. This has made possible the use of the colour transparencies purchased earlier with a grant from the Carnegie Trust for the Universities of Scotland to make the colour facsimiles of the pages in the *Manuscript Notebook*.

The collections of Blake's manuscripts, prints and related materials at the Fitzwilliam Museum,

Cambridge, like those of the British Library and the Department of Prints and Drawings of the British Museum, have been essential to my study. At the Fitzwilliam Museum, my research would not have been possible without the support and guidance of David Scrase, and the generous cooperation of the family of the late Sir Geoffrey Keynes in allowing me to see copies of Blake's works from his collection now on deposit there. To Sir Geoffrey I owe much, not least for many occasions at Lammas House when he showed me his collection and shared a lifetime's love and understanding of Blake with me. His generosity of spirit I now enjoy with his grandson, Randall, and his wife Zelfa, who have been steadfast in support of my work.

The opportunity to complete my research came with the award of a Senior Research Fellowship by the National Endowment for the Humanities and the appointment by the British Academy to a Research Readership in the Humanities. During this time I was also given fellowships to return to work at the Yale Center for British Art and the British Library Centre for the Book. After two years, I had two books instead of one and neither one had been written. In order to complete both I left Edinburgh. The present volume is the first to be published. Its other half, the biography of Blake in Lambeth during the anti-Jacobin Terror, will follow. A harbinger of both is the Lambeth section of the Blake exhibition opening at the Tate Gallery, now Tate Britain, in November 2000, of which I was invited to be guest curator. I think of it as my tribute to Martin Butlin. It and this book bring matters full circle, to that evening in 1978 at the Tate Gallery when I offered my first thoughts on the creation of Blake's *Songs*.

Researching and writing this book (and the biography) has given me the opportunity to enjoy wonderful friendships with some of the great authorities in the fields of study I have tried to make my way in. And to be with some very old friends who have given me extraordinary hospitality. David Alexander, Andrew Edmunds, Martin Hopkinson and Anthony Dyson have shared their exceptional knowledge of eighteenth century prints and printmaking. Over many years, I have gleaned from Bernard C. Middleton the ways in which eighteenth-century books were put together and learned about their design from Simon Rendall. John M. Anderson, John Beer, Detlef W. Dörrbecker, J. Paul Hunter, Stephen Lloyd, James D. McCord, the late D. F. McKenzie, David McKitterick, Jon Newman, Jon Stallworthy and Karina Williamson have been unstinting in their support. Justin G. Schiller, Raymond M. Wapner and Maurice Sendak have made possible the opportunity to study copies of the *Songs* in their possession and supplied photographs, as have other private collectors. John De Marco and Jim McCord made possible the inclusion of the colour-printed first state of *The Idle Laundress*. Andrew Lincoln generously read the manuscript and helped to make it a clearer and fuller account. His encouragement has meant a great deal. Robert Ewing, Joel Fadem and Richard Stein are very old and good friends indeed. My work at the Huntington Library and in New York respectively was often made possible as a result of their help. Anything that I could say to thank Lynne, Russell and India, would be inadequate. Finally, the subject of this book, and of Blake's life, work and printmaking methods, is now a graduate course at the Centre for Eighteenth Century Studies at the University of York, thanks to John Barrell.

My father, who was a writer for radio and television, attributing the observation to Madame de Sévigny, used to quip, 'If I had more time, I would have written a shorter letter.' This is a very short book, but, as its biography has indicated, one very long on friends.

A note on titles and measurements: Titles of the *Songs* are given as Blake relief etched and printed them, as in 'LONDON,' except in the course of manuscript draft, as in 'London.' Measurements give height before width.

Introduction

NOTHING can tell us more about Blake than study of the processes by which his works reached their final form. The *Songs* present a unique opportunity. The only manuscript drafts to survive that led to the production of one of Blake's published illuminated books are those relating to *Songs of Innocence and of Experience.* The relative absence of manuscript evidence has encouraged the view that Blake composed his poetry and designs directly onto his copper plates, unpremeditated.[1] A claim supported by Blake himself, who, like Milton, spoke of being subject to divine dictation.[2] But the manuscripts of the *Songs* reveal another Blake, just as the Trinity Manuscript discloses another Milton. Here we discover a maker of poetry and design, by dint of vacillation and doubt, hesitation and rejection, and experiment and meticulous care.

The manuscript of *An Island in The Moon* is the matrix of the *Songs.*[3] Composed of parody and satire, street cries and nursery rhymes, dramatic personae and ironic point of view, it contains the essential elements that formed the basis of Blake's conception. Here we find three of the *Songs of Innocence* in draft and the first suggestion of the idea of 'Illuminating' the text and having the 'writing Engraved instead of Printed.' *An Island in the Moon* provides more than a glimpse into the beginnings of the *Songs.* The *Manuscript Notebook* shows us in intimate detail Blake at the height of his powers, creating one after another of his greatest lyrics, planning his relief etching and selecting drawings to be used in illustration.

The *Manuscript Notebook* contains over fifty poems in draft leading to eighteen that were finally selected for *Songs of Experience.*[4] Various colours and shades of ink, nib sizes and pencil indicate the many stages and attempts Blake made between 1791 and 1793 first to establish and then to order and intensify his vision of the contrary state of the human soul. These drafts, which inscribe man's loss of innocence and fallen state, appositely face and occasionally overwrite pencil drawings in illustration of Milton's *Paradise Lost.* The drawings were entered into the *Manuscript Notebook* shortly before the first *Songs of Experience* were written, at a moment of enthusiastic revival of the reputation of England's greatest republican poet by many artists, writers, printmakers and publishers, including Blake.[5] *Paradise Lost* provided a metaphor for contemporary events in France and Milton's Satan the archetype of rebellion against repression and despotism. By the winter and spring of 1792 and 1793, Blake was in the midst of writing and revising many of the poems, including 'LONDON' and 'The Tyger', and beginning to etch his copper plates in preparation for printing. But events in France had provoked a reaction in Britain that became widespread and threatening against anyone who was known to support the Revolution: 'I say I shant live five years And if I live one it will be a Wonder,' Blake wrote in the *Manuscript Notebook* in June 1793. As the poems emerge in draft, often in an oblique but nonetheless creative dialogue with the facing illustrations to *Paradise Lost,* Blake's descriptions of and protests against the social and political causes of rebellion come sharply into view, during one of the most creative and menacing periods of his life.[6] But the manuscripts present only part of the story.

Blake's graphic process he called Illuminated Printing was invented in 1788 and within a year employed to produce *Songs of Innocence.* In 1793, this process was significantly developed and used to colour-print with opaque pigments the first issue of *Songs of Experience* creating a dramatic contrast with the first copies of *Songs of Innocence* coloured by hand in transparent water-colour wash. Blake's method is described as it was used to produce *Songs of Innocence* and, for the first time, as it was developed to colour-print the first copies of *Songs of Experience.* These descriptions of the invention and development of his process of relief etching,

colouring with water colour and colour-printing bear directly upon the import of the poems themselves. In terms of the manner of production, it is only in the first copies that he produced that the full impact of their contrary, inverse relationship was fully explored and developed.

The creation of the *Songs* took place over a period of more than ten years. My concern is to record in the detail of the manuscript drafts how the poems evolved and were made. Wherever possible, the occasion of writing is identified and set within its historical context. This has led to a reconsideration of when many of the poems in the *Manuscript Notebook* were composed. Blake's method of reproduction used for *Songs of Innocence* and the graphic experiments he undertook to colour-print *Songs of Experience* form an integral part of the narrative. They also reveal moments of failure as well as extraordinary innovation. Where possible, I have also tried to identify those who obtained the first copies from Blake, in order to provide a better idea of the audience he had in mind when producing his works in the way that he did.

Here, transcribed as Blake wrote them, are all of his surviving manuscripts. Following these descriptions, all of the manuscript folios have been reproduced in colour facsimile including, for the first time, the folios of the *Manuscript Notebook*. Also reproduced are drawings, trial impressions and a selection of plates to illustrate how Blake produced the first copies. But the story may be said to begin even earlier.

I. Intimations

As a boy, when attending Par's drawing school in the Strand, Blake collected prints of the artists he admired. With money from his father, he frequented the shops of the London print dealers and the auction sales at Langford's and Christie's. Benjamin Heath Malkin, who knew Blake, was told by him that 'Langford called him his little connoisseur; and often knocked down to him a cheap lot, with friendly participation. He copied Raphael and Michael Angelo, Martin Hemskerck and Albert Durer, Julio Romano, and the rest of the historic class, neglecting to buy any other prints, however celebrated.'[1] This interest persisted and two examples of collections of prints that Blake acquired have recently come to light. Both tell us a great deal about the origins of the *Songs*, in terms of their abiding theme and the idea of etching text and design together on copper plate for printing.

In 1773, during his second year as an apprentice engraver to James Basire, Blake acquired a copy of *Historia Del Testamento Vecchio Dipinta in Roma Nel Vaticano Da Raffaelle Di Urbino* (1603), a collection of the etched drawings by Annabelli Carracci after Raphael's Biblical paintings in the Vatican Logia; Raphael's Bible, as it was popularly known amongst artists. The second volume was *A Political and Satirical History of the Years 1756 and 1757. In a Series of Seventy-five Humorous and Entertaining Prints* (1757), a collection of copper plate etchings, many reproduced from prints first issued singly in a larger format, perhaps initially attractive to Blake as they were largely concerned with political events and characters during the year of his birth, 1757.

On the left side of the vellum cover of his copy of Raphael's designs, with a burin or sharp tool Blake has cut a sun burst with a human face. On the upper right side, he has cut his name 'W Blake' and underneath it the date '1773.' But inside, amidst the etchings after Raphael's renderings of scenes from the old and new testaments, is Blake's earliest surviving drawing, hidden in the gutter between the facing blank verso of the previous plate and the plate depicting the Expulsion of Adam and Eve from the Garden of Eden [FIG. 1]. Carefully, and with the skill and detail applied to a preparatory drawing, from two different angles Blake has copied Adam's left leg and foot, at the moment he steps from paradise forever; in other words, at the moment our first parents step from innocence to experience. Twenty years later, for the first issue of the combined *Songs of Innocence and of Experience* in 1794, Blake designed and printed a general title-page depicting this same moment, with one difference [FIG. 2]. In the upper left corner of the general title-page, just before the capital letter S, the admonishing angel stands with his right hand raised and index finger pointing to heaven. Far below, our first parents begin to make their solitary way through the fallen world of experience. As depicted by Blake, paradise is now remote and the subjected plain of this world has been reached [PLATE 1].

In his copy of *A Political and Satirical History*, Blake has written the date 'May 29 1773' on the title page amidst a series of examples of his autograph in various forms on the first three pages of the volume [FIGS. 3 & 4]. The signatures themselves are intriguing. For example, in writing 'Wm Blake his my Name' Blake reveals how he has become acutely aware of his Cockney origins and is now attempting to disguise them by overcompensating for his failure to pronounce the letter h. But, for our purposes, it is the etchings themselves that are fascinating. Here, as he studied them, we find on plate after plate variations in the combination of word and design, interlinear figures and hieroglyphs interpolating the text and ironic juxtapositions between word and image etched together and printed in book form from copper plates [FIGS. 5 & 6].

Both volumes are soiled and worn. The etchings after Raphael also show glue spots just like those that are found framing drawings in the *Manuscript*

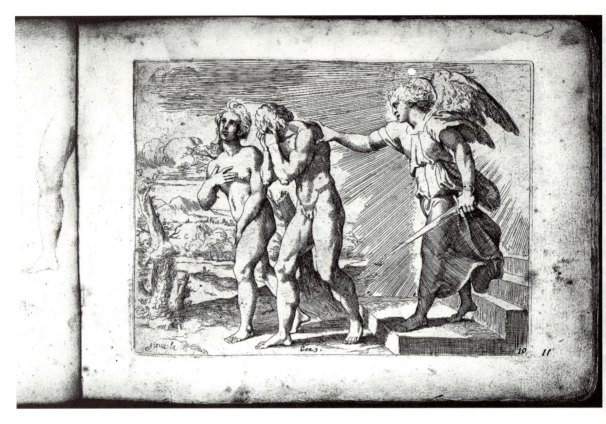

Fig. 1 Pencil drawings by William Blake inside margin of etching of Expulsion of Adam and Eve after Raphael. *Historia Del Testamento Vecchio Dipinta in Roma Nel Vaticano Da Raffaelle Di Urbino*, 1603. Plate 134 × 181 mm. Collection of Michael Phillips.

Fig. 2 General title-page, *Songs of Innocence and of Experience*, *Songs* Copy BB. Actual size. Size of Original 113 × 71 mm. Private Collection.

Notebook, where Blake has made tracings to use in his plate designs. *A Political and Satirical History* is so threadbare with use that several of the individually etched plates have fallen out and are now lost. As we shall see, at a formative moment both volumes established themes, images and ways of thinking about book production that took hold in Blake's imagination and later helped to produce his greatest collection of poetry and design.

FIG. 3 Autograph signatures of William Blake. Recto frontispiece facing Title page, *A Political and Satirical History of the Years 1756 and 1757. In a Series of Seventy-five Humorous and Entertaining Prints*, 1757. Leaf size 128 × 93 mm. Collection of Michael Phillips.

FIG. 4 Autograph signatures of William Blake. Title page, *A Political and Satirical History of the Years 1756 and 1757. In a Series of Seventy-five Humorous and Entertaining Prints*, 1757. Leaf size 128 × 93 mm.

FIG. 5 Plate 19, *A Political and Satirical History of the Years 1756 and 1757. In a Series of Seventy-five Humorous and Entertaining Prints*, 1757. Leaf size 128 × 93 mm. Plate size 109 × 79 mm.

FIG. 6 Plate 54, *A Political and Satirical History of the Years 1756 and 1757. In a Series of Seventy-five Humorous and Entertaining Prints*, 1757. Leaf size 128 × 93 mm. Plate size 108 × 76 mm.

II. *Songs of Innocence*

THERE are two surviving manuscript sources for *Songs of Innocence*, an early version of 'Laughing Song' written in a copy of Blake's first collection of poems, *Poetical Sketches*, privately printed in conventional letterpress in 1783, and the manuscript of *An Island in the Moon* written between 1782 and 1785.

In the autumn of 1784, William and his wife Catherine were living at No. 27 Broad Street, Golden Square, next door to No. 28, the family home and place of business, Blake's birthplace and where he spent his childhood until he was apprenticed to the engraver James Basire. In 1784, No. 27 Broad Street also served as the print shop of Parker and Blake. At this time, and until his death in 1787, William's beloved younger brother, Robert, also lived with them. In Wardour Street, near-by, lived their close friends John and Nancy Flaxman. In *A Book for a Rainy Day*, J. T. Smith describes this period in Blake's life:

This year [1784] Mr. Flaxman, who then lived in Wardour Street, introduced me to one of his early patrons, the Rev. Henry Mathew [*sic*, A. S. Mathew], of Percy Chapel, Charlotte Street, which was built for him; he was also afternoon preacher at Saint-Martin's-in-the-Fields. At that gentleman's house, in Rathbone Place, I became acquainted with Mrs. Mathew and her son. At that lady's most agreeable conversaziones I first met William Blake, the artist, to whom she and Mr. Flaxman had been truly kind. There I have often heard him read and sing several of his poems. He was listened to by the company with profound silence, and allowed by most of the visitors to possess original and extraordinary merit.[1]

One of the outcomes of attending this circle was the offer of financial support to print Blake's first collection of poems, *Poetical Sketches*, privately in 1783. When the sheets were returned from the printer, we know that Blake made corrections to the text in three copies and gave them to the Flaxmans, who in turn presented them to friends and acquaintances in the spring of 1784, apparently

with the intention of promoting Blake's reputation.

One of these copies, presented by Flaxman to the Shakespearean scholar Isaac Reed, is now in the collection of the Alexander Turnbull Library, Wellington, New Zealand. It is unique in having three pastoral lyrics attributed to Blake transcribed in an unknown contemporary hand in light brown ink on to the blank leaves preceding the text [FIGS. 7 & 8]. These poems may be examples of the songs Blake sang, as described by J. T. Smith. What they do show at an early stage is Blake working out his own voice within the English pastoral tradition that he will go on to develop and handle with supreme understatement and skill in *Songs of Innocence*.

Laughing Song

The three poems were written into the copy of *Poetical Sketches* as follows:

Songs by Mr Blake

Song 1st by a Shepherd

1st

Welcome stranger to this place,
Where joy doth sit on Every bough,
Paleness flies from every face.
We reap not, what we do not sow.

2d

Innocence doth like a Rose,
Bloom on every Maidens cheek;
Honor twines around her brows,
The jewel Health adorns her neck

Then, written on the facing blank leaf:

Song 2d by a young Shepherd

1st

When the trees do laugh with our merry Wit,
And the green hill laughs with the noise of it,

When the meadows laugh with lively green
And the grasshopper laughs in the merry scene,

<div align="center">2^d</div>

When the greenwood laughs with the voice of joy,
And the dimpling stream runs laughing by,
When Edessa, & Lyca, & Emilie,
With their sweet round mouths sing ha, ha, he,

<div align="center">3^d</div>

When the painted Birds laugh in the shade,
Where our table with cherries & nuts is spread;
Come live & be merry & join with me
To sing the sweet chorus of ha, ha, he.

Turning the page, on the blank leaf facing the title-page is written the third song, as follows:

<div align="center">Song 3^d by an old shepherd</div>

<div align="center">1st</div>

When silver decks Sylvio's cloaths
And jewel hangs at shepherd's nose,
We can abide life's pelting storm
That makes our limbs quake, if our hearts be warm.

<div align="center">2^d</div>

Whilst Virtue is our walking staff,
And Truth a lantern to our path;
We can abide life's pelting storm
That makes our limbs quake, if our hearts be warm.

<div align="center">3^d</div>

Blow boisterous Wind, stern Winter frown,
Innocence is a Winter's gown;
So clad, we'll abide life's pelting storm
That makes our limbs quake, if our hearts be warm.

In 1789, Blake reworked the second poem in preparation for relief etching and printing in *Songs of Innocence* as the 'Laughing Song,' as follows:

<div align="center">Laughing Song</div>

When the green woods laugh, with the voice of joy
And the dimpling stream runs laughing by,
When the air does laugh with our merry wit,
And the green hill laughs with the noise of it.

When the meadows laugh with lively green
And the grasshopper laughs in the merry scene,
When Mary and Susan and Emily,
With their sweet round mouths sing Ha, Ha, He.

When the painted birds laugh in the shade
Where our table with cherries and nuts is spread
Come live & be merry and join with me,
To sing the sweet chorus of Ha, Ha, He.

For the published version, Blake has stripped away any signs of the classical shepherds' singing contest. The first two lines were then taken from the second stanza and placed above the original first and second lines, becoming lines three and four. In creating the new third line, Blake also replaced 'trees do' with 'air does.' The original third and fourth lines become the first two lines of the second stanza.

Other changes reveal Blake's indebtedness and skill in renewing the pastoral. The change of names from Edessa and Lyca to those of Mary and Susan acknowledge the signal departure from convention made by Edmund Spenser in *The Shepheardes Calender*, when he rejected classical in favour of native English names. In the penultimate line, Blake alludes to the tradition of pastoral lyrics of idealised statement and satiric reply initiated by Christopher Marlowe's 'Come live with me and be my love.' Most significant, is his choice of language, simple, native and unaffected in relation to the still prevailing fashion for a Latinate poetic diction. The choice of language is itself a metaphor for innocence. Blake's ability to restore the pastoral to its pristine simplicity found its natural counterpart in his instinct for irony.

An Island in the Moon MS

A second outcome of the gatherings at the Mathew's salon, and meetings at the home of John Flaxman and others during the early 1780s, was the composition of the manuscript of *An Island in the Moon*. The manuscript, now in the Fitzwilliam Museum, Cambridge, is incomplete. What has survived is a thin foolscap folio of sixteen leaves,

Songs by Mr Blake

Song 1st by a Shepherd

1

Welcome stranger to this place,
Where joy doth sit on every bough,
Paleness flies from every face,
We reap not, what we do not sow.

2

Innocence doth like a Rose,
Bloom on every Maidens cheek;
Honor twines around her brows,
The jewel Health adorns her nec[k]

ex Bibliotheca Heberiana,
fourth portion
sold by Evans
9 Dec 1834.

There is an extraordinary force of Original Genius
gleaming at intervals through these elegant Stanzas
This Blake may have been an embryo Gray.

Song 2d by a young Shepherd

1

When the trees do laugh with our merry wit
And the green hill laughs with the noise of it
When the meadows laugh with lively green
And the grasshopper laughs in the merry scene
2

When the greenwood laughs with the voice of joy
And the dimpling stream runs laughing by,
When Edessa, & Lyca, & Emilie,
With their sweet round mouths sing ha, ha, he,
3

When the painted Birds laugh in the shade,
Where our table with cherries & nuts is spread
Come live & be merry & join with me
To sing the sweet chorus of ha, ha, he,

measuring 310 × 185 mm, originally a single quire, of which the first eight present a consecutive text on both recto and verso amounting to sixteen pages, beginning 'In the Moon. Is a certain Island' that has given the manuscript its name. The last eight leaves are blank, with the exception of the recto of folio nine and the verso of folio sixteen. On the recto of folio nine, the manuscript continues for nineteen lines following a lost section of probably two or four leaves, a result of a missing sheet or sheets from the centre of the quire. The manuscript is mostly fair copy evidently transferred from earlier drafts written between 1782 and 1785. During this period different sections of the manuscript were composed, indicated by different inks used in transcription and corresponding topical allusion. For example, in an early part of the manuscript reference is made to the controversy over the authenticity of Thomas Chatterton's Rowley poems current in 1782, and in a later part of the manuscript to the death of Samuel Johnson in December 1784. There are also alterations and revisions. These may be even later. On the back of the last leaf, folio sixteen verso, is found a series of pen-and-ink sketches together with examples of Blake's autograph and copper-plate script. As we shall see, both shed light on the creation of the *Songs*.[3]

An Island in the Moon is a dramatic satire in which a number of the characters are thinly disguised caricatures of friends, acquaintances and

Song 3ᵈ by an Old Shepherd

When silver snow decks Sylvio's Cloath,
And jewel hangs at Shepherds nose,
We can abide life's petting storm
That makes our limbs quake, if our hearts be warm

2ᵈ

Whilst virtue is our walking Staff,
And truth a lantern to our path;
We can abide life's petting storm
That makes our limbs quake, if our hearts be warm

3ᵈ

Blow boisterous Wind, stern Winter frown,
Innocence is a Winter's gown;
So clad, we'll abide life's petting storm
That makes our limbs quake if our hearts be warm

London personalities of the day engaged in conversation and song, including Blake and his brother Robert. It discloses Blake's instinct for satire and for its vehicles of parody, burlesque and ironic juxtaposition and point of view. Its special interest, in this context, is the presence in draft of three of the *Songs of Innocence* that are found together with the disclosure of Blake's ambition to produce his own book by 'Illuminating the manuscript' and an experiment in reverse or mirror writing essential for etching his texts.

The first hint of the *Songs* comes in Chapter nine. On folio five verso, a scene of irreverent banter and song is suddenly interrupted by the cries of a boy selling matches in the street outside, what Martha

W. England has called Blake's 'first Song of Innocence:'[4]

1ˢᵗ	Vo	Want Matches
2ᵈ	Vo	Yes Yes Yes
1	Vo	Want Matches
2ᵈ	Vo	No ————
1ˢᵗ	Vo	Want Matches
2ᵈ	Vo	Yes Yes Yes
1ˢᵗ	Vo	Want Matches
2ᵈ	Vo	No ————

There follows 'Great confusion & disorder.' Moved by what she has heard, Mrs Nannicantipot begins

to sing, perhaps prompted by one of several published medleys of the cries of London:

> I cry my matches as far as Guild hall
> God bless the duke & his aldermen all

But Little Scopprell interjects with a mocking chorus. Then Suction the Epicurean calls upon Steelyard the Lawgiver to sing, to which he complies with the gentle pastoral:

> As I walkd forth one may morning
> To see the fields so pleasant & so gay
> Oh there did I spy a young maiden sweet
> Among the Violets that smell so sweet
>> Smell so sweet
>> Smell so sweet
> Among the violets that smell so sweet

More interruptions follow. Then Miss Gittipin is invited to 'favour us with a fine song.' She sings 'This frog he would a wooing ride', a version of the nursery rhyme 'The Frog and the Mouse' recently collected by Joseph Ritson in *Gammer Gurton's Garland: or, The Nursery Parnassus. A Choice Collection of Pretty Songs and Verses, For the Amusement of All Little Good Children, who can neither read nor run*, 1783. Ritson may have encouraged Blake's interest in the street ballad and nursery rhyme. At the time, Blake was engraving plates for Ritson's *A Select Collection of English Songs*, 1784. To Miss Gittipin's nursery rhyme, Sipsop replies 'hang your Serious Songs.' The street cries of children, pastoral song and nursery rhyme have been ironically juxtaposed, carelessly interrupted and rudely undercut in a rhetorical riposte of innocent and experienced points of view. Here, perhaps, is the inception of the *Songs* and clearly a harbinger of what is to follow.

HOLY THURSDAY

Chapter 11, beginning on folio seven verso, is set in the house of Steelyard the Lawgiver, a caricature of Blake's friend and neighbour, the young sculptor John Flaxman and his social gatherings in Wardour Street. 'After Supper Steelyard & Obtuse Angle. Had pumpd Inflammable Gass quite dry. they playd at forfeits & tryd every method to get good humour. said Miss Gittipin pray M^r Obtuse Angle sing us a song then he sung.' Immediately following, as shown in facsimile, Blake entered the following fair copy draft in light grey ink [PLATE 2]:

> Upon a holy thursday their innocent faces clean
> The children walking two & two in grey & blue
>> & green
> Grey headed beadles walkd before with wands as
>> white as snow
> Till into the high dome of Pauls they like thames
>> waters flow

> O what a multitude they seemd, these flowers of
>> London town
> Seated in companies they sit with radiance all
>> their own
> The hum of multitudes were there but multi-
>> tudes of lambs
> And all in order sit waiting the chief chanters
>> commands

> Then like a mighty wind they raise to heavn the
>> voice of song
> Or like harmonious thunderings the seats of
>> heavn among
> When the whole multitude of innocents their
>> voices raise
> Like angels on the throne of heavn raising the
>> voice of praise

The annual gathering of children from the charity schools of London to give thanks to God and to their benefactors began in 1704, but on 2 May 1782 first took place in St. Paul's, where it became established. Blake must have witnessed one of these first processions to St. Paul's. If Benjamin Heath Malkin's suggestion is correct, he was present at the 'sublime display of natural munificence and charity' when, according to the account in *The European Magazine*, 1782, '6000 charity children were arranged under the dome.'[5]

Unhappy with his fair copy draft, Blake deleted the final line of the second stanza with a swirling

stroke of his pen and below it inserted the following line:

> Thousands of little girls & boys raising their
> innocent hands

He then deleted the whole of the last stanza, using the same swirling stroke, and composed a new opening line, as follows:

> Let cherubim & seraphin now raise their voices
> high

Beginning at the left margin of the page, Blake struck out this line and possibly after working out the lines on another sheet, entered a new concluding stanza overwriting 'sits' with 'sit', as follows:

> Then like a mighty wind they raise to heavn the
> voice of song
> Or like harmonious thunderings the seats of
> heavn among
> Beneath them sit[s] the revrend men the
> guardians of the poor
> Then cherish pity lest you drive an angel from
> your door.

The moral admonition in the last line recalls Hebrews 13:2: 'Be not forgetful to entertain strangers: for thereby some have entertained angels unawares.' This warning is like those found in the hymns of moral instruction that the charity children were obliged to sing, that here Blake addresses to their betters. Finishing his revisions, Blake added the company's response to Obtuse Angle's song, 'After this they all sat silent for a quarter of an hour,' and set down his pen.

In preparation for etching the plates for *Songs of Innocence*, Blake made several changes to the version of 'HOLY THURSDAY' taken from the manuscript. In the first stanza, first line, 'Upon a' was altered to 'Twas on a,' second stanza, third line, 'were' to 'was,' third stanza, first line, 'Then' to 'Now,' and third line, 'revrend men the guardians' to 'aged men wise guardians.' Another change appeared slight, in the second line, from 'The children walk-

ing two & two in grey & blue & green' to 'red & blue & green,' until Stanley Gardner made the following discovery:

The children in grey wore the uniform of the Greycoat Hospital, in Blake's Westminster. In the 1780s the Hospital went through a period of particular infamy, until the children rioted and fired the place in desperation. The case was upheld and the matron arrested. The year was 1788. When Blake put 'Holy Thursday' into *Songs of Innocence* a few months after this event, he took out the 'grey' coats in the second line, and replaced them with 'red', dissociating the poem for his immediate readers from the publicity surrounding the Greycoat Hospital.[6]

In 1789, following these changes, relief etched and printed the poem read as follows [PLATES 35–38]:

HOLY THURSDAY

Twas on a Holy Thursday their innocent faces
 clean
The children walking two & two in red & blue &
 green
Grey headed beadles walkd before with wands
 as white as snow
Till into the high dome of Pauls they like Thames
 waters flow

O what a multitude they seemd these flowers of
 London town
Seated in companies they sit with radiance all
 their own
The hum of multitudes was there but multitudes
 of lambs
Thousands of little boys & girls raising their
 innocent hands

Now like a mighty wind they raise to heaven the
 voice of song
Or like harmonious thunderings the seats of
 heaven among
Beneath them sit the aged men wise guardians
 of the poor
Then cherish pity, lest you drive an angel from
 your door.

Gardner's observation may question the trenchant irony commonly pointed to in the last line. The irony that it does not affect is Blake's transformation, after Swift and Gay, of the pastoral into an urban setting.[7]

Nurses Song

When Blake returned to the manuscript, this time using dark brown ink, he entered two more songs that were later adopted for *Songs of Innocence*. Picking up where he had stopped in light grey ink, he wrote '& Mrs Sigtagatist said it puts me in Mind of my [grand *del.*] mothers song.' But Blake changed his mind, deleted '& Mrs Sigtagatist' and above it he wrote '& Mrs Nannicantipot.' Using the same pen and brown ink, Blake started the new song by writing 'The voice,' smudged it out, below it wrote 'The,' in front of 'The' wrote 'When' and continued writing, as follows:

> When The tongues of children are heard on the green
> And laughing upon the hill
> My heart is at rest within my breast
> And every thing else is still
>
> Then come home children the sun is down
> And the dews of night arise
> Come Come leave off play & let us away
> Till the morning appears in the skies

Turning the page, to the top of folio eight recto, Blake continued writing, this time apparently composing on the page: [PLATE 3]

> No No let us play for it is yet day
> And we cannot go to sleep till its dark
> The flocks are at play & we cant go away

After completing the third line on this page, Blake deleted it and in the line above it overwrote 'go to' to read 'get to,' then changed his mind back to his original reading and above it wrote 'go to' and at the end of the second line deleted 'till its dark.' He then continued, as follows:

> Besides the Sky the little birds fly
> And the meadows are coverd with Sheep
>
> Well Well go & play till the light fades away
> And then go home to bed
> The little ones leaped & shouted & laughd
> And all the hills ecchoed

Looking over what he had written, in the first stanza, second line, he deleted 'up' of 'upon' and above it wrote 'is heard.' In the second stanza, first line, he inserted 'my' between 'home children', and 'gone' between 'is down.' And in the third stanza, third line, he inserted 'in' above 'Besides the.' Amended, the poem read as follows:

> When the tongues of children are heard on the green
> And laughing is heard on the hill
> My heart is at rest within my breast
> And every thing else is still
>
> Then come home my children the sun is gone down
> And the dews of night arise
> Come Come leave off play & let us away
> Till the morning appears in the skies
>
> No No let us play for it is yet day
> And we cannot go to sleep
> Besides in the Sky the little birds fly
> And the meadows are coverd with Sheep
>
> Well Well go & play till the light fades away
> And then go home to bed
> The little ones leaped & shouted & laughd
> And all the hills ecchoed

When Blake copied this poem from the manuscript to etch for *Songs of Innocence*, he made only two changes. In the first line he altered 'tongues' to 'voices' and in the third stanza, last line, 'meadows' to 'hills.' Relief etched and printed in 1789, the poem read as follows [PLATE 57]:

Nurses Song

When the voices of children are heard on the green
And laughing is heard on the hill,
My heart is at rest within my breast
And every thing else is still

Then come home my children the sun is gone down
And the dews of night arise
Come come leave off play, and let us away
Till the morning appears in the skies

No no let us play, for it is yet day
And we cannot go to sleep
Besides in the sky, the little birds fly
And the hills are coverd with sheep

Well Well go & play till the light fades away
And then go home to bed
The little ones leaped & shouted & laugh'd
And all the hills ecchoed

One may agree with Stanley Gardner, that the scene depicted is Wimbledon Common, where the children of the poor of St. James, Westminster, were sent to nurse 'till six or seven years of age' by the enlightened 'gentlemen, Churchwardens and Overseers of the Poor' of Blake's parish. The alternative had been the workhouse, where death was commonplace, the same workhouse supplied with cloth by 'Mr Blake Haberdasher,' Blake's father.[8]

The Little Boy lost

Using the same dark brown ink, Blake started to introduce the next song by writing 'Then Miss Gittipin,' deleted it and wrote 'Tilly Lally sung,' which he also deleted, and then wrote 'Quid Sung,' a thinly disguised burlesque persona for himself. Later, still unable to make up his mind, he deleted 'Quid' with a swirl of grey-black ink and then reintroduced it, to read 'Then Sung Quid.' The song was the following:

O father father where are you going
O do not walk so fast
O speak father speak to your little boy
Or else I shall be lost

The night it was dark & no father was there
And the child was wet with dew
The mire was deep & the child did weep
And away the vapour flew

'Here nobody could sing any longer.' In July 1784 Blake's father died. This may explain the change in mood, and the hesitation over attributing and finally giving the song to Quid.

No more songs were written in the manuscript that Blake later used for *Songs of Innocence*. When he adopted this poem, changes were made by deleting the exclamations at the beginning of lines one and three and, in the second stanza, first line, deleting 'it' and '&' and in the second line, 'And.' Relief etched and printed, the poem read as follows:

The Little Boy lost

Father, father, where are you going
O do not walk so fast.
Speak father, speak to your little boy
Or else I shall be lost,

The night was dark no father was there
The child was wet with dew.
The mire was deep, & the child did weep
And away the vapour flew.

Each of these songs has been presented from a distinct point of view. And, within the songs themselves, each presents a different perspective upon the child and childhood. In 'HOLY THURSDAY,' it is that of the distant but moved observer, sung by Obtuse Angle, a name that itself is suggestive of ways of seeing or not seeing. In 'Nurses Song,' we are taken back, in reverie: 'it puts me in mind of my *grand* mothers song' by the singer and by the song. And, in 'The Little Boy Lost,' sung by Blake's own persona, Quid the Cynic, in the first stanza the child speaks to us directly and poignantly, abandoned by his parent. We have been brought full circle, back to the match seller's cries. In *Songs of Innocence*, Blake will fully explore and modulate the contrary perspectives of innocence and experience first seen here.

Blake's focus upon the child and childhood within an urban setting, seen developing in the manuscript of *An Island in the Moon*, anticipates the transformation of the pastoral that he made in *Songs of Innocence*. The pastoral had always been written either implicitly or explicitly in contrast with life in the city. In the eighteenth century, it was used either to evoke a Golden Age, following the neo-classical theory of Rapin, or, according to Fontenelle, to celebrate an idealised country life. Both forms placed the reader at a distance from what was rendered: either, it was futile to hope for, or, it was illusory; as, increasingly, both poets and painters were depicting the harsh realities of the rural scene. In a word, apart from its survival within the tradition of the religious hymn, which Blake calls upon, the pastoral as a metaphor for a spiritual condition had died with Milton.

In *Songs of Innocence* Blake renewed this intuitive and visionary pastoral, locating his paradise within man and there to be regained; not in a remote past, or in a far off landscape. To emphasise this point, the topography of *Songs of Innocence* is London, or set in relation to it, the streets of the city known by little black boys, chimney sweeps and wards of its parishes: the antithesis of conventional pastoral. If the *Songs* may be said to express a single purpose or theme, it is to invoke and renew in man that perception of the world that is immediate and visionary, as beheld by a child and that innocence embodies.

In the *Manuscript Notebook*, where Blake will write *Songs of Experience*, is a sketch in outline of the motif used on the title-page of *Songs of Innocence*, of a child standing or kneeling before a seated adult [FIG. 9]. Originally, this design was one of a series of drawings Blake made beginning shortly after his younger brother Robert's death in 1787, that eventually led to the production of the emblem book *For Children The Gates of Paradise*. This drawing was not finished, apparently because another use had been found for it. In the title-page of *Songs of Innocence* we can see these outlines defined in the finished design [PLATE 23]. A seated nurse or mother holds out to a boy and girl standing

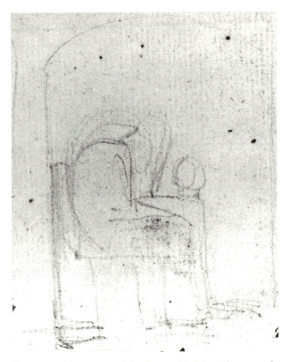

FIG. 9. Drawing adapted for the motif of the title-page of *Songs of Innocence*, from emblem drawing of *For Children The Gates of Paradise*, 1793. Detail, 90 × 70 mm., *Manuscript Notebook*, N. 55. Reproduced by permission of the British Library Board.

at her knee an open book, into which they look, or from which they are reading or learning to read. The children are being introduced to the book and what it beholds by the adult. The iconography is clear enough. Through the means of the book the values, conventions and moral principles of the adult's world are being conveyed and instilled, as in countless books of the kind produced in the eighteenth century for the instruction and improvement of children. Or so it would appear. The book that is open before these children is of course representative of the book that we have opened and are about to read, *Songs of Innocence*. The conventional roles have been reversed. In the pages that follow, it is we who are about to learn from the children, to reawaken a part of ourselves that in relation to the world of experience, to our world, has been diminished or altogether lost.

III. Illuminated Printing *Songs of Innocence*

I N 1788, Blake invented a method of reproducing poetry and design he called Illuminated Printing. It was composed of writing and drawing on a copper plate using an acid-resistant varnish, etching the unprotected surfaces away leaving both text and design standing in relief, and then inking and printing the relief surfaces on a printmaker's rolling press. In a prospectus dated 10 October 1793, he described this method as 'Printing both Letter-press and Engraving in a style more ornamental, uniform, and grand, than any before discovered, while it produces works at less than one-fourth of the expense.' For Blake, it was 'a method of Printing which combines the Painter and the Poet.'[1] Technically, it gave to both the poet and the painter the freedom to write and draw directly on the copper plate, that when etched became the means of reproduction.[2] *Songs of Innocence* was one of the first works to be published using this method.

As an apprentice, Blake learned the traditional method of intaglio etching. Robert Dossie's *Handmaid to the Arts* was a standard handbook during the period. It offered the following definition and instruction:

ETCHING . . . is engraving by corrosion, produced by the means of *aqua fortis*, instead of cutting with a graver or tool. The manner (in a general view) by which this is performed, is the covering the surface of the plate with a proper varnish or ground, as it is called, which is capable of resisting *aqua fortis*, and then scoring or scratching away, by instruments resembling needles, the parts of this varnish or ground, in the places where the strokes or hatches of the engraving are intended to be. Then, the plate being covered with *aqua fortis*, the parts that are laid naked and exposed by removing the ground or varnish, are corroded or eaten by it, while the rest, being secured and defended, remain untouched.[3]

Blake inverted this process. Instead of covering the entire plate with a varnish or ground and cutting his design into it with engraver's tools, he used the varnish like ink and the copper plate like a sheet of paper. Dipping his quill pen or fine pencil brush into the acid resistant varnish he wrote his text and drew his design directly on the polished surface of the plate, just as a writer would write out fair copy and as an artist would draw. All of the surfaces that were not protected were then corroded or eaten away by the acid.

The earliest account of Blake's method is that of J. T. Smith, who became acquainted with Blake in 1784 through his friendship with Blake's younger brother, Robert. In 1787 Robert died, aged nineteen, but spiritually became an inspiration for Blake, as Smith described:

Blake, after deeply perplexing himself as to the mode of accomplishing the publication of his illustrated songs, without their being subject to the expense of letter-press, his brother Robert stood before him in one of his visionary imaginations, and so decidedly directed him in the way in which he ought to proceed, that he immediately followed his advice, by writing his poetry, and drawing his marginal subjects of embellishments in outline upon the copper-plate with an impervious liquid, and then eating the plain parts away with aquafortis considerably below them, so that the outlines were left as a stereotype. The plates in this state were then painted in any tint that he wished, to enable him or Mrs. Blake to colour the marginal figures up by hand in imitation of drawings.[4]

John Linnell, who met Blake in 1818, later annotated a copy of Smith's account. The details he supplies are of particular value as Linnell was also a skilled printmaker and had worked in collaboration with Blake.[5]

The liquid mentioned by M[r] Smith with which he says Blake used to Draw his subjects in outline on his copper plates was nothing more I beleive [*sic*] than the usual stopping as it is called used by engravers made chiefly of pitch and diluted with Terps.

Linnell then added:

The most extraordinary facility seems to have been attained

by Blake in writing backwards & that with a brush dipped in a glutinous liquid for the writing is in many instances highly ornamental & varied in character as may be seen in his Songs of Innocence and the larger work of one hundred plates called Jerusalem.[6]

In 1811, George Cumberland, who had received instruction in printmaking from Blake, also referred to how writing backwards 'demanded the talents of a Blake, who alone excels in that art.'[7]

The exact formula of the stopping out liquid or etching ground that Blake used is unknown. According to Joseph Viscomi, the varnish described by Linnell appears to have been an asphaltum varnish. Exposed to air, the solvent would have evaporated and the solution thickened until it became hard. When ground with linseed oil and diluted with turpentine it would have behaved like ink.[8] This was essential. The varnish had to flow smoothly from Blake's pen or brush and not run. It then had to harden to prevent the acid eating it away and biting through the surface of the copper plate. When the liquid was fluid it provided a medium that was free and immediately responsive to the hand of the artist. When it became solid it turned a freely drawn artefact composed of poetry and design into one capable of etching. By creating a formula possessing these contrary aspects, and putting it to use in just this manner, Blake unified the relationship of the poet and the painter with that of the book producer.

Contemporary handbooks give several recipes of stopping out varnish that Blake could have made up or altered to suit his purpose.[9] One such handbook, *Valuable Secrets Concerning Arts and Trades* (1759; Dublin 1778), gives a recipe used 'To engrave with aquafortis, so that the work may appear like a basso relievo.' As Robert N. Essick was first to point out,[10] this account anticipates Blake's requirements for etching his text and design in relief:

Take equal parts of vermilion and of black lead: two or three grains of mastick in drops. Grind them all together, on marble, with linseed oil; then put this composition into a shell. Next to this operation, cut some soft quils, and let your steel or iron be well polished. Try first, whether your colour runs sufficiently with your pens: and, if it should not, you must add a little more oil to it; without making it, how-

ever, too limpid; but only so as to have your pen mark freely with it, as if you were writing, with ink, on paper. Then rub well your plate of steel with wood ashes, to clean and ungrease it; after which, you wipe it with a clean rag, and draw your design upon it, with your pen, prepared as before, and dipped into your liquor.[11]

Blake used copper plate. With text and design written on the plate, it was left to dry, according to the same account, and then baked over a dish of coals until the varnish was hard. Using the same varnish, the areas of design that had been drawn in outline and filled in with a pencil brush were then ready 'to scratch, with the point of a needle, those etchings, or places, which you want to be engraved [...] with aquafortis.' In other words, using an etching needle the larger areas of hardened varnish could be scratched with lines and then etched together with the other unprotected areas outside of the design. When etched, these lines print white and provide definition within the larger relief surfaces when they are inked and printed. This describes the type of white line etching technique that Blake has used on several plates of *Songs of Innocence*, including the lower areas of the title-page [PLATE 33]. Mistakes that occurred at any point in writing his text and drawing the design could be removed quickly with turpentine or later by scraping with an etching needle and reworking the area again with pen and stopping out varnish.

In order to copy his text onto the copper plate Blake had to become skilled in reverse or mirror writing. Although the principle of reversal in printmaking was established during his apprenticeship, of seeing and perceiving things in terms of contraries, Blake did not acquire this specialist skill during the 1770s. However, on the final leaf of the manuscript of *An Island in the Moon*, folio sixteen verso, written during the early 1780s, we can see Blake practising copper plate script [FIG. 10]. In the upper left corner he has written the capital letter 'B.' Lower left, in the same hand, Blake has written the first letters of his surname 'Bla' in mirror writing. This is the earliest evidence we have of Blake gaining the skill that was later witnessed and spoken of by George Cumberland and John Linnell. Significantly, also present in this manu-

FIG. 10 *An Island in the Moon* MS, folio 16ᵛ, turned sideways. Leaf size 310 × 185 mm. Reproduced by permission of the Syndics of the Fitzwilliam Museum, Cambridge.

script is a self-parody of ambitions to produce illustrated books with the 'writing Engraved instead of Printed,' as we have seen, in addition to the drafts of three songs that were later selected for *Songs of Innocence*.

In 1788, the first plates etched by his new process, measuring no more than 60 × 40 mm, and some less than 50 × 30 mm, show Blake's progress in mirror writing. In what appears to be the first of these experiments, the plates of *All Religions are One*, letters are awkwardly formed and sometimes lean toward the left [FIG. 11]. When they are compared with the plates in the two slightly later series *a* and *b* of *There is No Natural Religion*, there is already a noticeable improvement as well as some plates being written in a continuous or cursive hand instead of in roman lettering. By 1789, when Blake etched the plates of *Songs of Innocence*,

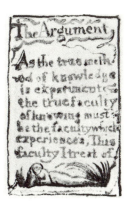

FIG. 11 Plate 3 'The Argument', *All Religions are One*, *c*.1788. Actual size. Size of original 48 × 30 mm. Reproduced by permission of the Henry E. Huntington Library and Art Gallery, San Marino, California.

though imperfections are still to be found, mirror writing in both cursive and roman has been all but mastered.

For the design, Blake may have drawn his images directly and freely on the polished and degreased copper plate at the time that he wrote his text in

mirror writing. However, in the *Manuscript Notebook* there are a number of drawings related to images used in the illuminated books, including *The Book of Thel*, *The Marriage of Heaven and Hell*, *Visions of the Daughters of Albion*, *America a Prophecy* and *Songs of Experience*.[12] As we have seen, another example is the motif of the seated woman with children reading at her knee used on the title-page of *Songs of Innocence*. Also to survive is a rejected page layout drawn in pencil for *The Book of Thel* (1789) and preliminary designs for the title pages of both *America a Prophecy* (1793) and *Europe a Prophecy* (1794).[13] These and other examples clearly indicate that his larger designs (not the interlinear flourishes and figures) were not created spontaneously on the copper plate but prepared beforehand or taken from other projects.

The drawings taken almost unchanged from the *Manuscript Notebook* are, left to right, the reverse of the printed images [PLATES 48 & 64]. This shows that Blake copied these images freehand, the way they had been drawn, onto the plate, instead of transferring them by counterproofing. The text was also written freehand, but in reverse. As a result, the image printed the opposite way round from the original drawing, and the text the right way round so that it could be read. For both text and design, the copper plate was therefore the location of the last stage in the creative process, where the design was recomposed to scale and where any final amendments to the text had to be made.

Songs of Innocence was printed from thirty-one copper plates. The smallest plate measures 111 × 63 mm, 'The Voice of the Ancient Bard', and the largest 123 × 76 mm, 'A Dream,' with different dimensions within this range.[14] These plates were cut from larger plates, indicated by vestiges of the plate maker's mark *JONES Nº 47 & 48 / SHOE LANE LONDON* found in posthumous impressions taken from eight plates of *Songs of Experience* etched on the backs[15] [FIG. 12]. In a posthumous copy of *Europe a Prophecy* (1794), Copy I, complete plate marks have been found on all seventeen plates punched on the backs of plates of *America a Prophecy* (1793), as follows: *JONES AND / PONTIFEX Nº 47 / SHOE LANE LONDON*. In this case,

all of the plates had been cut and made to size for Blake by his former supplier, recently joined in partnership by William Pontifex.[16] These plates measure between 164 × 231 mm and 173 × 234 mm. If they are representative of the copper plates Blake purchased earlier, then eight plates of these sizes quartered would provide thirty-two plates in the sizes used to etch *Songs of Innocence*. Cutting them would also leave elements of the plate maker's mark in the corners and at the edges of the plates, as indeed they are found in the posthumous impressions of *Songs of Experience*.[17]

The plates of *Songs of Innocence* have been cut evenly, probably by heavily scoring and then breaking the plate between two planks. Clean plate edges can be clearly seen in the heavily embossed posthumous impressions of *Songs of Innocence* and *Songs of Experience* in Copy a in the British Library.[18] However, as they vary considerably in size, it is likely that Blake cut and etched the plates for *Songs of Innocence* a few at a time, as he completed poems, had copper plate available and time; and not in a single, measured and carefully planned effort. The presence of different styles of script, evidence of growing accomplishment in mirror writing and changes in the layout of the plates also suggest that they were prepared and etched in small groups over time until enough poems and plates had accumulated to form a volume. As we shall see, the plates of *Songs of Experience* were also built up in stages.[19]

When they had been cut to size, the copper plates had to be made ready for etching. Each plate was hardened by hammering or planishing and then the surface made level and smooth by grinding with water, first with a grindstone, then pumice followed by oil stone and finally smooth wood charcoal. Any fine scratches that remained were removed by burnishing the plate with a rounded piece of steel, oil and felt 'till it be as bright as looking-glass.' Using either stale breadcrumbs or fine powdered chalk any traces of grease were removed.[20] The plate was now ready for Blake to write his text in reverse and draw his design in the acid resistant varnish. With the text of his poem written in reverse on the plate and the design drawn surrounding and interlining

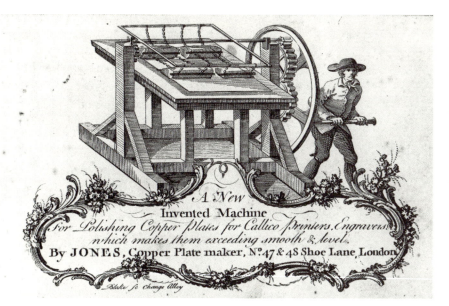

it, the liquid was left to dry and harden before etching, probably by setting it near a fire or over a brazier [PLATE 30]. Using soft sealing wax, Blake then formed a small border of wax resembling 'a little wall or rampart' around the edge of the plate to contain the acid, just as Robert Dossie describes in *The Handmaid to the Arts* as appropriate when using soft varnish. Evidence of this wax wall may be seen in late (and posthumous) impressions where Blake has printed these protected relief borders to help frame the image. Acid was then poured onto the plate until all of the areas to be etched were covered to a 'finger's breadth.'[21]

Depth of bite was controlled by the strength and type of acid used and by the length of time the plate was submitted to its corrosive action. Blake may have used nitric acid, but the smooth and regular striations in evidence on the only surviving example of one of his relief etched copper plates indicates a less aggressive mordant, perhaps ferric chloride. Etching in relief took time, relative to intaglio etching, due to the large areas of exposed metal to be corroded and the need to bite deeply. It also demanded special care in order to avoid underbiting. This occurs when the acid has bitten away the exposed surface and begins to erode text and design from below the ground of protective varnish, first by biting down and then sideways, caus-

ing the ground to lift or scale. As it becomes active, nitric acid turns blue, emits bubbles, that are brushed away with a feather, and fumes of nitric oxide in yellowish-brown purlings. If Blake did use a form of nitric acid, the presence of these bubbles and eddying fumes would have alerted him to the danger of underbiting.[22] Blake then removed the acid from the plate and washed and dried it [PLATE 31]. He then carefully repainted text and design with stopping out varnish before further etching.

The only example of one of Blake's original relief etched copper plates to survive is a damaged fragment measuring 82 × 58 mm, from a cancelled plate for *America a Prophecy*, 1793. We can see from an enlargement of this fragment how shallow the first bite was by noticing how Blake has minutely repainted and carefully surrounded several of the relief surfaces with stopping out liquid before again subjecting the plate to the acid [FIG. 13]. For example, at top right there is evidence of meticulous repainting of the broad copper plate letters 'ecy' of 'Prophecy' and, below, of surrounding a number of letters and words in the much smaller semi-cursive script. At the left edge of the fragment can also be seen an escarpment formed by the acid biting at the base of the wax wall. Repainting was done when this plate had been etched only to a depth of approximately .05 mm. The plate was then

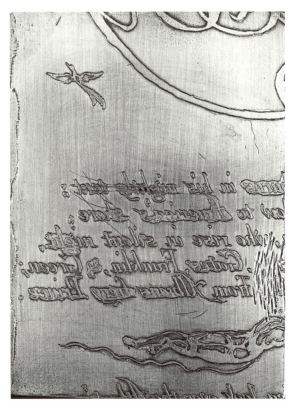

FIG. 13 Enlargement of fragment of rejected copperplate 'a' of *America a Prophecy*, 1793. Size of original 82 × 58 mm. Reproduced by permission of the National Gallery of Art, Washington, D. C. Accession number 1943.8.1848.a.

etched again, approximately a further .07 mm, amounting to a total bite of .12 mm.[23] As the unprotected surfaces are bitten away, those forming Blake's text and design that have been protected appear to emerge from the copper and are left standing in relief [PLATE 32].

Once the plate had been etched and cleaned it was ready to be inked. Blake prepared his inks himself until they were thick and glutinous, using nut or linseed oil heated, burned and reduced to the viscosity required and then ground together with colour pigments. This strong ink as it was called, normally prepared for intaglio printing, produced the characteristic granulated or reticulated effects Blake obtained when the impression was peeled back from the plate. Under magnification, the inks he used for relief printing his illuminated books often show a separation between coarsely ground

pigments and the binding agent. It is this separation that produces these granulated or minutely reticulated effects. Rebecca Donnan, Mellon Fellow in Advanced Paper Conservation, National Gallery of Art, Washington D. C., has suggested that these effects may have been obtained by using an aqueous binder such as gum, instead of oil, with the addition of a bulking agent such as chalk or lead white.

Inking only the relief surfaces of the plate with a dauber or ball required great skill. For the first copies of *Songs of Innocence* produced for sale, Blake was careful to wipe the plate borders and any ink that had touched in the etched shallows of the plate. This was made easier when text and design were etched close together, as in the plate of 'Holy Thursday' of *Songs of Innocence* [PLATE 35]. It was more difficult with a shallow bite where large areas or whites were etched, as in the fragment from the cancelled plate of *America a Prophecy* and the title-page of *Songs of Innocence* [PLATE 32]. John Jackson, noting in his *Treatise on Wood Engraving* (1839) the similarities between inking and printing from woodcuts and Blake's 'metallic relief engravings,' as he called them, described what was involved, evidently from personal experience of seeing Blake at work:

Blake's metallic relief engravings were printed by himself by means of a rolling or copper-plate press, though the impression was obtained from the lines in relief in the same manner in which the pressure was applied. As it is difficult, according to Blake's process, to corrode the large white parts to a depth sufficient to prevent their being touched by the dauber or ball in the process of inking, and thus preventing a soiled appearance in the impression, he was accustomed to wipe the ink out where it had touched in the hollows. As this occupied more time than the mere inking of the plate, his progress in printing was necessarily slow. [24]

This is the only first-hand account we have that describes Blake inking and wiping his plates. Its significance has been overlooked.

Jackson has noticed what was exceptional about Blake's method, not only technically but also in terms of what it involved. In particular, that when Blake wiped the ink from 'where it had touched in

the hollows' this was a 'necessarily slow' process. In other words, wiping the ink from the etched shallows of the plate required time and especially care. We can see why when we compare impressions of the title-page and 'HOLY THURSDAY' from Copy U with the same plates in copies C and E of *Songs of Innocence* [PLATES 34 & 36, 33 & 37]. Identified by Joseph Viscomi, Copy U is a trial copy, the first that Blake printed, where the plates have been inked and wiped to reveal faults in the text and design.[25] In copies C and E, the same plates have been inked, the borders and shallows wiped and then the plates have been printed in preparation for sale. In Copy U, the problems that arise when care is not taken are apparent in both examples, even in the small and relatively protected areas at the top and bottom of the plate of 'HOLY THURSDAY.' By comparison, they show how scrupulously Blake has inked and wiped the plates before printing the pristine impressions included in copies C and E. Jackson's observation makes clear that Blake could not print great numbers of impressions from his relief etched plates quickly. It belies the suggestion that several hundred impressions could be printed to the standard Blake achieved in a matter of a few days.[26]

Once the plate had been inked and any residue wiped away, it was placed on the bed of the rolling press in preparation for printing. Blake then turned to the stack of paper that he had measured, torn and prepared for printing. On the evidence of watermarks, Blake's choice of paper for printing his illuminated books was that made by I. Taylor, Edmeads & Pine and particularly J. Whatman: 'The most beautiful wove paper that could be procured,' as he stated in 1793 in his prospectus. Both 'E & P' and 'J. Whatman' watermarks are found in the first copies of *Songs of Innocence*, with leaves containing both marks used to make up a single copy. [27] Wove copper plate printing paper, as it was called, was available in Double Crown measuring 500 × 720 mm and Imperial measuring 555 × 760 mm. One of either of these sheets folded in half the long way and torn, and each of the two long halves folded in half from side to side and torn, and folded in half again from side to side and torn, would produce eight octavo leaves of the size that Blake used

to print the *Songs*.[28] The leaves were then dipped in clean water and in piles laid between planks, pressed with a weight and left for up three weeks so that the fibres would swell and be ready to fully absorb the ink, to 'rot' as it was called.[29] Copy E of *Songs of Innocence* and Copy H of *Songs of Experience* are amongst the first copies to be produced in both series. Both have survived as they left Blake's hands, with the untrimmed leaves stitched between buff paper wrappers [PLATES 22 & 23]. Most clearly in Copy E, the deckle edges of the original sheets of wove paper from which Blake tore the leaves for printing can be seen along some edges, including inside edges next to the stitch holes. The survival of these unbound leaves makes clear that each impression of the *Songs* was printed separately and not in conjunct pairs on a single sheet to then be folded, stitched and trimmed as in letterpress printing.[30]

In preparation for printing, a sheet of 'pasteboard' or 'Paper' was fixed to the bed of the press.[31] The paper was either cut to the same size as the sheets to be printed, or the size of the sheets to be printed was marked in outline on the paper. The inked plate was then carefully placed on the paper in the position it was to print on the facing leaf. The dampened and blotted sheet of wove paper to be printed was aligned to the underlying sheet and gently and evenly laid on the inked plate. Blake aligned the plate and the sheet of paper to be printed so that each impression would face the other in the same position, on both sides of the leaf. But examples of misalignment also exist in early copies, as in the surviving plates of Copy X of *Songs of Innocence*, one of the first copies to be printed, and very occasionally in slightly later copies, like Copy E. In Copy X, plates printed recto and verso on the same sheet are badly askew. This suggests that aligning and printing first on one side of the leaf and later on the other side had to be learned and required constant attention. Blake used the underlying sheet and his eye to place the plate squarely in approximately the same position each time, bearing in mind that the plates often varied slightly in size. With plate and paper aligned, either felt blankets nipped between the rollers at one end,

Fig. 14 Plate of copperplate printmakers rolling press and equipment, Berthiau and Boitard, *Nouveau Manuel Complet de L'Imprimeur en Taille-Douce*, 1831. Plate size 142 × 455 mm. Reproduced by permission of the British Library Board.

Fig. 15 Plate of copperplate printmakers workbench and equipment, Berthiau and Boitard, *Nouveau Manuel Complet de L'Imprimeur en Taille-Douce*, 1831. Plate size

or pasteboard to print firmly from relief surfaces was laid over both. The plate was ready to print.

Blake turned the star cross of the press slowly and evenly until the underlying registration sheet, plate, paper and blankets had passed between the rollers. The blankets were then turned back and the impression taken by the corners and carefully lifted from the plate. By using pieces of thin card or paper-thin brass folded in half between thumb and index finger to lift the impression, smudging it with ink was avoided and Blake was able to work unassisted when Catherine was not able to help. Little pressure was required in printing from relief etched plates, probably little more than the weight of the roller that had been carefully and evenly adjusted in preparation for the plate. This left no raised or embossed areas on the verso and both sides available for printing. Because of the viscosity of the ink, Blake could leave the plate on the bed of the press, place another sheet of paper on it and take a second impression. The result was lighter in colour and thinner in texture, but a clear, clean and sometimes more desirable impression for colouring was possible. This was made easier once the plate was printing well, when the ink had been worked up to just the right consistency against the ball or dauber, a feel for inking and wiping a particular plate had been gained and the pressure of the roller was right for the plate. Once a plate was printing in this way it encouraged printing several impressions before stopping and beginning again with another plate. This and the fact that the early copies of *Songs of Innocence* are found printed either in green, yellow ochre or raw sienna, apart from the single trial Copy U printed in charcoal black, indicates that Blake printed several sets of impressions at a time. The impressions were then hung on lines to dry and then stacked, pressed and put away for stock. Apparently, some impressions were arranged in sets of monochrome copies before the ink was entirely dry. In Copy E of *Songs of Innocence*, for example, in the Berg Collection of the New York Public Library, offsets from the next plate in the set are just visible on the versos of the frontispiece, which shows a ghost of the title-page, and of the title-page, which shows a ghost of the

'Introduction.' Blake's printmaking equipment, workbench and wooden rolling press would have been essentially the same as those depicted in the diagrams given in Berthiau and Boitard, *Nouveau Manuel Complet de L'Imprimeur en Taille-Douce* (1831), published just at the moment when metal gearing was being introduced and the old wooden presses were about to be replaced altogether by cast iron and steel[32] [FIGS. 14 & 15]. The plate from William Faithhorne, *The Art of Graving and Etching*, (second edition, 1702) shows a copper plate printer at work on a wooden rolling press of the type Blake used [FIG. 16].

The original copies of *Songs of Innocence* were made up of thirty-one plates printed on seventeen leaves. The Frontispiece, title-page and Introduction were each printed on a separate leaf and the remaining twenty-eight plates were printed on both recto and verso. Between 1789 and 1793 Blake printed twenty-two copies of *Songs of Innocence* that are known. The first copy to be printed was the trial copy, Copy U, now in the Houghton Library, printed in charcoal black on only one side of the leaf to check the plate [PLATES 34 & 36]. This was followed by four copies printed in green, mixed from Prussian blue and gamboge, *Songs of Innocence* Copies I, J, X and *Songs of Innocence* in *Songs* Copy F [PLATES 26, 27 & 62]. This printing was followed by sixteen copies printed either in yellow ochre, or in raw sienna colour mixed from vermilion and Prussian blue [PLATES 38 & 40]. The copy of *Songs of Innocence* in *Songs* Copy F, formerly George Cumberland's copy now in the Yale Center for British Art, was printed in green ink in the following plate pairs recto and verso, with the first three plates printed on one side only:

Frontispiece
Title-page
Introduction
The Shepherd *and* The Little Black Boy
The Little Black Boy *and* On Anothers Sorrow
The Ecchoing Green *two plates recto verso*
The Chimney Sweeper *and* Spring
Spring *and* The School Boy
Laughing Song *and* A Dream

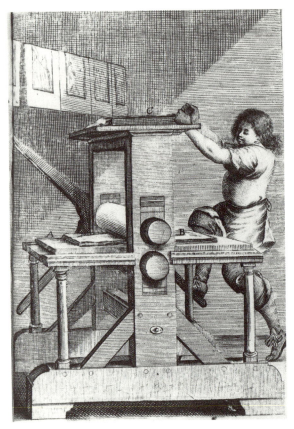

FIG. 16 Copper plate printer at work at a rolling press. William Faithhorne, *Art of Graving and Etching*, Second Edition, 1702. Plate size 137 × 87 mm. Reproduced by permission of the British Library Board.

The Little Boy lost *and* The Little Boy
　found *recto verso*
The Lamb *and* Nurses Song
The Little Girl Lost *and* The Little Girl Lost/
　The Little Girl Found
The Little Girl Found *and* Voice of the Ancient
　Bard
The Divine Image *and* HOLY THURSDAY
A CRADLE SONG *two plates recto verso*
Infant Joy *and* The Blossom
Night *two plates recto verso*

Songs of Innocence Copy I, in the H. E. Huntington Library, and Copy X, in the collection of the National Gallery of Victoria, Melbourne, also printed in green, have different combinations of plates printed on the recto and verso of each leaf. In Copy I, nearly every combination differs from those in *Songs of Innocence* in *Songs* Copy F, apart from consecutive pairs of plates like 'A CRADLE SONG' and 'The Little Boy lost' and 'The Little Boy found.' In Copy X, only fourteen plates printed recto verso on seven leaves have survived.[33] But compared with the combinations of plate pairs in Copy F, four of the seven pairs have been printed with different combinations of poems on recto and verso. The combinations of plates in Copy X are also different from those in Copy I. In other words, all of these copies have been printed with different plates on either side of each leaf, with the exception of poems occupying more than one plate that have been printed in sequence. This suggests that the copies printed in green were either printed on separate occasions or, what is more likely, they were printed together in a not very orderly manner. The misalignment of plates in Copy X contributes to the suggestion that Blake was feeling his way in this first printing session of *Songs of Innocence*. All of these combinations are also noticeably different from the next set of copies Blake printed, apart from consecutive two- or three-plate poems.

Songs of Innocence Copies A–H, K–M and Z, and the copies of *Songs of Innocence* in *Songs* Copies B, C, D and E were printed together in the same session, a printing session that produced sixteen copies amounting to nearly five hundred impressions. As described by Joseph Viscomi, during this printing session sets of plates were printed in both yellow ochre and raw sienna where 'the exact recto/verso plate combinations are repeated' in all of these copies.[34] Like the copies printed in green the plate borders have been wiped before printing and they have all been printed using the same Edmeads and Pine and J. Whatman paper stock. Some copies printed in yellow ochre also contain a few plates printed in raw sienna, and some copies printed in raw sienna contain a very few plates in yellow ochre, for example, *Songs of Innocence* Copies B, D and F and *Songs of Innocence* in *Songs* Copies D and E.

In yellow ochre, *Songs of Innocence* Copy C in the English Poetry Collection, Wellesley College,

Library, Copy E in the Berg Collection of the New York Public Library and Copy G in the Paul Mellon Collection at the Yale Center for British Art, were printed recto verso in the following pairs, apart from the first three plates printed on one side of the leaf:

Frontispiece
Title-page
Introduction
A Dream *and* The Little Girl Lost
The Little Girl Lost/The Little Girl Found *and*
 The Little Girl Found
The Lamb *and* The Blossom
The Ecchoing Green *two plates recto verso*
The Divine Image *and* The Chimney Sweeper
Infant Joy *and* The Shepherd
Night *two plates recto verso*
A CRADLE SONG *two plates recto verso*
The Little Boy lost *and* The Little Boy found
Nurses Song *and* HOLY THURSDAY
On Anothers Sorrow *and* Spring
Spring *and* The School Boy
Laughing Song *and* The Little Black Boy
The Little Black Boy *and* The Voice of the
 Ancient Bard

Also printed in yellow ochre is Copy B of *Songs of Innocence*, in the Rosenwald Collection, Library of Congress. But in Copy B two plate pairs differ from those in copies G and E. The two plates of 'Spring' have been printed recto verso on one leaf and 'On Another's Sorrow' and 'The School Boy' on another.

In raw sienna, Copy A in a private American collection and Copy D in the Pierpont Morgan Library have both been printed with the same combination of plates recto and verso as Copies C, E and G printed in yellow ochre. But *Songs of Innocence* Copy K, in the Pforzheimer Library, New York Public Library, is different. It is also printed in raw sienna in the same plate pairs, except for 'A Dream,' which is printed on the recto of the first plate of 'Spring' instead of 'On Anothers Sorrow.' 'On Anothers Sorrow' has been printed in a distinct brown ink on a separate leaf on a lighter weight of wove paper. It may have been added later when the copy was coloured in what appears to be a slightly later style. Copy K also lacks the three plates that make up 'The Little Girl Lost' and 'The Little Girl Found.' The recently discovered copy of *Songs of Innocence* in the Bayerische Staatsbibliothek, Munich, Copy Z, is also printed in raw sienna. It also lacks the three plates of 'The Little Girl Lost' and 'The Little Girl Found' and the plate of 'On Anothers Sorrow.' These copies, and particularly Copy Z, may have been prepared for sale at the time Blake issued his prospectus of works for sale in illuminated printing on 10 October 1793, where *Songs of Innocence* is listed as 'Octavo, with 25 designs, price 5s.' The Munich copy is foliated by Blake beginning with the 'Introduction,' one to twenty-five. The composition of both copies may also reflect Blake's decision to transfer 'The Little Girl Lost' and 'The Little Girl Found' to *Songs of Experience* at about this time.

To print sixteen copies in a single printing session would have demanded care, organisation and time. We can see evolving in the printing of the earlier sets of copies in green ink mistakes being made and solutions being found for the problems encountered when printing from copper plates on both sides of separate leaves to create a book with facing pages. As a result, it is clear that Blake established a method of using one set of plates for printing the rectos of the leaves, and a second set of plates for printing the versos, that was ordered and mindful of consecutive plates of multiple plate poems. This may possibly have been simplified even further by printing two impressions at a time and placing them on the bed of the press as they were meant to face each other.[34]

Nearly five hundred impressions were required to make up sixteen sets of thirty-one plates on seventeen leaves. While printing these copies every area of Blake's studio would be occupied. Dozens of impressions would be hanging from the lines running below the ceiling until the paper and ink were dry enough for the leaves to be taken down, pressed, dampened again and stacked ready to be printed on the versos. The marble inking slab would be glistening with stiff yellow ochre and raw sienna ink and the ink daubers worked up. After

inking each plate, as John Jackson observed, Blake slowly and painstakingly wiped the plate borders and etched shallows of ink. The plate was taken to the press and a sheet of paper registered to the plate. Then the sound of the star cross turning the heavy rollers on their greased axles, slowly and evenly, would be heard, the blankets being thrown back, another impression peeled from the plate, lifted away and draped over a line to dry. Finally, pressed and stacked in sets, sixteen copies were wrapped for safekeeping and placed in cupboards or drawers in Blake's drawing and painting studio in preparation for finishing.

In preparing *Songs of Innocence* for sale, Blake would take a set of monochrome impressions from stock. As J. T. Smith described, 'The plates in this state were then painted in any tint that he wished, to enable him or Mrs. Blake to colour the marginal figures up by hand in imitation of drawings.'[36] Alexander Gilchrist described Blake's method of mixing his colours and his choice of pigments:

He ground and mixed his water-colours himself on a piece of statuary marble, after a method of his own, with common carpenter's glue diluted, which he had found out, as the early Italians had done before him, to be a good binder. Joseph, the sacred carpenter, had appeared in a vision and revealed *that* secret to him. The colours he used were few and simple: indigo, cobalt, gamboge, vermilion, Frankfort-black freely, ultramarine rarely, chrome not at all. These he applied with a camel hair brush, not with a sable, which he disliked.[37]

As we shall see, Blake made no use of indigo or cobalt, and chrome yellow was not available to him. He did use ultramarine, gamboge, madder lake and black. Earths, such as red and yellow ochre, also formed part of his basic palette. After finely grinding his pigments, Blake mixed them with water and a transparent binding medium. Gum arabic was commonly used as a binder, but it had a tendency to dry out and then crack and peel. To prevent this, honey, sugar or another binder such as gum senegal was added.[38]

Blake applied his water colours in a thin wash, as Gilchrist described, using a camel hair brush, which he preferred because it was finer, softer and less resilient than sable.[39] Each impression was delicately coloured to highlight details of design or title, with the text, background and borders left free of colour. Exceptions were the frontispiece and title-page and where a design is a central feature, as in 'Infant Joy' or 'A Divine Image', or occupying the top or bottom of a plate where water colour has been applied more generously. For the first copies printed in green, Blake characteristically applied a thin wash across the impression in order to create tints of colour behind text and design as well as highlighting particular elements and letter formations [Plates 26 & 27]. For the copies he printed in yellow ochre and raw sienna, Blake was characteristically more sparing in his use of water colour, just highlighting elements of the design and colouring larger images including the Frontispiece and title-page [Plates 33, 38 & 40].

Rebecca Donnan, in her research at the National Gallery of Art, Washington, D. C., has established that Blake made use of very few pigments in colouring his early illuminated books: bone black, Prussian blue, natural ultramarine, vermilion, madder lake, yellow ochre and gamboge. To obtain the shade of raw sienna that he used in his water colours and his inks, Blake mixed Prussian blue and vermilion. His greens were a mixture of Prussian blue and gamboge and his shades of red orange a mixture of vermilion with gamboge. For the paint out of the pigments and mixes reproduced here, she has used the same pigments that were available to Blake in the 1790s mixed with hot gelatine, an animal glue [Plate 42].

Because Blake used only a few colours based upon these pigments, this has led to the view that all of the copies that were produced in a printing session were coloured together as an edition, probably with Catherine Blake's help.[40] Following the session in which sixteen copies of *Songs of Innocence* were printed in yellow ochre and raw sienna, this would have entailed colouring nearly five hundred impressions. But what is clear is that each copy has been coloured distinctly, and not in a uniform or rote manner as sometimes practised in the hand colouring of commercial prints. It is more likely that one copy was coloured to show potentia

customers and another to have on hand for immediate sale. This would demonstrate that each copy shared general characteristics with other copies but that it was finished distinctly. Leaving the remaining copies in stock uncoloured offered an attractive alternative, either of colouring a copy specially for a particular customer or selling it as it had been printed, in monochrome. What is clear and distinctive about Blake's colouring of these early copies is that he consistently used thin transparent wash, sparingly and unobtrusively, and carefully maintained the balance between text and design, making clear that they were complementary [PLATES 38, 40 & 62].

When Blake had selected and coloured a set of plates for sale they were gathered together and step-stitched in paper wrappers [PLATES 22 & 23]. The Frontispiece, printed on one side, was placed with the recto blank and the image facing the title-page. The title-page and Introduction followed, both printed on the recto only. The remaining fourteen leaves printed recto and verso were then arranged so that poems occupying more than one plate were in sequence. Because the leaves were not printed conjunct and then folded and bound as in letterpress printing, there was no predetermined order for the seventeen separate leaves to follow, apart from obvious sequences such as the Frontispiece, title-page and 'Introduction' and those of multiple plate poems. The seventeen leaves were placed on the right half of a piece of heavy buff paper a little more than twice the width of the leaves and slightly larger at top and bottom. The wrapper was then folded in half over the set of leaves, from left to right, and held in one hand. With the other hand, a needle and binder's linen thread was pierced up through the lower wrapper half way down the inside margin, through the seventeen leaves and out through the upper wrapper. About an inch and a half above the hole at the centre of the inside margin, the needle and thread was then pierced through the upper wrapper and drawn through the leaves and the lower wrapper. Pulling the needle and thread through, it was then taken down about an inch and half below the first hole and pierced through the lower wrapper, drawn through the

leaves and upper wrapper and returned to the centre. Piercing the needle and thread down through the first hole again, it joined the end of the thread, was tied off firmly at the back and the loose ends cut.[41] The other illuminated books that have survived as Blake issued them in the 1790s show that he followed this same procedure, what was in fact standard practice by booksellers in the eighteenth century. Books and pamphlets were purchased in this way and then the customer decided whether it was to be left in wrappers or bound. Many booksellers had facilities for binding and obliged their customers according to their instructions. Blake left his customers to make their own arrangements.

The identity of the first customers for *Songs of Innocence* indicates that they were largely sold to Blake's friends and acquaintances. The copy of *Songs of Innocence* bound with one of the first copies of *Songs of Experience*, *Songs* Copy F, was obtained by George Cumberland (1754–1848), one of Blake's closest friends.[42] Cumberland was in receipt of a substantial income. He was a keen amateur printmaker and would have been amongst the first to obtain a copy from Blake. From 1788, Cumberland was travelling in Italy and living in Rome, but in 1790 he returned to England. The copy of *Songs of Innocence* in *Songs* Copy F is printed in green, one of the first four copies to be printed by Blake [PLATES 26 & 27]. Another copy, Copy C, printed in yellow ochre and now in the collection of Wellesley College Library, was specially 'executed' for the poet and collector Samuel Rogers (1763–1855) [PLATES 33 & 38]. In 1788, Rogers became the principal heir to the family banking business, and, following his father's death in June 1793, becoming the sole heir he was in receipt of five thousand pounds per annum. Rogers used his fortune to establish one of the finest collections of illuminated manuscripts, now in the collection of the British Library.[43]

Copy D of *Songs of Innocence*, now in the collection of the Pierpont Morgan Library, was obtained by another close friend and supporter of Blake's work, John Flaxman (1855-1826). According to the sale catalogue of Flaxman's collection at Christies's, 26 April 1876, this copy was '[C]oloured by Blake

for Flaxman.'[44] John Flaxman and his wife Ann left for Rome on 14 September 1787 and did not return until late November 1794.[45] While abroad, Flaxman made little effort to keep in touch with friends, and on the one occasion that he did write to Blake there was evidently no reply.[46] However, within a year of their return, Flaxman recorded the following outlays in his account book marked 'Jany 1795' preserved in the British Library:

<div align="center">Pd for . . .</div>

Board & [et]c———————————2	12	6
Nancy ————————————2	2	–
Blakes Book —————————	10	6
Shoes —————————————	1	3
Advertisement for House————	4	–
Paper —————————————		9
Nancy ————————————9	19	6 [47]

Songs of Innocence Copy D was also printed monochrome in yellow ochre, apart the plates of 'A Cradle Song' and 'Infant Joy' which have been printed in raw sienna. Blake made up Copy D for Flaxman, colouring it in the established manner but with great care adding finish in pen and ink. The price of ten shillings and six pence is more than twice the price of a copy of *Songs of Innocence* as listed in the prospectus of 10 October 1793. This suggests that Flaxman may have purchased a copy of *Songs of Experience* together with *Songs of Innocence*.[48] Or, the additional amount he paid may have been for colouring. There is also the possibility that paying something more was a way of supporting his friend's work. At the time of his return, Flaxman had an established reputation. According to the same account book, he 'Recd in the year 95_' over twelve hundred pounds. Copy A, printed in 1795, was also prepared for a close friend, the portrait painter George Romney (1734–1802). *Songs of Innocence* Copy A was part of a set of illuminated books specially commissioned by Romney on large paper.[49]

In May 1793, Blake published together with the bookseller Joseph Johnson *For Children The Gates of Paradise*. In September 1794, in correspondence between the antiquarian collectors Francis Douce and Richard Twiss, we learn that in addition to *The Gates of Paradise* 'several more of Blakes books

[may be seen] at Johnsons in St. Ps Ch. Yd.'[50] Possibly, before September 1794, Blake established with Johnson an arrangement whereby examples of his illuminated books could be viewed at his premises. *Songs of Innocence* would have been one of the most accessible to the public. This may offer one explanation of why Blake printed a number of copies in raw sienna and yellow ochre following the earlier printing of only a few copies in green. Blake's preparations for advertising his works 'To the Public' in his prospectus of 10 October 1793 may suggest another reason.

As we have seen, for the first copies that Blake produced for sale great care has been taken in inking both the text and design as well as in wiping any traces of ink from the plate borders and etched shallows. The result is that these impressions have printed clearly and legibly. This, together with the method of discreet colouring in transparent wash, emphasises Blake's desire that they should be read as well as appreciated visually, a balance that is lost in some later heavily decorated copies. All of the copies represented by these first issues of *Songs of Innocence* are distinct in the particulars of their hand colouring, but they also possess an unmistakable family resemblance. It seems clear that Blake finished some copies for sale. Copies may also have been 'executed' for particular customers, like John Flaxman and Samuel Rogers. But what is apparent from these first issues is that Blake was of a mind as to how they were to be finished, regardless of a particular customer's taste or pocket. In other words, these first examples of *Songs of Innocence* clearly represent his original conception of the book [PLATES 22 & 23, 26 & 27]. This attitude and conception would change, and change significantly, after the turn of the century.

After 1800, Blake characteristically printed on only one side of the leaf, so that when the leaves were gathered and stitched together in wrappers for sale emphasis was less upon reading a book and more upon looking through a bound set of prints. This coincided with printing the plate edges, heavily decorating each leaf and adding framing lines. There were exceptions to this style of decoration. The copy of *Songs of Innocence* catalogued as *Songs*

Copy O, that was sold to John Flaxman in 1814 and is now in the collection of the Houghton Library at Harvard, Blake printed in brown ink and discreetly highlighted in sepia wash [PLATE 71]. Another copy of the *Songs*, *Songs* Copy BB, sold to Robert Balmano in 1816 and now in a private collection in Germany, was printed in charcoal black and carefully highlighted in charcoal water colour wash [PLATE 72]. But, for the most part, copies produced after 1800 were decorated more elaborately, often disguising the fact that they had been printed with less care. It is in the first copies that the method of their making, combined with the way that they have been finished, most clearly represents what Blake meant in October 1793, when, in his prospectus, he distinguished his works as being produced in 'Illuminated Printing.'

Blake's method of relief etching both text and design on a single copper plate dispensed with the complex conventional means of illustrated book production of his day. Joseph Ritson's *A Select Collection of English Songs*, published by Joseph Johnson in 1783, is representative of what was involved and the part that Blake played and earned his living by [FIG. 17]. The text of the poems was printed from the raised or relief surfaces of cast lead type composed in formes and printed on a common hand-powered wooden screw press. For an octavo like *A Select Collection of English Songs*, eight pages would be set and printed on each side of a single sheet. But, as the copper plate illustrating the text was engraved in intaglio, with the lines cut below the surface and filled with ink, it had to be printed under great pressure in a copper plate rolling press. In other words, to produce a page printed in letterpress with an engraved illustration required two fundamentally different kinds of specialised printing and the careful organisation and management of the entire procedure by the bookseller. For Johnson, this entailed obtaining the manuscript from Ritson, editing it in preparation for the letterpress printer, marking the page layout for illustration, hiring Thomas Stothard to make the designs and Blake to engrave them. When everything was ready, the edited text was delivered to the letter press workshop where the text was printed, then the printed sheets and engraved copper plates were delivered to the copper plate printers, where they were printed. Returned to Johnson, the sheets were collated, folded, gathered, pressed and sewn into paper wrappers and priced roughly twice the cost of materials and labour ready for publication and sale.[51] By writing his own text, making his own designs and etching them together in relief so that the entire page could be printed from the same surface, Blake placed himself in sole charge of each step in the creation, reproduction, pricing and publication of his illuminated books, apart from making the paper.

But the invention that Blake described as Illuminated Printing was something more. On Plate 14 of the *Marriage of Heaven and Hell* he signifies his method:

But first the notion that man has a body distinct from his soul, is to be expunged; this I shall do by printing in the infernal method, by corrosives, which in Hell are salutary and medicinal, melting apparent surfaces away, and displaying the infinite which was hid.

Blake's method is symbolic of his philosophy of mind, of a deeply held belief in the existence of innate ideas and vehement opposition to the philosophical empiricism that dominated his age, in particular as expressed by John Locke in *An Essay Concerning Human Understanding*:

Let us then suppose the Mind to be, as we say, white Paper, void of all Characters, without Ideas; How comes it to be furnished? [. . .] to this I answer, in one word, From Experience. In that, all our Knowledge is founded; and from that it ultimately derives it self.[52]

Blake had read Locke's *Essay* 'when very Young.'[53] His opposition to its principles and to all who upheld them was uncompromising:

Reynolds Thinks that Man learns all that he Knows I say on the Contrary That Man Brings all that he has or Can have Into the World with him, Man is Born Like a Garden ready Planted & Sown.[54]

For a man of Blake's training and beliefs, the analogy between Locke's metaphor for the human mind as *tabula rasa*, a blank slate, and a copper plate prepared for conventional intaglio etching and

DRINKING SONGS.

SONG I.

THE HONEST FELLOW.

PHO! pox o'this nonfenfe, I prithee give o'er,
 And talk of your Phillis and Chloe no more;
Their face, and their air, and their mien—what a rout!
Here's to thee, my lad!—pufh the bottle about.

Let finical fops play the fool and the ape;
They dare not confide in the juice of the grape:
But we honeft fellows—'fdeath! who'd ever think
Of puling for love, while he's able to drink.

'Tis wine, only wine, that true pleafure beftows;
Our joys it increafes, and lightens our woes;
Remember what topers of old us'd to fing,
The man that is drunk is as great as a king.

VOL. II. B 'Tis

engraving would have been apparent.[55] Its contrary, etching in relief by biting the surfaces of the copper away to reveal from within poetry and design, similarly would have been appreciated as a corresponding metaphor for the existence of innate ideas, for the divine within man awakened and raised to life [PLATE 32].

The medium that Blake chose to finish the first copies of *Songs of Innocence* complemented his beliefs. The use of thin transparent water colour wash was used to achieve a particular effect, as Marjorie B. Cohn in her study of the development of the materials and use of water colour makes clear:

Methods of washing and colour blending focused the artist's attention on colour effects, especially as the properties of water-colors seemed to embody in practice theories about color and light which rode at the forefront of contemporary science in the late eighteenth century. The very transparency of eighteenth-century organic watercolor pigments in particular stimulated an awareness of the sublest aspects of color, for a transparent pigment on white paper will assume its hue more from the color of the light transmitted *through* it, reflecting off the white paper and back to the eye, than from the light reflected *off* of it.[56]

This luminous quality, of light being reflected off the ground and back through transparent colour, complements the abiding theme of the poems themselves, epitomised by 'The Divine Image,' and gives a particular connotation to Blake's description of the method used to produce them. In terms of both the method of production and the manner of their finish, it was fitting that *Songs of Innocence* should be one of the first works Blake published in Illuminated Printing, and that these pages in particular, so to speak, from within, should emanate light.

IV. *Songs of Experience*
The Manuscript Notebook

THE *Manuscript Notebook* was originally a sketchbook owned by Blake's beloved younger brother, Robert, which upon his death in February 1787 aged seventeen passed to William. Until his own death forty years later, it remained one of Blake's most treasured possessions. It is a small quarto, measuring 196 × 157 mm, now in the collection of the Manuscripts Department of the British Library catalogued as Add. MS 49,460. At the time that it came into William's possession, the first few pages contained Robert's sketches and pen and wash drawings. The remaining pages were blank. Before the poems leading to *Songs of Experience* were introduced, these blank leaves were used for two series of drawings.

The first series of drawings extended almost continuously from N. 15 to N. 101. They led to the production of an emblem book recording man's journey from birth to death, a project that was probably started not long after Robert's death and prompted by it. When Blake began to draft *Songs of Experience*, beginning at the back of the *Manuscript Notebook*, the pages leading from the front were being filled with these drawings. By spring 1793, a final selection of seventeen of these images had been engraved, one proof copy produced and on 17 May the small, pocket-sized volume entitled *For Children The Gates of Paradise* was published jointly by Blake in Lambeth and by the bookseller Joseph Johnson at 72 St. Paul's Churchyard.

The designs for *The Gates of Paradise* were completed and being selected while Blake was writing *Songs of Experience*. That spring and summer, some of the drawings that had not been engraved for *The Gates of Paradise* were adapted for *Songs of Experience*. Three drawings are related to the design used for the motif of the title-page, on N. 33, N. 37 and N. 43 [FIG. 18]. The last of these Blake

copied exactly [PLATES 48 & 49]. On a personal level, this scene and many like it in the series must have been a reminder to William of Robert's passing. Images of sickness, death and the grave are found in the greatest numbers, followed by those of war, plague and imprisonment. On N. 57, the drawing of a soul reclining on a cloud is used for the design on the lower part of the plate of the 'Introduction' [FIG. 24]. On N. 74, the drawing of a woman shocked at discovering a dead child lying on the ground is used for the plate of 'HOLY THURSDAY' [PLATES 61 & 63]. On the same page are drawings that will be used for or anticipate figures on the Frontispiece, 'The SICK ROSE' and 'My Pretty ROSE TREE.' The design used for 'The Angel' is on N. 65 [FIG. 32]. In this case, glue spots at the four corners of the drawing in pen and ink finished in grey wash indicate that it was first prepared to be transferred to copper using tracing paper, but not used and later selected for the design of 'The Angel.' The changes Blake made to the printed image suggest that for the plate for *Songs of Experience* it was drawn freehand facing the same direction, left to right, as with the design for the title-page, 'HOLY THURSDAY' and the other drawings he used, where it then printed the other way round.

Drawings that were adapted for the plates of 'The SICK ROSE' and 'LONDON' are even more revealing. In relation to the plate of 'The SICK ROSE,' the drawing on N. 21 shows a rose in bloom, upright and healthy, with a figure with outstretched arms about to fly unheeded from the stamen while a second figure looks on[1] [FIG. 19]. In contrast, on the plate of 'The SICK ROSE,' the rose is pulled down to earth by the weight of its own luxuriance, symbolic of its sickness, and the figure with outstretched arms is seen trying to escape from an encircling worm. The emblem drawing

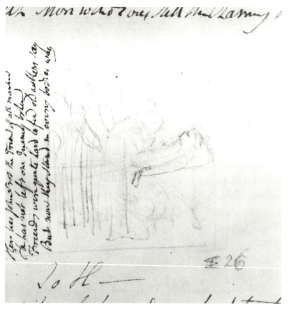

FIG. 18 Drawing leading to title-page *Songs of Experience* from emblem drawings of *For Children The Gates of Paradise*, 1793. Detail, *Manuscript Notebook*, N. 37. Reproduced by permission of the British Library Board.

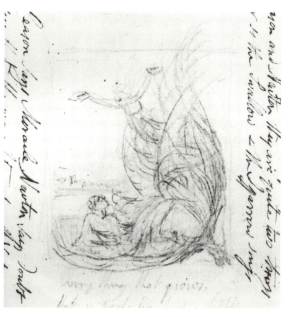

FIG. 19 Drawing used for 'The SICK ROSE,' *Songs of Experience*, from emblem drawings of *For Children The Gates of Paradise*, 1793. Detail, *Manuscript Notebook*, N. 21. Reproduced by permission of the British Library Board.

that Blake used for the plate of 'LONDON' is found on N. 54. Significantly, in place of Holbein's celebrated figure of Death leading old age to the grave, most recently reproduced in Thomas Bewick's *Emblems of Mortality* (1789) [Fig. 20], in both the drawing and the plate of 'LONDON' old age is being led by the hand of a child [PLATES 64 & 66]. These examples demonstrate a creative exchange and ironic interplay between the traditional evocations of the emblem designs and the creation of the plates of *Songs of Experience*. No less, perhaps, than the poems of *Songs of Experience* inscribe the earthly reality of the melancholy journey recorded in the emblems of *The Gates of Paradise*.

At the back of the *Manuscript Notebook*, turned sideways, with the page openings used from top to bottom, is the second series of drawings, in illustration of Milton's *Paradise Lost*. These drawings bear directly upon the creation of *Songs of Experience*. They share the same theme, inform the writing and on occasion charge specific poems with meaning. This was where Blake chose to write his poems.

The drawings in illustration of *Paradise Lost* probably date from September 1791, following publication on 1 September by Joseph Johnson and Henry Fuseli of proposals for a Milton Gallery:

PROPOSALS FOR ENGRAVING AND PUBLISHING BY SUBSCRIPTION THIRTY CAPITAL PLATES, FROM SUBJECTS IN MILTON; TO BE PAINTED PRINCIPALLY, IF NOT ENTIRELY, BY HENRY FUSELI, R.A. AND FOR COPYING THEM IN A REDUCED SIZE TO ACCOMPANY A CORRECT AND MAGNIFICENT EDITION, EMBELLISHED ALSO WITH FORTY-FIVE ELEGANT VIGNETTES, OF HIS POETICAL WORKS, WITH NOTES, ILLUSTRATIONS, AND TRANSLATIONS OF THE ITALIAN AND LATIN POEMS. By W. COWPER [...] Messieurs Bartolozzi, Sharp, Holloway, Blake, and other eminent Engravers have promised their Assistance in the Execution of the Plates.[2]

The project was still underway the following spring when Fuseli wrote to his friend and patron William Roscoe on 29 May 1792:

FIG. 20 Thomas Bewick after Hans Holbein, 'The Old Man,' *Emblems of Mortality; Representing, in Upwards of Fifty Cuts, Death Seizing all Ranks and Degrees of People,* 1789. Leaf size 161 × 91 mm. Plate size 62 × 51 mm. Reproduced by permission of the British Library Board.

Sharp had his picture (the picture itself, not a Copy) nearly these two months and is busy in the aquafortis part of both plates. [. . .] Of the Second Number Adam & Eve observed by Satan; and Satan taking his flight upwards from chaos which is of the same dimensions with Sharp's and intended for Blake, are much advanced; and upon the whole Sketches of a number of Subjects are ready and wait for execution on Canvas.[3]

Blake and Fuseli were close friends. A comparison of Fuseli's pencil, pen and brown ink drawing of Satan in flight compared with Blake's drawing of the same subject on N. 112 shows how closely the two men worked together and exchanged ideas [FIG. 21, PLATE 7]. Blake would later transform this image from the *Manuscript Notebook* into the great colour-print of *Satan Exulting over Eve*. His drawing of Adam and Eve observed by Satan is on N. 102.

The Milton Gallery ran into difficulty within a year and Blake took no further part in it. When he began to write the poems leading to *Songs of Experience* in this part of the *Manuscript Notebook,* these drawings had been completed. Their importance can not be overestimated. As we shall see, on each occasion that Blake introduced new poems, returned to amend or entirely rewrite them and finally made his selection for relief etching and printing, these drawings in illustration of man's fall and loss of innocence faced him.

N. 115

It appears that all of the poems on N. 115, the facing page, N. 114, and the two poems at the top of the next page, N. 113, were written in the *Manuscript Notebook* at the same time in the same sepia ink. However, in different natural lights, it is clear that a darker sepia ink has been used to write the two poems in the left column on N. 114 and that a sharper nib, a lighter sepia ink and a more concentrated hand has been used to write the poems in the right column on N. 114 and at the top of N. 113. This suggests that the poems in sepia ink on N. 115, N. 114 and N. 113 were written on three separate occasions. Furthermore, on N. 115, Blake appears to have transferred into the *Manuscript Notebook* fair copies of poems that he originally drafted elsewhere, but on the other occasions there is every indication that he composed on the page.

On the recto of the last leaf in the *Manuscript Notebook,* N. 115, is the first of over fifty poems of which eighteen would be finally selected for *Songs of Experience* [PLATE 4]. Having turned the *Manuscript Notebook* upside down and back to front, and using pale sepia ink, Blake transcribed six poems in fair copy. Dividing the page into two columns, left and right, the first was entered top left as follows:

FIG. 21 Henry Fuseli, 'Satan in Flight', pen and brown ink drawing, 202 × 305 mm. Reproduced by permission of the National Gallery of Canada, Ottawa.

A flower was offerd to me
Such a flower as may never bore
But I said Ive a pretty rose tree
And I passed the sweet flower oer

Then I went to my pretty rose tree
In the silent of the night
But my rose was turned from me
And her thorns were my only delight

A line was drawn beneath this draft and the next poem entered below it:

Never seek to tell thy Love
Love that never told can be
For the gentle wind does move
Silently invisibly

I told my love I told my love
I told her all my heart
Trembling cold in ghastly fears
Ah she doth depart

Soon as she was gone from me
A traveller came by
Silently invisibly
He took her with a sigh

Blake also marked off this poem by drawing a line underneath it in preparation for writing the next poem.

The CLOD & the PEBBLE

The last poem was written at the bottom of the left column, as follows:

Love seeketh not itself to please
Nor for itself hath any care
But for another gives its ease
And builds a heaven in hells despair

So sung a little clod of clay
Trodden with the cattles feet
But a pebble of the brook
Warbled out these metres meet

Love seeketh only self to please
To bind anothers to its delight
Joys in anothers loss of ease
And builds a hell in heavens despite

Unaltered, this fair copy draft was later selected for the first issue of *Songs of Experience*, transferred in mirror writing to copper, relief etched and printed with the addition of only punctuation and capitalisation as 'The CLOD & the PEBBLE.'

Blake drew a line beneath the last poem in the left column, a vertical line down the middle of the page and entered three more drafts in fair copy beginning top right:

I laid me down upon a bank
Where love lay sleeping
I heard among the rushes dank
Weeping Weeping

Then I went to the heath & the wild
To the thistles & thorns of the waste
And they told me how they were beguild
Triven out & compelld to be chaste

Looking over his fair copy, Blake corrected one slip in transcription. In the last line, overwriting the capital letter 'T' Blake corrected 'Triven' to 'Driven.' The poem was later abandoned. Drawing a line beneath it, he wrote the next fair copy draft:

I went to the garden of love
And a saw what I never had seen
A chape was build in the midst
Where I used to play on the green

And the gates of this chape was shut
And thou shalt not writ over the door
And I turnd to the garden of love
That so many sweet flowers bore

And I saw it was filled with graves
And tomb-stones where flowers should be
And priests in black gounds were walking
 their rounds
And binding with briars my joys & desires

Again, drawing a line beneath the poem, the last fair copy was entered below it:

I saw a chapel all of gold
That none did dare to enter in
And many weeping stood without
Weeping mourning worshipping

I saw a serpent rise between
The white pillars of the door
And he forcd & forcd & forcd
Till he broke the pearly door

And along the pavement sweet
Set with pearls & rubies bright
All his slimy length he drew
Till upon the altar white

Vomiting his poison out
On the bread & on the wine
So I turnd into a sty
And laid me down among the swine

Once Blake had finished transferring these fair copy drafts into the *Manuscript Notebook* on N. 115, he looked over what he had written. In the second poem in the left column, 'Never seek to tell they love,' first line, he deleted 'seek' and above it wrote 'pain' and then deleted the last line and above and to the right of it wrote 'O was no deny.' But looking it over again, he deleted the entire first stanza. The poem was left and later abandoned.

The GARDEN of LOVE

The corrections Blake made to 'I went to the garden of love' are clearly faults of transcription from earlier drafts. In the second line, Blake altered 'And a saw' to 'And I saw.' In the third line, he amended 'A chape was build' to 'A chapel was built' and, in the fifth line, 'And the gates of the chape was shut' to 'And the gates of the chapel were shut.' Much later, this time with pencil, he returned and in the penultimate line of the second stanza deleted the first word 'And' and in front of it wrote 'So.' When 'I went to the garden of love' was selected for *Songs of Experience* and

transferred to copper for relief etching, in line two Blake deleted 'I' and added capitalisation and punctuation, as follows:

The GARDEN of LOVE

I went to the Garden of Love,
And saw what I never had seen:
A Chapel was built in the midst,
Where I used to play on the green.

And the gates of this Chapel were shut,
And Thou shalt not. writ over the door;
So I turn'd to the Garden of Love,
That so many sweet flowers bore.

And I saw it was filled with graves,
And tomb-stones where flowers should be:
And Priests in black gowns, were walking their
 rounds,
And binding with briars, my joys & desires.

Although 'The GARDEN of LOVE' was one of the first poems in sequence to be entered in the *Manuscript Notebook*, it was not included in *Songs of Experience* until 1794. 'The GARDEN of LOVE' may have been written in response to an initiative in South Lambeth on the part of local property speculators to erect by subscription a proprietory chapel on the village green known as the Lawn. The deed was signed and witnessed in April 1793 with subscriptions beginning at £50. Only those having paid a subscription were entitled to a pew.[4]

My Pretty ROSE TREE

On the next occasion that Blake turned to the *Manuscript Notebook*, he entered two poems in the left column on N. 114 using darker sepia ink. He then turned back to review the poems that he had written on N. 115. Using the darker sepia ink, in 'A flower was offerd to me', top left, he deleted the second line in the second stanza, 'In the silent of the night,' and, above it, wrote 'To tend it by day & by night.' The poem now read as follows:

A flower was offerd to me
Such a flower as may never bore
But I said Ive a pretty rose tree
And I passed the sweet flower oer

Then I went to my pretty rose tree
To tend it by day & by night
But my rose was turned from me
And her thorns were my only delight

On a much later occasion, this time using pale or very thin grey ink, he turned back again to N. 115 and to 'A flower was offerd to me'. This time he deleted 'was turned from me' in the penultimate line and above it wrote 'was filled with jealousy', had second thoughts about the change, deleted 'was filld' and in front of it wrote 'turnd away'. Finally revised, the poem read as follows:

A flower was offerd to me
Such a flower as may never bore
But I said Ive a pretty rose tree
And I passed the sweet flower oer

Then I went to my pretty rose tree
To tend it by day & by night
But my rose turnd away with Jealousy
And her thorns were my only delight

Later still, Blake drew a vertical line in pencil through the poem indicating selection, probably for etching. With the addition of punctuation and capitalisation, for the first issue of *Songs of Experience* in 1793 'A flower was offerd to me' was relief etched as 'My Pretty ROSE TREE' on the plate with 'THE LILLY' and 'AH! SUN-FLOWER' [PLATE 68].

On N. 115, Blake had completed drafts of three poems that would be selected for *Songs of Experience*. 'My Pretty ROSE TREE' and 'The CLOD & the PEBBLE' were included in the first copies of *Songs of Experience* of seventeen plates, and 'The GARDEN of LOVE' in the combined *Songs of Innocence and of Experience* first issued in 1794. 'The CLOD & the PEBBLE' is the first poem in the *Manuscript Notebook* to be expressed in terms of contrary states, worked out in the poem's

antithetical structure with the principles espoused in the first stanza diametrically opposed to those expressed in the third. 'The GARDEN of LOVE' is another example, this time accomplished through the pastoral metaphor of the garden and the juxtaposition of present and past, adult and child.

I saw a chapel all of gold

Much later, Blake made one other change on N. 115, this time using a finely sharpened nib and black ink. Turning back to N. 115, and reading through 'I saw a chapel all of gold' at the bottom right of the page, Blake drew a line through the last line of the second stanza, 'Till he broke the pearly door.' In the margin to the right he wrote 'Down the golden hinges tore.' The final version now read:

> I saw a chapel all of gold
> That none did dare to enter in
> And many weeping stood without
> Weeping mourning worshipping
>
> I saw a serpent rise between
> The white pillars of the door
> And he forcd & forcd & forcd
> Down the golden hinges tore
>
> And along the pavement sweet
> Set with pearls & rubies bright
> All his slimy length he drew
> Till upon the altar white
>
> Vomiting his poison out
> On the bread & on the wine
> So I turnd into a sty
> And laid me down among the swine

This poem is clearly related to 'The GARDEN of LOVE' written just above it. If 'The GARDEN of LOVE' was inspired by the building of the chapel on the Lawn at South Lambeth, then 'I saw a chapel all of gold' may extend Blake's vision of those who were responsible and further express his sense of revulsion.

When Blake altered 'And' to 'So' at the beginning of line seven of 'The GARDEN of LOVE' in pencil, it was on one of the last occasions that he reviewed

the poems in the *Manuscript Notebook*, apparently while selecting poems for etching as *Songs of Experience*. On N. 115, pencil has also been used to cross through 'A flower was offerd to me', 'Love seeketh not itself to please' and 'I saw a chapel all of gold.' But here, as we shall see on other pages, poems that have been crossed through in pencil were not always selected for *Songs of Experience* nor were they always excluded.

N. 114

I asked a thief to steal me a peach

On the next occasion that Blake turned to the *Manuscript Notebook*, he used a noticeably darker sepia ink and entered two poems in the left column of N. 114, the first, top left, as follows [PLATE 5]:

> I asked a thief if he'd steal me a peach
> And he turnd up his eyes
> I askd a lithe lady to lie her down
> And holy & meek she cries
>
> As soon as I went an angel came
> And he winkd at the thief
> And he smild at the dame
> And without one word spoke
> Had a peach from the tree
> And twixt earnest & game
> He enjoyd the dady

Using the same pen and ink, Blake made a number of changes. In the first line, he deleted 'if he'd' and above it wrote 'to,' in the second line he deleted 'And' and overwrote 'he' to read 'He', then altered 'turnd' to read 'turned'. In the fourth line he also deleted 'And' and overwrote 'holy' to read 'Holy' In the second stanza, second line, he deleted 'And' and overwrote 'he' to read 'He.' In the third line he deleted 'he' and in the fourth line deleted 'spoke' and following it wrote 'said.' At the end of the penultimate line, he overwrote 'game' to read 'joke' and in the final line he deleted 'He,' overwrote 'enjoyd' to read 'Enjoyd' and corrected 'dady' to read 'Lady' Later, on the third occasion he wrote in the

Manuscript Notebook, using lighter sepia ink and a finer nib, he scored out the entire penultimate line and following it wrote 'And still as a maid.' Finally revised, the poem read as follows:

> I asked a thief to steal me a peach
> He turned up his eyes
> I askd a lithe lady to lie her down
> Holy & meek she cries
>
> As soon as I went an angel came
> He winked at the thief
> And smild at the dame
> And without one word said
> Had a peach from the tree
> And still as a maid
> Enjoyd the Lady

Although Blake later drew a vertical line in pencil through the poem, denoting selection, 'I asked a thief to steal me a peach' was taken no further.

The Human Abstract

Drawing a line beneath 'I asked a thief to steal me a peach,' with the same pen and darker sepia ink Blake wrote the following poem beneath it, with 'The Divine Image' of *Songs of Innocence* clearly in mind. As he wrote, he returned to the second line and added 'ing' to 'spring' to rhyme with the first line:

> I heard an Angel singing
> When the day was springing
> Mercy Pity & Peace
> Is the worlds release
>
> Thus he sung all day
> Over the new moan hay
> Till the sun went down
> And haycocks looked brown
>
> I heard a Devil curse
> Over the heath & the furze
> Mercy could be no more
> If there was nobody poor

> And pity no more could be
> If all were as happy as we
> Thus he sang & the sun went down
> And the heavens gave a frown

Blake then drew a line beneath the last line. For a moment the poem was left. He then decided to write another stanza:

> And down pourd the heavy rain
> Over the new reapd grain
> And Mercy & Pity & Peace descended
> The Farmers were ruind & harvest was ended

Drawing a line beneath this last stanza, the poem was left.

This may not have been Blake's first attempt at drafting a contrary state of 'The Divine Image.' 'The Divine Image' articulated with syllogistic conviction the ideology of *Songs of Innocence*, with its crucial minor premise formulated in the third stanza:

> For Mercy has a human heart
> Pity, a human face:
> And love, the human form divine,
> And Peace, the human dress.

Another poem, entitled 'A DIVINE IMAGE,' is found in only one copy of the *Songs*, sold by Blake in 1816, and in a handful of separate impressions that may all be posthumous [FIG. 22]. There is no extant manuscript. Sir Geoffrey Keynes considered it 'so savage that I could only suppose that Blake had never dared to include it in the copies he sold to his customers.'[5] It reads as follows:

A DIVINE IMAGE

> Cruelty has a Human Heart
> And Jealousy a Human Face
> Terror, the Human Form Divine
> And Secrecy, the Human Dress
>
> The Human Dress, is forged Iron
> The Human Form, a fiery Forge
> The Human Face, a Furnace seald
> The Human Heart, its hungry Gorge.

As Robert F. Gleckner suggested in 1961, the first draft in the *Manuscript Notebook* of 'I heard an Angel singing' may therefore be Blake's second attempt at writing a contrary state of 'The Divine Image' of *Songs of Innocence* for *Songs of Experience*, having already rejected 'A DIVINE IMAGE'.[6] If so, the draft on N. 114 replaced direct antithesis with circumspect dramatic dialogue.

The next time that Blake worked on 'I heard an Angel singing' it was after he had entered a third set of poems in the *Manuscript Notebook*, in the right column of N. 114 and at top left and right on N. 113. He then looked back over the poems that he had written earlier. Completing amendments on N. 115, he turned to the poems on N. 114 beginning with

'I asked a thief if he'd steal me a peach,' rewriting the penultimate line. Blake then looked over the first draft of 'I heard an Angel singing.' Looking at the stanza that he had added at the end, he drew a light line through each of the first two lines, apparently unwilling to discount them altogether. Then, turning the nib of his pen on its side, in contrast he heavily scored through the last two lines ending each with a flourish. In the space that remained at the bottom of the page, he tried to write a last stanza again, with the opening lines of 'The Divine Image' of *Songs of Innocence* in mind:

> And Mercy Pity & Peace
> Joyd at their increase

The second line was not right. Smudging it out with his finger, he tried again:

> With Povertys Increase

This he also deleted, started again by writing 'Are,' but smudged that out. Blake then moved to the space at the right of these four lines and rewrote the stanza:

> And distress increase
> Mercy Pity Peace
> By Misery to increase
> Mercy Pity Peace

He inserted 'by' between 'And distress' in the first line, probably as he finished the line, but in the end deleted the first two lines leaving the final stanza to read as follows:

> And down pourd the heavy rain
> Over the new reapd grain
> By Misery to increase
> Mercy Pity Peace

He then drew a line beneath these lines, marking off the small space remaining at the bottom of the page.

Much later, Blake returned to N. 114 and to his drafts of 'I heard an Angel singing.' This time, using

a finely trimmed nib and charcoal grey ink, in the fourth stanza, line three, he deleted 'Thus he sang &' with a single stroke and above it wrote 'At his curse.' He then went down to the opening of the fifth stanza and deleted 'And' at the beginning of the first line and capitalised and overwrote the second word 'Down' to begin the line. He then turned to the last two lines of his final attempt at rewriting the last stanza at the bottom of the page:

> By misery to increase
> Mercy Pity Peace

Scoring through both lines, Blake then turned to the space that remained at the bottom of the page in the left column and wrote the following two lines:

> And Miseries increase
> Is Mercy Pity Peace

The poem, with its greatly reworked final stanza, now read as follows:

> I heard an Angel singing
> When the day was springing
> Mercy Pity & Peace
> Is the worlds release
>
> Thus he sung all day
> Over the new moan hay
> Till the sun went down
> And haycocks looked brown
>
> I heard a Devil curse
> Over the heath & the furze
> Mercy could be no more
> If there was nobody poor
>
> And pity no more could be
> If all were as happy as we
> At his curse the sun went down
> And the heavens gave a frown
>
> Down pourd the heavy rain
> Over the new reapd grain
> And miseries increase
> Is Mercy Pity Peace

This was how the poem was left. Much later, after entering and revising more than twenty poems in the *Manuscript Notebook*, including 'LONDON' and 'The Tyger,' Blake turned to N. 107 that was still all but blank. Using pale grey ink, he entered the title 'The human Image' in an effort to try again to write the contrary state of 'The Divine Image' of *Songs of Innocence*, this time successfully, as we shall see.

A cradle song

On the third occasion Blake returned to the *Manuscript Notebook*, this time using a very sharp nib, a lighter sepia ink and writing in a more concentrated hand, he entered drafts of four poems. Two were written down the right column of N. 114, alongside 'I asked a thief' and 'I heard an Angel singing,' and one each at the top left and right of N. 113. The first of these, 'A cradle song,' top right on N. 114, was composed on the page, clearly in an attempt to write an antithesis of 'A CRADLE SONG' of *Songs of Innocence*. The first stanza was written as follows:

> Sleep Sleep; in thy sleep
> Thou wilt every secret keep
> Sleep Sleep beauty bright
> Thou shalt taste the joys of night

Blake then deleted the last line and below it wrote 'Dreaming oer the joys of night'. Then, leaving a space, below that he wrote the first line of the next stanza, 'Yet a little while the moon.' This he deleted and tried again by writing 'Silent' below it. This was another false start. But now he went straight on and drafted the second stanza as follows, making revisions to the first and second lines as he wrote:

As thy softest limbs I [touch *del.*] [stroke *del.*] feel
Smiles as of the morning [broke *del.*] steal
Oer thy cheek & oer thy breast
Where the little heart does rest

The third and fourth stanzas went smoothly:

> O the cunning wiles that creep
> In thy little heart asleep

When thy little heart does wake
Then the dreadful lightnings break

Sweet Babe in thy face
Soft desires I can trace
Secret joys & secret smiles
Such as burning youth beguiles

Only in the last stanza did Blake again run into difficulty. Beginning the first line, Blake wrote 'O the cunning wiles that creep', but immediately wiped it away. Overwriting the line, he carried on writing, returning to make changes to the penultimate line:

> From thy cheek & from thy eye
> Oer the youthful harvests nigh
> Female wiles & female smiles
> Heaven & Earth of peace beguiles

In the same pen and ink, Blake returned to the third line, deleting 'Female' at both points, and before and above the line wrote 'Infant,' maintaining the correlation with 'A CRADLE SONG' of *Songs of Innocence*.

Blake then looked over the completed poem and saw that it had to be rearranged, bearing in mind stanzas like the following from 'A CRADLE SONG' of *Songs of Innocence*:

> Sweet babe in thy face,
> Holy image I can trace.
> Sweet babe once like thee,
> Thy maker lay and wept for me

> Wept for me for thee for all,
> When he was an infant small.
> Thou his image ever see,
> Heavenly face that smiles on thee.

> Smiles on thee on me on all,
> Who became an infant small.
> Infant smiles are his own smiles.
> Heaven & earth to peace beguiles.

First, on N. 114, the lines of the first stanza were numbered and rearranged, 3, 4, 1 and 2. Then, the stanzas themselves were rearranged and, beginning with the first stanza numbered 1 above it, the stanzas were renumbered at the left, 3, 4, 2 and 5. Finally, to the right of the number 1, above the first stanza, he wrote the title 'A cradle song.' The poem now read:

A cradle song

> Sleep Sleep beauty bright
> Dreaming oer the joys of night
> Sleep Sleep; in thy sleep
> Canst thou any secret keep

> Sweet Babe in thy face
> Soft desires I can trace
> Secret Joys & secret smiles
> Such as burning youth beguiles

> As thy softest limbs I feel
> Smiles as of the morning steal
> Oer thy cheek & oer thy breast
> Where thy little heart does rest

> O the cunning wiles that creep
> In thy little heart asleep
> When thy little heart does wake
> Then the dreadful lightnings break

> From thy cheek & from thy eye
> Oer the youthful harvests nigh
> Infant wiles & infant smiles
> Heaven & Earth of peace beguiles

Later, Blake returned to look over the poems on N. 114, this time with a pen and pale grey ink. At the same time that he wrote the title 'Christian forbearance' above the poem written below beginning 'I was angry with my friend,' he amended the fourth line of 'A cradle song', 'Canst thou any secret keep.' Writing a capital letter 'T' over 'thou,' he then inserted a wedge between 'thou' and 'any' and above it wrote 'canst.' Later still, at the time that he added the two lines at the bottom of 'I heard an Angel singing,' using a finely trimmed nib and charcoal black ink, he moved to the top right column and to the amended fourth line of 'A cradle song.' He deleted the line with a stroke and drew another line

through 'canst' written above it. Above that, he wrote 'Little sorrows sit & weep.' Looking through the rest of the poem, he deleted the last line of the newly numbered second stanza, 'Such as burning youth beguiles' and, to the right of it, wrote 'Little pretty infant wiles.' Looking further down, to the penultimate line of the last stanza, he hesitated over the first word of the line that he had deleted when working on the poem in sepia ink, 'Female wiles & female smiles.' Blake had altered the line to read 'Infant wiles & infant smiles.' He now confirmed the amendment by drawing a line through the original first word in charcoal black ink.

Composed on the page, 'A cradle song' read as follows following Blake's revisions, rearrangement of the first four lines, all five stanzas and final revisions in pale grey and black ink:

A cradle song

Sleep Sleep beauty bright
Dreaming oer the joys of night
Sleep Sleep; in thy sleep
Little sorrows sit & weep

Sweet Babe in thy face
Soft desires I can trace
Secret joys & secret smiles
Little pretty infant wiles

As thy softest limbs I feel
Smiles as of the morning steal
Oer thy cheek & oer thy breast
Where thy little heart does rest

O the cunning wiles that creep
In thy little heart asleep
When thy little heart does wake
Then the dreadful lightnings break

From thy cheek & from thy eye
Oer the youthful harvests nigh
Infant wiles & infant smiles
Heaven & Earth of peace beguiles

Here we can see Blake subverting, utterly, 'A CRADLE SONG' of *Songs of Innocence*, itself bearing an ironic relationship to Isaac Watts's 'A Cradle Hymn.'[7] By displacing its namesake with the birth of its opposite, and closing the poem with the verbally slight but sublimely awful inversion of the last line from 'A CRADLE SONG', 'Heaven and earth to peace beguiles,' the birthright of every child is doomed. Logically, this appears to have confounded Blake's motive for writing *Songs of Experience*, however great his rage became, if all hope was relinquished and man at birth was evil. The poem was abandoned. As we shall see, there are more examples in the *Manuscript Notebook* of reversal, subversion and repudiation of particular *Songs of Innocence*. They do not always succeed. In the process many poems will be abandoned. What becomes clear, as Blake enters new poems, returns to revise them and to write more, is that his vision of *Songs of Experience* becomes sharper, more penetrating and more uncompromising with each stage. But however dark his vision becomes, nihilism never displaces the moral imperative that impels the creation of the poems.

A POISON TREE

At the bottom right of N. 114, beneath 'A cradle song,' Blake wrote a poem beginning 'I was angry with my friend.' The first two stanzas went smoothly as did the first two lines of the third stanza. But after writing the next line, 'And I gave it to my foe,' Blake turned the quill on its side and crossed through what he had written with a single broad stroke and wrote a new line immediately below it, 'And my foe beheld it shine.' Starting the first word of the fourth stanza, 'And,' too close to the last line of the third stanza, he smudged it out, dropped down a space and started again finishing the poem without further trouble:

I was angry with my friend
I told my wrath my wrath did end
I was angry with my foe
I told it not my wrath did grow

And I waterd it in fears
Night & morning with my tears
And I sunned it with smiles
And with soft deceitful wiles

And it grew by day & night
Til it bore an apple bright
And my foe beheld it shine
And he knew that it was mine

And into my garden stole
When the night had veild the pole
In the morning Glad I see
My foe outstretchd beneath the tree

On another occasion, this time using pale grey ink, Blake introduced the title 'Christian forbearance.' When this poem was selected for *Songs of Experience*, in the third stanza, first line, Blake altered 'by' to 'both' and changed the title to 'A POISON TREE.' The poem may reflect events in Lambeth during the winter of 1792, when loyalist committees encouraged informers to report anyone who had published, circulated or expressed seditious views in any form.[8]

Later, on N. 114, indicating some form of selection, Blake drew a vertical line in pencil through the entire poem and, from top to bottom, through both poems in the left column, 'I asked a thief' and 'I heard an Angel singing.' Later, on N. 107, under the title 'The human Image,' he would rewrite 'I heard an Angel singing,' and in *Songs of Experience* reproduce it as 'The Human Abstract.' At bottom right, under the tentative title 'Christian Forbearance', he had also completed 'A POISON TREE,' that would be transferred to copper, relief etched and printed in the first issue of *Songs of Experience*.

N. 113

I feard the roughness of my wind
& Silent Silent Night

At the time that Blake wrote the two poems in the right column on N. 114, he went on to write two poems in the same concentrated hand and using the same fine nib and light sepia ink at the top left and right of N. 113 [PLATE 6]. The first of these, top left, was 'I feard the roughness of my wind:

I feard the roughness of my wind
Would blight all blossoms fair & true

And my sun it shind & shind
But my wind it never blew

But a blossom fair or true
Was not found on any tree
For all blossoms grew & grew
Fruitless false tho fair to see

On this occasion, Blake made only one change. In the fourth line, he deleted 'But' and in front of it wrote 'And.' He then drew a line beneath the poem. Later, in black ink, after writing the two poems below it, left and right, in the first line he deleted 'roughness' and above it wrote 'fury.' The poem was left and later abandoned.

Using the same pen and light sepia ink, to the right of 'I feard the roughness of my wind,' Blake wrote a second fair copy, perhaps, initially, in a second attempt at parody of 'A CRADLE SONG' of *Songs of Innocence*, as follows:

Silent Silent Night
Quench the holy light
Of thy torches bright

For possessd of Day
Thousand spirits stray
That sweet joys betray

Why should joys be sweet
Used with deceit
Nor with sorrows meet

But an honest joy
Does itself destroy
For a harlot coy

No changes were made to this fair copy. Drawing a line under the poem, it was left and also later abandoned.

Why should I care for the men of thames
& O lapwing

On the fourth occasion that Blake entered new poems in the *Manuscript Notebook*, he used a finely sharpened nib and coal black ink. In a concentrated

hand, he wrote the first draft of two stanzas beginning 'Why should I care for the men of thames' and a couplet beginning 'O lapwing,' respectively in the left and right columns on N. 113, as follows:

> Why should I care for the men of thames
> Or the cheating waves of charterd streams
> Or shrink at the little blasts of fear
> That the hireling blows into my ear
>
> Tho born on the cheating banks of Thames
> Tho his waters bathed my infant limbs
> I spurnd his waters away from me
> I was born a slave but I long to be free

To the right of it, he wrote the following two lines:

> O lapwing thou fliest around the heath
> Nor seest the net that is spread beneath

After writing the two poems, it is likely that Blake looked over what he had just written and decided to alter 'Why should I care for the men of thames,' on this occasion making a single but significant amendment using the same finely sharpened nib and black ink. Crossing through the penultimate line, 'I spurned his waters away from me,' above it Blake wrote 'The Ohio shall wash his stains from me.' The poem now read:

> Why should I care for the men of thames
> Or the cheating waves of charterd streams
> Or shrink at the little blasts of fear
> That the hireling blows into my ear
>
> Tho born on the cheating banks of Thames
> Tho his waters bathed my infant limbs
> The Ohio shall wash his stains from me
> I was born a slave but I long to be free

It is possible that this amendment could have been made later. Amendments that are indistinguishable, in terms of nib, ink and the character of the writing style, are present on N.101, N.105, N. 109, N. 111 and below on N. 113.

In 1968, Nancy Bogen recognised that Blake's amendment referring to the Ohio was indebted to

Gilbert Imlay's *A Topographical Description of the Western Territory of North America* first published in 1792, immediately followed by a second edition in 1793 and a third in 1798.[9] Joel Barlow may have been another source. Barlow was an American poet who arrived in Europe in 1788 as a representative of the Ohio Company. In England, he quickly made the acquaintance of radical circles in London and met Joseph Johnson, who in January 1792 published his *Advice to the Privileged Orders*.[10] During his travels to France, Barlow became acquainted with J. P. Brissot de Warville and translated his *New Travels in the United States* (1788), published in London by J. S. Jordan in 1792. Barlow used the opportunity of his translation to eulogise the new republic, but the concluding description of the Western Territory is brief and mentions the Ohio only once.[11] Blake may have met Barlow at Johnson's. But by 1790 his association with the Ohio Company had failed and it would seem unlikely that he would have encouraged anyone to emigrate there. Gilbert Imlay's account, however, was detailed and unqualified in its lavish descriptions, specifically of the Ohio Valley. As Nancy Bogen pointed out, Imlay's account was also set against negative descriptions of Europe that in their phrasing clearly anticipate 'Why should I care for the men of thames' and the poem that it was salvaged to create on N. 109, 'LONDON.'

The reference to Imlay's *A Topographical Description* is significant in helping to establish the *terminus ad quem* for Blake's writing of *Songs of Experience* in the *Manuscript Notebook*. Hitherto, it has been assumed that Blake wrote a continuous sequence of poems beginning on N. 115 and ending on N. 99 and N. 98 with the drafts of 'Fayete beside King Lewis stood.' As first noted by F. W. Bateson, news of La Fayette's jailing by the Austrians in August 1792, referred to in the poem, did not reach London until the end of October. Bateson also claimed that by the end of November this news was no longer topical and that after this date Blake would have no reason to refer to it.[12] This has been accepted as the *terminus ad quem* by all subsequent editors.[13] What has not been noticed, is that Imlay's *A Topographical Description* was not listed

The Public Advertiser.

NUMBER 18253]　　　　WEDNESDAY, December 12, 1792.　　　　[Price Three-pence Half-penny.

KING'S THEATRE, HAY-MARKET.

THIRD TIME THIS SEASON.

AT the King's Theatre, Haymarket, This Day will be presented

ARTAXERXES.

Artaxerxes, Mr. DIGNUM; Artabanes, Mr. KELLY; Arbaces, Mrs. CROUCH; Rimenes, Mr. Caulfield; Mandane, Madame MARA; Semira, Mrs. Bland.

To which will be added,

MISS IN HER TEENS.

Captain Lovewit, Mr. Whitfield; Fribble, Mr. R. Palmer; Flash, Mr. Barrymore; Jasper, Mr. Phillimore; Miss Biddy, Miss De Camp; Tag, Mrs. Edwards.

Boxes 6s. Second Account 3s.
Pit 3s. 6d. Second Account 2s.
Gallery 2s. Second Account 1s.

No Money to be returned.

Places for the Boxes to be taken of Mr. Foshrook at the Theatre.

The Doors will be opened at a Quarter Five, and the Performance to begin at a Quarter Six.

Vivant Rex & Regina.

To-morrow the TEMPEST, with the PRISONER.

COVENT GARDEN.

SEVENTH TIME.

AT the NEW THEATRE ROYAL in Covent Garden, This Day will be performed

COLUMBUS;

Or, A WORLD DISCOVERED.

The Scenes principally new, designed and painted by Messrs. Richards, Hodgkins, Pugh, Walmsley, and Assistants.

The principal Characters by
Mr. LEWIS,
Mr. QUICK,
Mr. HOLMAN,
Mr. POPE,
Mr. FARREN,
Mr. MUNDEN,
Mr. Harley, Mr. Macready,
Mr. Cubit, Mr. Powel,
Mr. Thompson, Mr. Evatt,
Mrs. ESTEN,
Mrs. POPE.

The Prologue to be spoken by Mr. Holman, The Epilogue by Mrs. Pope.

After which (1st time) a new Musical Farce, called

HARTFORD BRIDGE;

Or, The SKIRTS of the CAMP.

With new Music, Dresses, &c.

The Music composed by Haydn, Sacchini and Shield.

The Principal Characters by
Mr. QUICK,
Mr. MUNDEN,
Mr. INCLEDON,
Mr. FAWCETT,
Mr. Blanchard, Mr. Macready, Mr. Powel,
Mr. Thompson, Mr. Cross, Mr. Rock,
Mr. Farley, Mr. Rees,
Mrs. Harlowe, Mrs. Cross,
And Mrs. CLENDINING.

In which will be introduced a new ballet called the LUCKY ESCAPE, by Messrs. Byrn, Holland, Mrs. Watts, and Madame Rossi.

No Money to be returned.

ASSOCIATION

For preserving

LIBERTY AND PROPERTY

Against

REPUBLICANS AND LEVELLERS.

Crown and Anchor Tavern, Dec. 11, 1792.

AT a Meeting of the Committee of this Society,

JOHN REEVES, Esq; Chairman.

Complaints having been made of the licentiousness of certain Print-shops, wherein libellous Pictures and Engravings are daily exhibited, to the great scandal and offence of his Majesty's loyal and affectionate subjects,

Resolved,

NEW PUBLICATIONS.

Printed for J. DEBRETT, opposite Burlington-House, Piccadilly.

SURVEY of the RUSSIAN EMPIRE, according to its present newly regulated State, divided into different Governments; shewing their Situation and Boundaries, the Capital and District Towns of each Government; Manners, and Religion of the various Nations that compose that extensive Empire, &c. &c.

The whole illustrated with a Correct Map of Russia, and an Engraving exhibiting the Arms and Uniforms of the several Governments of that Empire. By Capt. Sergey Plescheef. The Third Edition, published at St. Petersburg. And Translated from the Russian, with considerable Additions. By James Smirnove, Chaplain to the Legation of H. I. M. of all the Russias, at the Court of Great-Britain. Price 6s. in boards.

The PARLIAMENTARY REGISTER; or, the HISTORY of the PROCEEDINGS and DEBATES in Both Houses of Parliament; containing an Account of the most interesting Speeches and Motions, authentic Copies of all important Letters and other Papers laid before the House; authentic Minutes of the most material Evidence, Protests, Bills, and Petitions, during the last Session. In 3 vols. 8vo. price 11. 9s. half-bound and lettered.

The Parliamentary Register of the former or First Session of the present Parliament, in three Vols. Price 11. 11s. 6d. half-bound and lettered.

The Parliamentary Register from the General Election in 1780 to the Dissolution of Parliament in 1784. In 17 Vols. Price 51. 5s. half-bound and lettered.

The Parliamentary Register, from the General Election in 1784 to the Dissolution of Parliament in 1790. In 13 Vols. Price 61. 12s. half-bound and lettered.

The Debates and Proceedings of both Houses of Parliament, from the Year 1743, to the Year 1774.

JOURNAL of a VOYAGE to PORT JACKSON, in New South Wales; with a full and accurate account of his Majesty's Settlements there; a description of the natives, and of the natural productions of New Holland; a correct diary of the weather, latitudes, longitudes, &c. By John White, Esq; Surgeon General to the Settlement, and Corresponding Member of the Medical Society in London. Illustrated with sixty-five elegant engravings, from drawings copied from nature, by Miss Stone, Mr. Nodder, Mr. Catton, &c. exhibiting near one hundred figures of non-descript birds, lizards, curious cones of trees, animals, &c. of New South Wales, accompanied with scientific descriptions, and an elegant engraved title page and vignette, by Milton, in one volume, royal quarto, price 11. 16s. in boards; or with 65 plates, beautifully coloured after the originals, price 51. 6s. in boards.

Extracts of Letters from Arthur Philip, Esq; Governor of New South Wales, to Lord Sydney, &c. To which is annexed, a Description of Norfolk Island, by

South Wales, to Canton, in 1788, through an unexplored Passage.

By THOMAS GILBERT, Esq;
Commander of the Charlotte.

illustrated with Views of the following Islands discovered on the Passage, viz. Chatham's, Ibbitson's, Matthew's, Calvert's, Knox's, Daniel's, Mariar's, and Gilbert's; elegantly printed in Quarto. Price 5s. sewed.

TRINITY-HOUSE, LONDON,

Dec. 6, 1792.

AT a time when some of the most CONSIDERABLE SOCIETIES of MEN in this Kingdom, have thought it right to stand forward to check the insidious designs of a wicked Party, who would wish to alter and debase our present excellent Constitution: the CORPORATION of TRINITY-HOUSE, of DEPTFORD STROND, cannot forbear to shew their detestation of the daring attempts of designing men, to disturb the peace and happiness of this Country; they have therefore thought it proper to issue forth directions and instructions to all their Officers and Servants on the River Thames, and in every port where they have jurisdiction, to watch over the CONDUCT and BEHAVIOUR of such DISTURBERS of the PUBLIC PEACE, in order that they may be brought to justice: And they have further resolved, that if any Officer or Servant of the Corporation shall be found to favour or countenance any such seditious conduct or behaviour, they will instantly dismiss them from their service; and the Corporation earnestly recommend to all Younger Brethren, Masters of Ships, Mates, and others in the Merchants service, to do their utmost in assisting these efforts for the preservation of TRANQUILLITY, and the GOVERNMENT of this GLORIOUS and HAPPY CONSTITUTION.

By Command of the Corporation,
DAVID COURT, Secretary.

MERCHANT TAYLORS HALL,

Dec. 5, 1792.

AT a very numerous Meeting of MERCHANTS, BANKERS, and TRADERS held here this day, in consequence of Public Advertisement.

SAMUEL BOSANQUET, Esq; in the Chair,

The Chairman having read the Advertisement by which this Meeting was called:

RESOLVED,

That it is expedient, at this time, for the MERCHANTS, BANKERS, TRADERS, and other INHABITANTS of LONDON, to make a Public Declaration of their firm attachment to the Constitution, and of their resolution to support the same.

Then the following Declaration was read,

DECLARATION

In support of the

CONSTITUTION of GREAT-BRITAIN.

"We, the Merchants, Bankers, Traders, and other Inhabitants of London, whose names are here unto subscribed, perceiving, with the deepest concern, that attempts are made to circulate opinions contrary to the dearest interests of Britons, and subversive of those principles which have produced and preserved our most valuable privileges, feel it a duty we owe to our Country, ourselves and our posterity, to invite all our Fellow Subjects to join with us in the expression of a sincere and firm attachment to the Constitution of this Kingdom, founded in remote, and improved in succeeding ages, and under which the glorious Revolution in 1688 was effected; a Constitution wisely framed for the diffusion of Happiness and true Liberty, and which possesses the distinguished merit, that it has on former occasions been, and, we trust, will in future be found, competent to correct its errors, and reform its abuses. Our experience of the improvements in Agriculture and Manufactures, of the flourishing state of Navigation and Commerce, and of increased Population, still further compels us to make this Public Declaration of our determined resolution to support, by every means in our power, the ANCIENT and MOST EXCELLENT CONSTITUTION of GREAT-BRITAIN, and a Government by KING, LORDS, and COMMONS; and to exert our best endeavours to impress on the minds of those connected with us, a reverence for and a due submission to the Laws of their Country, which have hitherto secured the Liberty, protected the Property, and increased the enjoyments of a Free and Prosperous People."

And the same having been read a second time,

Resolved unanimously,

That this Declaration be approved, and be SUBSCRIBED by all such MERCHANTS, BANKERS, TRADERS, and OTHER INHABITANTS of LONDON as may approve thereof, and that it do lie at this Hall until Saturday next inclusive for signature.

Resolved unanimously,

That Sam. Bosanquet, Tho. Boddington, Abraham Bracebridge, John Blackwood, Joseph Cotton, Edw. Forster, George Griffin, Tho. Hankey, John Harman, Rob. Hunter, James Langston, Wm. Manning, Sam. Smith, Theoph. Pritzler, Rich. Muilman Trench Chitwell, John Melish, Rich. Neave, Edw. Payne, Benj. Winthrop, John Read, Tho. Parry, Dan. Giles, Tho. Raikes, and John Cottin, Esquires, be a Committee to attend the signing of this Declaration, and they are hereby requested to cause the same to be published in the newspapers, and in any other manner they may think most advisable.

Resolved unanimously,

That the Thanks of this Meeting be given to the Committee of the Court of Assistants of the Merchant Taylor's Company, for the very polite and friendly manner in which the Committee afforded the use of the Hall for the Meeting this day, and that the Chairman be requested to transmit a copy of this Resolution.

A motion being made and seconded,

St. BRIDE'S, LONDON,

Dec. 10, 1792.

AT a numerous and respectable Meeting of the Inhabitants of St. Bride's, in the Parish Church, convened by public Advertisement,

Mr. Deputy NICHOLS in the Chair;

(Messrs. Herring and Beresford also attending, as Representatives of that Part of the Parish of St. Martin Ludgate, which is in the Ward of Farringdon Without,)

1. Resolved unanimously,

That in the present situation of public affairs, it is the duty of every good citizen, and more peculiarly incumbent upon ourselves as Inhabitants of the largest parish within the City of London, to declare in the most unequivocal terms, which we do most heartily, our sincere satisfaction under the mild and equitable Government of our Sovereign Lord King George; and to express our inviolable Attachment to the illustrious House of Hanover, and to the Constitution as by Law established, which, happily for us, is at present the Envy of the World.

2. Resolved unanimously,

That this Meeting do publicly testify their concurrence in the well timed and laudable Resolutions of the Corporation of London of the 29th of November last, as published in every Newspaper throughout the United Kingdom.

3. Resolved Unanimously,

That, from the general spirit of loyalty which universally pervades every description of our fellow-subjects, and the vigilance thereby produced, we have every reason to believe that the wicked intentions both of foreign and domestic incendiaries have been rendered abortive. But, the more effectually to crush any future exertions of the seditious, the inhabitants of St. Bride's will at all times be ready, in their several stations, to strengthen the hands of the Civil Magistrate; and will strenuously discountenance whatever may tend to interrupt the order and good government of the Metropolis, or the general tranquillity of the British Empire.

4. Resolved Unanimously,

That these Resolutions be signed by the Chairman, and published in all the Morning and Evening Papers; and that they be also entered in the Vestry-Clerk's Book, and laid in the Vestry Room this afternoon till four o'clock, and again to-morrow, and every day this week, from the hours of ten to twelve, that every Inhabitant may have an opportunity of signifying his approbation: And that the Deputy, with the Common Council for this Parish, the Churchwardens, Overseers, Gentlemen of the Inquest, and Thirteen other Inhabitants to be nominated by this Meeting, be appointed a Committee for carrying these Resolutions into effect; and that any three of them be empowered to act.

Resolved Unanimously,

That the following Thirteen Gentlemen be Members of the Committee:

The Rev. John Pridden,　Mr. John Grant
M.A.　　　　　　　　　　　William Moore
Andrew Strahan, Esq　　　Samuel Chamberlain
Mr. Benjamin Sargeant　　H.W. Mortimer
Samuel Ibbetson　　　　　John Tyce
Joseph Brasbridge　　　　James Dobie
Robert Tangate　　　　　Benjamin Faulkner.

6. It having been signified, that it is the wish of many respectable Inhabitants of that part of the Parish of St. Martin's, Ludgate, which is in the Ward of Farringdon Without, to express their concurrence in these principles of loyalty on which the present Meeting is assembled:

Resolved Unanimously,

That all such inhabitants of that part of St. Martin's Parish, as approve of these Resolutions, be invited to join them; and that Mr. Herring and Mr. Beresford be added to the Committee.

7. Resolved Unanimously,

That the Thanks of this Meeting be given to Mr. Deputy Nichols, Mr. William Wright, and Mr. Charles Sharp, our representatives in Common Council, for their attention to the duties of their office, in calling this Meeting; to Mr. Herring and Mr. Beresford for their attendance as Representatives of St. Martin's; and to Mr. Deputy Nichols, in particular, for his candour and impartiality as Chairman.

Signed, by Order of the Meeting,
JOHN NICHOLS, Chairman.

BARNET ASSOCIATION.

Instituted in 1747, renewed in 1774, for the Preservation of Good Order, and for the Protection of Persons and Property in the several associating Parishes, viz. Chipping Barnet, East Barnet, Shenley, Elstree, Ridge, Aldenham, and Totteridge in the County of Hertford, and South Mimms, Hadley, and Enfield District, in the County of Middlesex:

AT a very numerous Meeting of the Members of this Association and others, held at the Red Lion Inn, Chipping Barnet, the 10th day of December, 1792,

JAMES QUILTER, Esq; in the Chair.

At this Meeting, after the immediate business of the Association had been transacted, it was intimated that several Gentlemen and others, inhabitants of the above associated Parishes (but not being Members of this Association), desired to be admitted to join in the diffusion of the Resolution hereafter mentioned; and they being admitted accordingly,

It was Unanimously Resolved,

That it is expedient at this time for the Members of this Association, and all other inhabitants of the Associating Parishes, to make a Public Declaration of their firm attachment to the Constitution of this Country, as by Law established, and a Government by King, Lords, and Commons, and of their resolution to support the same; and that they will by every legal means in their power, collectively and individually, endeavour to prevent or suppress any attempt that may be made to disturb the peace of the

for sale until Wednesday 12 December 1792, when the first notices of publication appeared in the London *Public Advertiser* [FIG. 23].

If, as a result of reading or hearing about Imlay's enthusiastic descriptions of the prospect of freedom and prosperity in the Ohio Valley Blake made the amendment, which seems likely, then a *terminus ad quem* of November or possibly December 1792 for writing *Songs of Experience* is no longer adequate. At the time that Blake wrote 'Why should I care for the men of thames,' more than forty poems had yet to be written in the *Manuscript Notebook*. It is possible that the amendment is later. This would make the poems written after 'Why should I care for the men of thames,' like 'LONDON,' later still. There is also the possibility that Blake made the amendment before December 1792, but, as we shall see, there are other reasons for considering that many of the poems were not only revised but also written through the winter of 1792 and into the spring and early summer of 1793. The assumption that N. 115 through N. 98 forms a continuous sequence will also be questioned.

'Why should I care for the men of thames' is the first poem in the *Manuscript Notebook* of overt political protest. References to 'blasts of fear' and to the 'hireling' have a specific resonance in November and December 1792 with the rise of the loyalist associations. In this context, as E. P. Thompson has shown, 'charterd' was a pivotal term in the controversy that had been initiated by Edmund Burke's *Reflections on the Revolution in France* (1790):

You will observe that from Magna Charta to the Declaration of Right it has been the uniform policy of our constitution to claim and assert our liberties as an *entailed inheritance* derived to us from our forefathers, and to be transmitted to our posterity [...] We have an inheritable crown, an inheritable peerage, and a House of Commons and a people inheriting privileges, franchises, and liberties from a long line of ancestors.[14]

Burke published his *Reflections* in November 1790. Three months later, Thomas Paine replied in what became the First Part of the *Rights of Man*:

That which a whole nation chooses to do, it has a right to do. Mr. Burke says, No. Where then *does* the right exist? I am contending for the rights of the *living*, and against

their being willed away, and controuled and contracted for, by the manuscript assumed authority of the dead; and Mr. Burke is contending for the authority of the dead over the rights and freedom of the living.[15]

In February 1792, Paine published the Second Part. It was the Second Part that provoked the Royal Proclamation of 21 May against seditious publications, that eventually led to Paine's trial and conviction in December *in absentia*. Before his escape to France in September, Blake entered a portrait drawing of Paine in the *Manuscript Notebook*[16] [PLATE 61]. It is in the Second Part that the force behind the use of the term 'charterd' in 'Why should I care for the men of thames,' and later in 'LONDON,' can be felt:

It is a perversion of terms to say, that a charter gives rights. It operates by a contrary effect, that of taking rights away. Rights are inherently in all the inhabitants; but charters, by annulling those rights in the majority, leave the right by exclusion in the hands of a few. [...] the only persons on whom they operate, are the persons whom they exclude.[17]

From this point in the *Manuscript Notebook*, the politics of the winter of 1792 and spring of 1793 become a noticeable force in the making of *Songs of Experience*.

When Blake next turned to the *Manuscript Notebook*, the third occasion on N. 113, he used thin medium grey ink. Above the two stanzas of 'Why should I care for the men of thames,' he wrote the title 'Thames,' but then smudged it out. Reading through the poem, he stopped at the last line and with two fine strokes of his pen crossed through 'long' and above it wrote 'go,' displacing the speaker's acceptance to remain 'a slave' longing to be free for the emphatic decision to leave for America and the Ohio Valley. In the same spirit, Blake added a second couplet to 'O lapwing' written to the right of 'Why should I care for the men of thames.' On both occasions, the writing of the one poem has occasioned turning to the other. Finally revised, the two poems now read as follows:

Why should I care for the men of thames
Or the cheating waves of charterd streams

Or shrink at the little blasts of fear
That the hireling blows into my ear

Tho born on the cheating banks of Thames
Tho his waters bathed my infant limbs
The Ohio shall wash his stains from me
I was born a slave but I go to be free

And to the right:

O lapwing thou fliest around the heath
Nor seest the net that is spread beneath
Why dost thou not fly among the corn fields
They cannot spread nets where a harvest yields

'Thames' and 'O lapwing' may also have been written in response to reading John Thelwall's *The Peripatetic*, published in April 1793. The chapter 'The Bird Catchers' is followed by the speaker approaching the Thames being provoked to write 'Thou, Commerce . . . whose *charter'd insolence / Barter's to Britain's Sons the Freeman's name*,' followed in the next chapter by an 'Ode to the American Republic.'[18] In his Preface, Thelwall's descriptions of being harried and threatened for his political views, and in his attempts to publish, bear comparison with Blake's remark of June 1793 in the *Manuscript Notebook*, N. 4.

INFANT SORROW

Using the same pen and ink, Blake drew a horizontal line beneath the two poems, leaving a space beneath 'O lapwing' and separating off the bottom half of the page. Below the line, in the left column he wrote two stanzas in fair copy, in contrast with 'Infant Joy' of *Songs of Innocence*:

My mother groand my father wept
Into the dangerous world I leapt
Helpless naked piping loud
Like a fiend hid in a cloud

Struggling in my fathers hands
Striving against my swaddling bands
Bound & weary I thought best
To sulk upon my mothers breast

In 'Infant Joy,' the speaker is two days old and has no name, suggesting that he or she has not been christened. The child of 'INFANT SORROW' enters a different world, of hardship, cruelty and restraint. But the poem was not left there. After writing the first two stanzas, Blake wrote two more, following the growth of the infant, initially with little difficulty:

And I grew day after day
Till upon the ground I stray
And I grew night after night
Seeking only for delight

Looking over what he had written, in the first line Blake deleted 'grew' and above it wrote 'soothd.'

From the beginning of the next stanza it becomes clear that Blake is composing on the page. The first two lines were written as follows:

But upon the nettly ground
No delight was to be found

Using the side of his nib, Blake deleted both lines and started again in the same medium grey ink:

And I saw before me shine
Clusters of the wandring vine
And beyond a mirtle tree
Stretchd its blossoms out to me

At this point, using the same pen and medium grey ink, Blake moved across to the right column and the blank space that had been marked off below the two couplets of 'O lapwing'. Here he wrote four more stanzas, this time introducing a scene of grotesque baptism that haunts the child for the rest of its life:

But a Priest with holy look
In his hand a holy book
Pronouncd curses on his head
Who the fruit or blossoms shed

I beheld the Priest by night
He embracd my mirtle bright
I beheld the Priest by day
Where beneath my vine he lay

Like a serpent in the night
He embracd my mirtle bright
Like a serpent in the day
Underneath my vines he lay

So I smote him & his gore
Staind the roots my mirtle bore
But the time of youth is fled
And grey hairs are on my head

Blake then drew a line beneath the last stanza to mark off the remaining space at the bottom of the page.

Using the same pen and thin medium-grey ink, Blake amended the four stanzas that he had just written in the right column of N. 113. In the first stanza in the right column, first line, he deleted 'But a' and above it wrote 'But many a.' In the second line, he deleted 'his,' above it wrote 'their' and added 's' to 'hand.' In the second stanza, first line, he added 's' to 'Priest.' In the second line, he overwrote 'He' with 'They' and in the third line again added 's' to 'Priest.' In the fourth line, he added 's' to 'vine,' deleted 'he' and above it wrote 'they.' In the third stanza, first line, he deleted 'a,' above it wrote 'to' and added 's' to 'serpent.' In the third stanza, second line, he overwrote 'He' with 'They.' In the third line, he wrote 'to' above 'a' and added 's' to 'serpent.' In the fourth line, he deleted 'my,' above it wrote 'the,' deleted 'he' and above it wrote 'they.' In the last stanza, first line, he overwrote 'him' with 'them,' deleted 'his' and above it wrote 'their.' Blake then renumbered the lines of the third stanza, 3, 4, 1 and 2. Revised and reorganised, the poem now read as follows:

My mother groand my father wept
Into the dangerous world I leapt
Helpless naked piping loud
Like a fiend hid in a cloud

Struggling in my fathers hands
Striving against my swaddling bands
Bound & weary I thought best
To sulk upon my mothers breast

And I soothd day after day
Till upon the ground I stray
And I grew night after night
Seeking only for delight

And I saw before me shine
Clusters of the wandring vine
And beyond a mirtle tree
Stretchd its blossoms out to me

But many a Priest with holy look
In their hands a holy book
Pronouncd curses on his head
Who the fruit or blossoms shed

I beheld the Priests by night
They embracd my mirtle bright
I beheld the Priests by day
Where beneath my vines they lay

Like to serpents in the day
Underneath the vines they lay
Like to serpents in the night
They embracd my mirtle bright

So I smote them & their gore
Staind the roots my mirtle bore
But the time of youth is fled
And grey hairs are on my head

Blake then drew a faint line underneath the last stanza in the right column.

Before setting down his pen, characteristically Blake turned back to review the poems that he had written on N. 115 and N. 114 using the same pen and thin medium grey ink. It is possible that before entering new poems in the *Manuscript Notebook* Blake first revised poems he had written earlier, but the substantial purpose for returning appears to be to record or compose new poems. He found nothing to alter on N. 115, but on N. 114, bottom right, he introduced the title 'Christian forbearance' above the lines beginning 'I was angry with my friend' that would later be selected for *Songs of Experience* and given the title 'A POISON TREE.'

On the fourth occasion that Blake turned to N. 113, he used a fine charcoal black ink and

sharpened nib. Turning to the space beneath the line under the four stanzas in the right column, he drafted another stanza, working it out as he wrote, as follows:

> When I saw that rage was vain
> And to suck would nothing gain
> I began to so

Deleting the third line, Blake continued:

> Seeking many an artful wile
> I began to soothe & sm[o *del.*]ile

Blake then crossed out the second attempt at the third line, and above and at the end of it wrote 'Turning many a trick or wile.' Then, in the second line, he altered 'suck' to 'sulk.' The stanza now read:

> When I saw that rage was vain
> And to sulk would nothing gain
> Turning many a trick or wile
> I began to soothe & smile

Blake then drew a wedge between the two columns leading from the new stanza to indicate that it was to be inserted following the second stanza in the left column. Using the same black ink, he made two changes to the new fourth and fifth stanzas at the bottom left of the page. In the new fourth stanza, first and third lines, he deleted 'grew' and above it wrote 'smild' (in the first line wedging it in between 'grew soothd' that he had written above earlier), connecting 'smild' with the newly drafted third stanza marked for insertion above it. Then, in the last stanza at the bottom of the left column, he deleted the third line, above it wrote 'And many a lovely flower & tree' and in the fourth line deleted 'its' and above it wrote 'their.'

Using the same pen and charcoal black ink, Blake then made a fundamental change in the stanza at the top of the right column. In the first line, he drew a thin line through the amended 'But many a' that had been written above 'But a Priest,' and above it wrote 'My father then.' In the second line, he drew a line through 'their' that had been written above 'his,' restoring the original reading. In the third line, he deleted 'his' and above it wrote 'my.' Then he deleted the entire fourth line and below it wrote 'And bound me in a mirtle shade.' The new sixth stanza read as follows:

> My father then with holy look
> In his hands a holy book
> Pronouncd curses on my head
> And bound me in a mirtle shade

Wishing to preserve the drawing on the facing page N. 112, Blake turned to the next page, N. 111, in order to find space to complete his revision [PLATE 8].

On N. 111, by this stage in the revision of 'IN-FANT SORROW,' Blake had already written the drafts of 'Thou hast a lap full of seed' and 'EARTH'S Answer' in medium grey ink, including the stanza written over part of the drawing on the right. But space remained at bottom right beneath the drawing, and at the very bottom left beneath the line that had been drawn under the drafts of 'EARTH'S Answer.' Using the same nib and charcoal black ink that he had used to revise the stanzas on N. 113, Blake wrote the catch phrase 'in a mirtle shade,' making explicit the connexion with the stanzas on N. 113, and then the following three stanzas:

> in a mirtle shade
>
> Why should I be bound to thee
> O my lovely mirtle tree
> Love free love cannot be bound
> To any tree that grows on ground
>
> Oft my mirtle sighd in vain
> To behold my heavy chain
> Oft the priest beheld us sigh
> And laughd at our simplicity
>
> So I smote him & his gore
> Staind the roots my mirtle bore
> But the time of youth is fled
> And grey hairs are on my head

When Blake transferred the last stanza from N. 113, bottom right, he made only one change, in the first line from 'them & their' back to 'him & his.' In the space remaining at bottom left on N. 111, he started to write a fourth stanza:

> To a lovely mirtle bound
> Blossoms showring all around

Scoring through these two lines, Blake started again, this time with more success:

> O how sick & weary I
> Underneath my mirtle lie
> Like to dung upon the ground
> Underneath my mirtle bound

Using the same nib and charcoal black ink, Blake numbered the stanzas, in the right column 1 and 3 and in the left column 2. Looking over what he had written, in the third line of the stanza renumbered 3 he deleted 'the priest beheld' and above it wrote 'my father saw.' This change, from 'priest' to 'father', complemented the amendment that he had made to the sixth stanza top right on N. 113.

With the revisions in charcoal black ink on N. 113, together with the stanzas written at the bottom right and left on N. 111 (which may have been written as an alternative set of stanzas), the poem now read as follows:

> My mother groand my father wept
> Into the dangerous world I leapt
> Helpless naked piping loud
> Like a fiend hid in a cloud
>
> Struggling in my fathers hands
> Striving against my swaddling bands
> Bound & weary I thought best
> To sulk upon my mothers breast
>
> When I saw that rage was vain
> And to sulk would nothing gain
> Turning many a trick or wile
> I began to soothe & smile

> And I smild day after day
> Till upon the ground I stray
> And I smild night after night
> Seeking only for delight
>
> And I saw before me shine
> Clusters of the wandring vine
> And many a lovely flower & tree
> Stretchd their blossoms out to me
>
> My father then with holy look
> In his hands a holy book
> Pronouncd curses on my head
> And bound me in a mirtle shade
>
> I beheld the Priests by night
> They embracd my mirtle bright
> I beheld the Priests by day
> Where beneath my vines they lay
>
> Like to serpents in the day
> Underneath the vines they lay
> Like to serpents in the night
> They embracd my mirtle bright
>
> Why should I be bound to thee
> O my lovely mirtle tree
> Love free love cannot be bound
> To any tree that grows on ground
>
> O how sick & weary I
> Underneath my mirtle lie
> Like to dung upon the ground
> Underneath my mirtle bound
>
> Oft my mirtle sighd in vain
> To behold my heavy chain
> Oft my father saw us sigh
> And laughd at our simplicity
>
> So I smote him & his gore
> Staind the roots my mirtle bore
> But the time of youth is fled
> And grey hairs are on my head

On the fifth occasion that Blake turned to N. 113, this time using medium charcoal-grey ink, he inserted the title 'Infant Sorrow' above the stanzas in

the bottom left column. Preserving the first two stanzas, he then crossed through the two stanzas below them. Running out of ink, he managed to draw two strokes and the beginning of a third from top to bottom through the stanzas in the right column, including the stanza in black ink at the bottom of the page. The stanzas that he had written at the bottom right and left on N. 111 under the heading 'in a mirtle shade' were left.

On the last occasion Blake turned to N. 113, working through the *Manuscript Notebook* making selections in pencil, he drew a vertical line through 'Why should I care for the men of thames' and through the first two (undeleted) stanzas of 'Infant Sorrow.' 'INFANT SORROW,' composed of these two stanzas, with only punctuation added, would be relief etched, printed and included in *Songs of Experience* in 1794. 'Why should I care for the men of thames,' evidently selected here with 'Infant Sorrow', was finally abandoned, but not before contributing to the creation of 'LONDON' on N. 109.

The remaining stanzas that Blake had written on N. 113 and N. 111, following the two stanzas that were relief etched as 'INFANT SORROW,' were not forgotten. Much later, turning through the pages of the *Manuscript Notebook* until he found a blank page on N. 106, in the top left corner, in pale grey ink, he wrote the title 'To my Mirtle.' As we shall see on N. 106, Blake salvaged what he could from the drafts on N. 113 and N. 111 to try once more, on this occasion to write a poem unrelated to 'Infant Joy.'[19]

N. 111

Thou hast a lap full of seed
& EARTH'S Answer

When Blake first turned to N. 111, on the left side he entered two related poems, one below the other, in order to avoid the pencil drawing of God the Father, Son and Satan made sideways from top to bottom on N. 111 and N. 110 [PLATES 8 & 9]. These two poems are written with a finely sharpened nib and medium grey ink that is distinguishable from the thinner pale grey ink that was the last to be used on N. 113. The two poems were entered as follows:

Thou hast a lap full of seed
And this is a fine country
Why dost thou not cast thy seed
And live in it merrily

Oft Ive cast it on the sand
And turnd it into fruitful land
But on no other ground can
Can I sow my seed
Without pulling up
Some stinking weed

Drawing a line beneath the last line, Blake went on to write the second poem, as follows:

The Earths Answer

Earth raisd up her head
From the darkness dread & drear
Her eyes fled dead
Stony dread!
And her locks coverd with grey despair

Prisond on watry shore
Starry jealously does keep my den
Cold & hoar
Weeping oer
I hear the father of the ancient men

Cruel father of men
Cruel jealous wintry fear
Can delight
Closd in night
The virgins of youth & morning bear

Break this heavy chain
That does close my bones around
Selfish vain
Thou my bane
Hast my love with bondage bound

After writing both poems, with the same pen and ink Blake made changes. In 'Thou hast a lap full of seed,' second stanza, first line, he deleted 'Oft Ive' and above it wrote 'Shall I'. In the second line, he deleted 'turnd' and above it wrote 'turn' and in the next line deleted 'But,' before it wrote 'For' and at the end of the line deleted 'can.'

Turning to 'The Earths Answer,' in the title he scored through the definite article and reading down through the poem, in the second stanza, second line, he drew three lines through the first word 'Starry,' changed his mind and wrote 'Starry' above it. In the second stanza, last line, he drew a line through 'the father of the,' at the end of the line above 'ancient men' wrote 'father of' and then scratched it out, restoring the original reading. In the third stanza, Blake deleted the first word 'Cruel' and before it wrote 'Selfish'. In the next line, he deleted 'wintry' and above it wrote 'selfish' and in the fourth line deleted 'Closd' and before it wrote 'Chaind'. Turning to the last stanza, second line, he deleted 'close' and above it wrote 'freeze,' in the penultimate line deleted 'Thou my' and before it wrote 'Eternal' and in the last line deleted 'Hast my,' before it wrote 'That' and above 'my' wrote 'free.'

Looking again at the third stanza, Blake scored half a dozen lines through it at an angle, moved to the right and, completely preoccupied with writing, drafted a new third stanza over the bottom of the drawing that earlier he had been careful to avoid, as follows:

> Does spring hide its delight
> When buds & blossoms grow
> Does the sower sow
> His seed by night
> Or the plowman in darkness plow

Looking over what he had just written, in the first line he deleted 'delight' and following it wrote 'joy.' Substantially revised, with a new third stanza, 'Earths Answer' read:

Earths Answer

Earth raisd up her head
From the darkness dread & drear
Her eyes fled dead
Stony dread!
And her locks coverd with grey despair

Prisond on watry shore
Starry jealously does keep my den
Cold & hoar

Weeping oer
I hear the father of the ancient men

Does spring hide its joy
When buds & blossoms grow
Does the sower sow
His seed by night
Or the plowman in darkness plow

Break this heavy chain
That does freeze my bones around
Selfish vain
Eternal bane
That free love with bondage bound

Characteristically, Blake then turned back in the *Manuscript Notebook* to earlier drafts. With the same pen and medium-grey ink used for writing these two poems, on N. 113 he introduced the title 'Infant Sorrow.'

The next time that Blake turned to N. 111, using a finely sharpened nib and charcoal black ink, it was to write the stanzas under the catch phrase 'in a mirtle shade' carried over from the bottom half of N. 113. When he had finished, he looked over the two poems that had already been written on N. 111. In the penultimate line of 'Thou hast a lap full of seed', he deleted 'pulling' and above it wrote 'tearing.' In 'Earths Answer,' first stanza, third line, he deleted 'eyes,' over it wrote 'orbs' and deleted 'fled.' In the new third stanza, written to the right and above 'in a mirtle shade,' in the first line he overwrote 'hide,' at the end of the third line deleted 'sow,' at the beginning of the next line deleted 'His seed' and in front of it wrote 'Sow.'

The last time that Blake amended poems on N. 111 he used pencil. Before drawing a vertical line through all three poems on this page, indicating some form of early selection, in 'Earths Answer,' first stanza, line three, he deleted 'orbs' and 'dead' and at end of the line wrote 'light fled.' Blake made one other change to 'Earths Answer,' when it was copied from the *Manuscript Notebook* onto copper for relief etching. Reading through all of the manuscript drafts, he restored the original third stanza, as well as keeping the stanza that he had written to

replace it. Incorporating all of these changes, as relief etched and printed the poem read as follows:

EARTH'S Answer

Earth rais'd up her head,
From the darkness dread & drear.
Her light fled:
Stony dread!
And her locks cover'd with grey despair.

Prison'd on watry shore
Starry Jealously does keep my den
Cold and hoar
Weeping o'er
I hear the Father of the ancient men

Selfish father of men
Cruel jealous selfish fear
Can delight
Chain'd in night
The virgins of youth & morning bear.

Does spring hide its joy
When buds and blossoms grow?
Does the sower?
Sow by night?
Or the plowman in darkness plow?

Break this heavy chain,
That does freeze my bones around
Selfish! vain!
Eternal bane!
That free Love with bondage bound.

Vertical pencil lines through 'Thou has a lap full of seed' and 'Earths Answer' indicate that both poems were selected together. Later, 'Thou has a lap full of seed' was abandoned. Shortly before a final selection was made of the poems to be printed in the first issue of *Songs of Experience*, Blake wrote and relief etched the 'Introduction' to *Songs of Experience* as we know it. It is not present in the *Manuscript Notebook*, and was almost certainly written after 'EARTH'S Answer,' with the emblem drawing of a soul reclining on a cloud on N. 57 used for the design of the plate [FIG. 24]. It was then etched on a newly cut

copper plate, on the back of which was etched the title-page. In establishing the voice of the bard in the 'Introduction' to *Songs of Experience*, in contrast to the piper in the 'Introduction' to *Songs of Innocence*, the point of view and compass of the response expressed in 'EARTH'S Answer' is profoundly altered. Now it expresses the fear, oppression and despair of the whole of fallen humanity and sets the scene for the poems that follow.

N. 109 & N. 108

The facing pages of manuscript draft on N. 109 and N. 108 are amongst the most complex and fascinating in the *Manuscript Notebook* [PLATES 10 & 11]. We have seen develop certain characteristics in the writing of *Songs of Experience*. After entering a new poem or poems, Blake turns back to revise earlier entries. Poems are often entered in fair copy, sometimes in groups, as on N. 115, or in pairs, as on N. 113, with revision of one poem leading to consideration of the other, as with 'Why should I care for the men of thames' and 'O lapwing.' On N. 109 and N. 108, these characteristics of composition reveal a sequence of creative relationships that in particular develop between two of Blake's greatest lyrics, 'LONDON' and 'The Tyger,' where the root cause of man's discontent finds its counterpart in an evocation of the revolutionary sublime.

LONDON & NURSES Song

On the blank page of N. 109, using thin pale grey ink, Blake transferred fair copy drafts of two poems into the *Manuscript Notebook*, beginning, top left with 'London':

London

I wander thro each dirty street
Near where the dirty Thames does flow
And see in every face I meet
Marks of weakness marks of woe

In every cry of every man
In every voice of every child

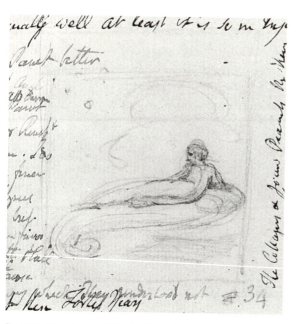

In every voice in every ban
The german forged links I hear

But most the chimney sweepers cry
Blackens oer the churches walls
And the hapless soldiers sigh
Runs in blood down palace walls

A line was then drawn beneath the last stanza, marking the end of the poem and establishing space below it for another.

In *Songs of Innocence* and *Songs of Experience* Blake often parodies earlier hymns and songs written for the moral instruction of children. The first draft of 'LONDON' is an example of this uncompromising irony, as it inverts the self righteous point of view of the speaker of Song IV, 'Praise for Mercies Spiritual and Temporal,' of Isaac Watts's *Divine Songs, Attempted in Easy Language for the Use of Children*, first published in 1715 and frequently throughout the eighteenth century:

Whene'er I take my walks abroad
　　How many poor I see!
What shall I render to my God
　　For all his gifts to me?

Not more than others I deserve,
　　Yet God hath giv'n me more;
For I have food while others starve,
　　Or beg from door to door.

How many children in the street
　　Half naked I behold?
While I am cloth'd from head to feet,
　　And cover'd from the cold.

While some poor wretches scarce can tell
　　Where they may lay their head,
I have a home wherein to dwell,
　　And rest upon my bed.

While others early learn to swear,
　　And curse, and lie, and steal;
Lord, I am taught thy name to fear,
　　And do they holy will.

Are these they favours day by day
　　To me above the rest?
Then let me love thee more than they,
　　And try to serve the best.[20]

The opening of 'London' also alludes to the closing lines of *Paradise Lost*, specifically to Milton's description of Adam and Eve after the Fall as they make their solitary way, 'with wandering steps and slow,' to the subjected plain.

Blake annotated Richard Bentley's edition of *Paradise Lost* (1732), specifically commenting upon the proposed amendment to this passage:

In either hand the hast'ning Angel caught
Our ling'ring Parents; and to th' Eastern Gate
Led them direct, and down the Cliff as fast
To the subjected Plain: then disappear'd.
They looking back, all th' Eastern side beheld
Of Paradise, so late their happy seat,
Wav'd over by that flaming Brand; the Gate
With dreadful Faces throng'd and fiery Arms.
Some natural tears they drop'd, but wip'd them soon:
The World was All before them, where to chose

FIG. 25 Annotations by William Blake, p.398, *Milton's Paradise Lost*. A New Edition, By Richard Bentley, D.D., 1732. Leaf size 283 × 216 mm. Collection of Michael Phillips.

There place of Rest; and Providence their guide:
They hand in hand with wand'ring steps and slow,
Through Eden *took their solitary way.*

In Bentley's edition, the last two lines have been printed in italic to indicate to the reader the lines he believes call for amendment. What became Bentley's most celebrated example of presuming to rewrite Milton, follows:

Then *hand in hand with* SOCIAL *steps their way*
Through Eden *took,* WITH HEAV'NLY COMFORT
CHEER'D.

In *The Spectator*, 3 May 1712, in the last of his papers on *Paradise Lost*, Joseph Addison had remarked, 'If I might presume to offer at the smallest Alteration in this Divine Work, I should think the Poem would end better with the Passage here quoted [ll. 648–9], than with the two verses which follow.' Quoting Addison, Bentley continued: 'If to make one small Alteration appear'd to be so *Presumptuous*; what Censure must I expect to incur, who have presum'd to make so many?' Blake did not hesitate. With pen and sepia ink he crossed through Bentley's note and, on the opposite page Bentley's proposed amendment [FIGS. 25 & 26]. Below Bentley's comment he then wrote his own signing it with his monogram, as follows:

I cannot enough admire the hardiness of Bentley, who would expunge these two last Lines, as proper and surely as beautiful as any in the whole Poem, and substitute cold expressions foreign to the Author's [Judgement *del*.] probable and natural meaning, viz "that they left Paradise with regret," if any one thinks otherwise I desire no better proof of the state of his feelings. WB

640 To the fubjected Plain : then difappear'd.
 They looking back, all th' Eaftern fide beheld
 Of Paradife, fo late their happy feat,
 Wav'd over by that flaming Brand ; the Gate
 With dreadful Faces throng'd and fiery Arms.
645 Some natural tears they drop'd, but wip'd them foon :
 The World was All before them, where to choofe
 Their place of Reft ; and Providence their guide :
 * *They hand in hand with wand'ring fteps and flow,*
649 *Through Eden took their folitary way.*
 * THEN *hand* in hand with SOCIAL *fteps their way*
 Through Eden *took*, WITH HEAV'NLY COMFORT CHEER'D.

fage foregoing. It contradicts the Poet's own Scheme ; nor is the Diction unexceptionable. He tells us before, That *Adam*, upon hearing *Michael's* Predictions, was even *furcharg'd with Joy*, v. 372 ; was *replete with Joy and Wonder*, 468 ; was in doubt, whether he fhould *repent of*, or *rejoice in his Fall*, 475 ; was *in great Peace of Thought*, 558 : and *Eve* herfelf *not fad*, but *full of Confolation*, 620. Why then does this Diftich difmifs our firft Parents in Anguifh, and the Reader in Melancholy ? And how can the Expreffion be juftified, *with wand'ring Steps and flow ?* Why *wand'ring ?* Erratic Steps ? Very improper : when in the Line before, they were *guided by Providence*. And why *Slow ?* when even

Eve profefs'd her Readinefs and Alacrity for the Journey, 614 ; *But now lead on :*
 In Me is no delay.
And why *their folitary Way ?* All Words to reprefent a forrowful Parting ? When even their former Walks in Paradife were as folitary, as their Way now : there being no Body befides Them Two, both here and there. Shall I therefore, after fo many prior Prefumptions, prefume at laft to offer a Diftich, as clofe as may be to the Author's Words, and entirely agreeable to his Scheme ?
 THEN *hand* in hand with SOCIAL *fteps their Way*
 Through Eden *took*, WITH HEAV'NLY COMFORT
 CHEER'D.

The E N D

FIG. 26 Annotations by William Blake, p.399, *Milton's Paradise Lost*. A New Edition, By Richard Bentley, D.D., 1732. Leaf size 283 × 216 mm. Collection of Michael Phillips.

As we have seen, it is just this moment that Blake will later depict in the design of the general title-page of *Songs of Innocence and of Experience*, that he now evokes in the opening lines of 'London' [FIG. 2 & PLATE 1].

Blake is also specific about the part of London through which the speaker wanders, 'thro each dirty street / Near where the dirty Thames does flow.' At the opposite end of Hercules Buildings from Westminster Bridge Road is Church Street [FIG. 27]. Turning to the right, about one hundred yards in the direction of the river, stands the parish church of St. Mary's Lambeth. Princes Street and Fore Street, the two main streets of the village, led west from St. Mary's along the edge of the Thames. Both were narrow, cobbled and damp with raised cellar doors to protect against the high tides. At right angles, Fore Street and Princes Street were

intersected by unlit lanes and alleyways running down to the river. In these streets and lanes were located the local manufactories. Here also lived those who laboured in them and their families, often in single rooms: 'from three to eight individuals, of different ages, often sleep in the same bed; there being, in general, but one room, and one bed, for each family.[21] During the 1850s, these same streets and lanes were photographed by William Strudwick shortly before being razed to build the Albert Embankment [FIG. 28].

In September 1793, George Romney described approaching the city from the south, before crossing the Thames, following a visit to the poet William Hayley at Eartham in Sussex:

[…] the approach to London affected me in various ways. I observed a sharpness of countenance in the people

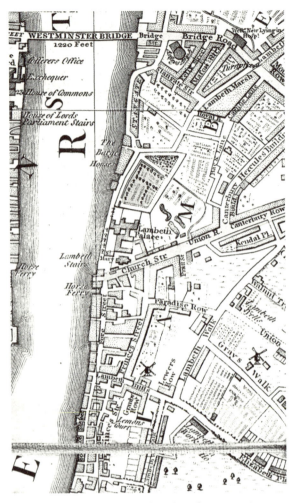

FIG. 27 Detail, *Bowle's New Plan of London, Westminster and Southwark*, 4 June 1793. Press Mark FG 1793. GLC 357. Reproduced by permission of London Metropolitan Archive, Corporation of London.

I met; with passions so strongly marked, I suppose none could mistake. Deep design, disappointed ambition, envy, hatred, melancholy, disease and poverty. These appearances one is for ever meeting in the skirts of London...[22]

In 1802, Dr Charles Stanger described the conditions that prevailed in areas like those along the Thames at Lambeth, in his *Remarks on the Necessity and Means of Suppressing Contagious Fever in the Metropolis*:

Air and light are, in a great measure, excluded from their habitations, whilst damp and cold frequently predominate. Human effluvia and exhalations from putrefying vegetable and animal substances, within and about their sordid dwellings, are constantly accumulating; and the atmosphere of one polluted cell is but exchanged, for that of another.... Whilst the frame is subject to physical circumstances so adverse to health, moral causes combine to irritate and depress the mind. The cries of children, the complaints of age, the lamentations of the distressed, the moans of the sick, the railings of the discontented, the quarrels of the passionate, the imprecations of the blasphemer, the riots of the drunkard, even the boisterous merriment of the gay, if mirth can here be found, preclude the possibility of repose.[23]

At night, walking through the streets that backed onto the Thames at Lambeth, Blake saw and heard things far removed from the earlier pastoral vision he expressed in *Songs of Innocence*. Here were the 'marks of weakness, marks of woe,' the cries of infants and of men, that he records in his great poem.

The second stanza of 'London' reflects the repressive atmosphere following the Royal Proclamation of 21 May 1792, banning any form of seditious activity including the publication of prints. The 'german forged links' are closely related. Throughout August and September 1792, the interests of the British monarchy were being served by the joint manifesto of 'their Majesties the Emperor of Germany and the King of Prussia' published and referred to throughout the British press. The manifesto commanded the Duke of Brunswick to march on France and restore the power and authority of the French monarchy, as the press recounted daily, which precipitated the massacres in Paris during August and September 1792 and, immediately following, widespread loyalist reaction in Britain.

NURSES Song

In the upper right corner, using the same pen and pale grey ink, Blake entered a second poem in fair copy beginning with the opening line from 'Nurses Song' of *Songs of Innocence*, signaling the relationship to the earlier poem:

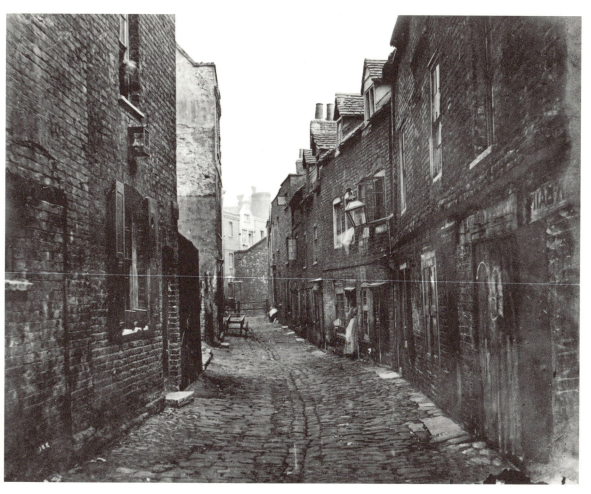

FIG. 28 Fore Street leading from Ferry Street, Lambeth Riverside. Note the pottery kilns at the far end of the view and the caged bird hanging outside the building. Photograph taken by William Strudwick, before construction of Albert Embankment 1866-68. Reproduced by permission of Lambeth Archives.

When the voices of children are heard on the
 green
And whisprings are in the dale
The desires of youth rise fresh in my mind
My face turns green & pale

Then come home my children the sun is gone
 down
And the dews of night arise
Your spring & your day are wasted in play
And your winter & night in disguise

The only amendment to this poem was made later, in pencil. In line three, Blake deleted 'desires,' wrote 'days' above it, not very clearly, and therefore wrote 'days' again in front of the line. The only other change was made later still, not in the manuscript, but at the time the plate was being relief etched. In the same line, the personal pronoun 'my' is introduced before 'youth.' In its final form, relief etched and printed, the poem read as follows [PLATES 55–60]:

NURSES Song

When the voices of children, are heard on the
 green
And whisperings are in the dale:
The days of my youth rise fresh in my mind,
My face turns green and pale.

Then come home my children, the sun is gone
 down
And the dews of night arise
Your spring & your day, are wasted in play
And your winter and night in disguise

These changes increase the distance and sharpen the contrast between the children at play and the Nurse's recollections of the 'days' of her youth. Recollections that now fester and bring to her face a 'looke so greene, and pale' they recall the description by Lady Macbeth (I. vii. 40). Blake's rough drawing in illustration of 'Pitty, like a naked New-borne-Babe' (I. vii. 21f.) faces the next page in the *Manuscript Notebook*.

LONDON

Blake was less satisfied with the fair copy draft of 'London.' Using the same pen and ink, in the first stanza, line three, he altered 'see' to 'mark,' the point of view of the speaker now explicitly parodying Locke in *An Essay Concerning Human Understanding* that he had read and annotated as a young man.[24] Biblical associations from Ezekiel ix.4, Genesis iv.15 and especially 'the mark of the beast' from Revelation xiii.16-17 may also be recalled.[25] In the second stanza, line two, he deleted 'every voice of every child' and, above it, wrote 'every infants cry of fear'. In the third stanza, he scored through the whole of the second line, 'Blackens oer the churches walls', and, at the end of the line, wrote 'Every blackning' and below it 'church appalls,' with the embedded pun on pall cloth transforming the church into a coffin. Following these revisions, the poem in its second stage of composition read as follows:

London

I wander thro each dirty street
Near where the dirty Thames does flow
And mark in every face I meet
Marks of weakness marks of woe

In every cry of every man
In every infants cry of fear
In every voice in every ban
The german forged links I hear

But most the chimney sweepers cry
Every blackning church appalls
And the hapless soldiers sigh
Runs in blood down palace walls

This was how the poem was left. Both 'London' and 'Nurses Song' were entered together as fair copy in the *Manuscript Notebook*, suggesting that they may have been composed together with the contrast between country and city in mind.

I was fond in the dark

On the next occasion Blake worked on N. 109, he used black ink and a sharper nib. Two poems were entered, below 'London' and 'Nurses Song' respectively, the first in the left column:

I was fond in the dark
In the silent night
I murmurd my fears
And I felt delight

In the morning I went
As rosy as morn
To seek for new Joy
But I met with scorn

Looking again at the opening line, with the same pen and ink Blake deleted 'was fond' and above it wrote 'slept.' This was how the poem was left, and later abandoned.

Are not the joys of morning sweeter

Turning to the right column immediately below 'Nurses Song', Blake introduced a second poem:

Are not the joys of morning sweeter
Than the joys of night
And are the vigrous joys of youth
Ashamed of the light

Let age & sickness silent rob
The vineyards in the night
But those who burn with vigrous youth
Pluck fruits before the light

[60]

No changes were made to these lines that later were also abandoned.

To Nobodaddy

On the third occasion that Blake turned to N. 109, he used thin pale grey ink and a broad nib, similar to but distinguishable from the pen and ink used to enter 'London' and 'Nurses Song.' In the space remaining in the left column, below 'I was fond in the dark' written in black ink, Blake entered two poems. Drawing a line beneath the last line of 'I was fond in the dark,' the first of these two new poems was written as follows:

Why art thou silent & invisible
Man of Jealousy
Why dost thou hide thyself in clouds
From every searching Eye

Why darkness & obscurity
In all thy words & laws
That none dare eat the fruit but from
The wily serpents jaws

Looking over the poem, Blake made one change. In the second line he deleted 'Man' and above it wrote 'Father.' Later, using darker charcoal grey ink, he wrote the title 'To Nobodaddy.' As F. W. Bateson remarked, 'Nobody's Daddy, the contemptuous colloquial 'contrary' to Father of All' of conventional Protestantism.[26] Later still, in pencil, Blake added a new last line, as follows:

Or is it because Secresy gains feminine applause

He then deleted 'feminine' and above it wrote 'females loud.' This addition, as the poem as a whole, may have been inspired by the drawings on these pages in illustration of *Paradise Lost*, particularly of God the Father. Finally revised, the poem read as follows:

To Nobodaddy

Why art thou silent & invisible
Father of Jealousy

Why dost thou hide thyself in clouds
From every searching Eye

Why darkness & obscurity
In all thy words & laws
That none dare eat the fruit but from
The wily serpents jaws
Or is it because Secresy gains females loud applause

Later, it was apparently selected, as a vertical pencil line has been drawn through it, but not etched, perhaps because its questionings and portents of the sublime were clearly subsumed by 'The Tyger,' subsequently drafted to the right of it and on the facing page.

THE LILLY

Blake drew a line immediately above and beneath 'To Nobodaddy,' and then started to write a second poem in the space below it:

The rose puts envious

Scoring through 'puts envious,' he wrote 'puts forth a thorn' immediately following and carried on:

The rose puts forth a thorn
The coward sheep a threatening horn
While the lily white shall in love delight
And the lion increase freedom & peace

Using the same pen and pale grey ink, Blake looked again at the first line and deleted 'rose' and above the line wrote 'lustful rose.' The poem now read as follows:

The lustful rose puts forth a thorn
The coward sheep a threatening horn
While the lily white shall in love delight
And the lion increase freedom & peace

Blake then drew a line beneath the last line marking off the remaining space at the bottom left of the page.

On the next occasion he worked on N. 109, Blake used a finely trimmed nib and medium-grey ink.

On this occasion, he wrote the first drafts of 'The Tyger' in the space remaining in the bottom half of the right side of N. 109 and continuing on to the facing page N. 108. When he finished, he looked back at the poems he had written earlier, including 'London,' where he tried, unsuccessfully, three times to write a new fourth stanza wedged between the poems on left and right, and, most recently, the two poems written at the bottom left. Above the first he inserted the title 'To Nobodaddy.' In the second, with a single stroke he scored through the last line, 'And the lion increase freedom & peace,' and beneath it and the line he had drawn to mark off the poem, wrote 'The priest loves war & the soldier peace.' The poem now read as:

> The rose puts forth a thorn
> The coward sheep a threatening horn
> While the lilly white shall in love delight
> The priest loves war & the soldier peace

On the next occasion Blake worked on this poem, he used darker charcoal grey ink and wrote in a more concentrated hand. On the same occasion, Blake worked again on 'The Tyger' and made a final and successful attempt at writing the fourth stanza of 'London.'

Turning to the lines at the bottom left of the page, above the first line, Blake wrote 'modest' before the deleted 'lustful' and in the second line deleted 'coward' and above it wrote 'humble'. Perhaps considering that it would be dangerous to publish, he scored through the new fourth line and below it wrote 'Nor a thorn nor a threat stain her beauty bright.' Later, he drew a pencil line from top to bottom through these lines and without further alteration for the first issue of *Songs of Experience* relief etched and printed the poem as 'THE LILLY' on the same plate with 'My Pretty ROSE TREE' and 'AH! SUN-FLOWER', as follows [PLATE 68]:

THE LILLY

The modest Rose puts forth a thorn
The humble Sheep, a threatening horn:
While the Lilly white, shall in Love delight,
Nor a thorn nor a threat stain her beauty bright.

The rewritten fourth line that had been deleted for the one used in the final version was not discarded, but transferred to the bottom of N. 107, where Blake tried to use it, unsuccessfully, in the drafts of 'The human Image.'

The Tyger

On the fourth occasion that Blake worked on N. 109, he used medium-grey ink and a finely sharpened nib. Drawing a line beneath 'Are not the joys of morning sweeter,' written earlier in black ink, he entered three stanzas:

> Tyger Tyger burning bright
> In the forests of the night
> What immortal hand & eye
> Could frame thy fearful symmetry
>
> In what distant deeps or skies
> Burnt the fire of thine eyes
> On what wings dare he aspire
> What the hand dare sieze the fire
>
> And what shoulder & what art
> Could twist the sinews of thy heart
> And when thy heart began to beat
> What dread hand & what dread feet

Apparently, the first three stanzas went smoothly, possibly due to being fair copy from earlier drafts. But with the next stanza Blake had difficulty. Following the end of the last stanza, the first three lines were written:

> Could fetch it from the furnace deep
> And in the horrid ribs dare steep
> In the well of sanguine woe

In the second line, he drew a vertical stroke through the letter 'e' of 'the' altering it to 'thy,' but then deleted all three lines and tried again:

> In what clay & in what mould
> Were thy eyes of fury rolld

He then deleted these two lines and tried to write the stanza a third time:

What the hammer what the chain
In what furnace was thy brain
What the anvil what the arm
Could its deadly terrors clasp

Without further difficulty, Blake ended the poem
by repeating (with slight changes) the first stanza,
as follows:

Tyger Tyger burning bright
In thee forests of the night
What immortal hand & eye
Dare form thy fearful symmetry

Using the same pen and ink, Blake moved across to
the facing N. 108 to draft another stanza, lower left,
overwriting part of the drawing in illustration of
Paradise Lost. With Milton's poem in mind he con-
tinued:

What the shoulder what the knee
Did he who made the lamb make thee
When the stars threw down their spears
And waterd heaven with their tears

In the first line, Blake deleted 'shoulder' and above
it wrote 'ankle,' then scored out the entire line and
above it started to write a new line with 'And is,'
then overwrote 'is' with 'did' and carried on:

And did he laugh his work to see
Did he who made the lamb make thee
When the stars threw down their spears
And waterd heaven with their tears

He then went back to the new first line, scored
through 'did he laugh,' above it wrote 'dare he smile,'
crossed out 'smile' and after it wrote 'laugh,' but de-
cided against it and deleted 'laugh' effectively restor-
ing 'smile.' Turning to the second line, he deleted
'Did' and above it wrote 'Dare.' Then, smudging it
out, he drew a line through 'Dare' restoring 'Did.'
Blake then rearranged the lines, writing before each
line down the page respectively 3, 4, 1 and 2. Revised
and reorganized, the stanza now read:

When the stars threw down their spears
And waterd heaven with their tears
And dare he smile his work to see
Did he who made the lamb make thee

On N. 109, over the line drawn earlier to mark off
space for the poem, Blake wrote the title above the
first stanza. In the first stanza, last line, he scored
through 'Could' and in front of it wrote 'Dare,'
bringing it into line with the wording of the last line
of the stanza he had just written on N. 108. In the
second stanza, first line, he deleted 'In what' and
above it wrote 'Burnt in.' Correspondingly, in the
second line he deleted 'Burnt the' and in front of it
wrote 'The cruel.' Revised, and with a new fifth
stanza, 'The Tyger' now read:

The Tyger

Tyger Tyger burning bright
In the forests of the night
What immortal hand & eye
Dare frame thy fearful symmetry

Burnt in distant deeps or skies
The cruel fire of thine eyes
On what wings dare he aspire
What the hand dare sieze the fire

And what shoulder & what art
Could twist the sinews of thy heart
And when thy heart began to beat
What dread hand & what dread feet

What the hammer what the chain
In what furnace was thy brain
What the anvil what the arm
Could its deadly terrors clasp

When the stars threw down their spears
And waterd heaven with their tears
And dare he smile his work to see
Did he who made the lamb make thee

Tyger Tyger burning bright
In thee forests of the night
What immortal hand & eye
Dare form thy fearful symmetry

Looking over what he had written, the revised draft was not acceptable. On the right side of the facing N. 108, Blake wrote fair copy of the first, third and final stanzas that he had written and revised on N. 109, and inserted the stanza that he had drafted on the lower left of N. 108 amending only the third line from 'And dare' to 'Did'. Substantially altered the poem now read:

> Tyger Tyger burning bright
> In the forests of the night
> What Immortal hand or eye
> Dare frame thy fearful symmetry
>
> And what shoulder & what art
> Could twist the sinews of thy heart
> And when thy heart began to beat
> What dread hand & what dread feet
>
> When the stars threw down their spears
> And waterd heaven with their tears
> Did he smile his work to see
> Did he who made the lamb make thee
>
> Tyger Tyger burning bright
> In the forests of the night
> What immortal hand & eye
> Dare frame thy fearful symmetry

To the left of these stanzas on N. 108, half way down the left column and over another smudged area of the drawing, Blake then wrote the following fair copy draft of the revised second stanza on N. 109:

> Burnt in distant deeps or skies
> The cruel fire of thine eyes
> Could heart descend or wings aspire
> What the hand dare sieze the fire

At the conclusion of this first stage of composition, the second, fair copy draft of the poem read as follows:

> The Tyger
>
> Tyger Tyger burning bright
> In the forests of the night

> What Immortal hand or eye
> Dare frame thy fearful symmetry
>
> Burnt in distant deeps or skies
> The cruel fire of thine eyes
> Could heart descend or wings aspire
> What the hand dare sieze the fire
>
> And what shoulder & what art
> Could twist the sinews of thy heart
> And when thy heart began to beat
> What dread hand & what dread feet
>
> When the stars threw down their spears
> And waterd heaven with their tears
> Did he smile his work to see
> Did he who made the lamb make thee
>
> Tyger Tyger burning bright
> In the forests of the night
> What immortal hand & eye
> Dare frame thy fearful symmetry

After writing fair copy on N. 108, Blake looked through the other poems on the facing page N. 109, beginning with 'London.'

LONDON

Blake read through the three stanzas of 'London' as they had been left written in pale grey ink in the upper left corner of N. 109. Using the same sharp quill and medium grey ink that he had just used to write and revise the first drafts of 'The Tyger,' Blake turned to the opening of the third stanza. With a firm stroke of his pen, he deleted 'But most' and inserted 'How' above it. 'But most' was to serve a new purpose. In the space left between the two poems below to left and right, 'I was fond in the dark' and 'Are not the joys of morning sweeter,' he drafted a fourth stanza beginning with 'But most', as follows:

> But most the midnight harlots curse
> From every dismal street I hear
> Weaves around the marriage hearse
> And blasts the new born infants tear

From top left to bottom right Blake crossed through these four lines and started again:

But most from every street I hear
How the midnight harlots curse
Blasts the new born infants tear
And hangs with plagues the marriage hearse

In the first line, he deleted 'every,' above it wrote 'wintry,' and after 'street' added 's' and looked through the stanza again. Dissatisfied, he started a third time, trying to get it right:

But most the shrieks of youth
 I hear

Having abandoned this third attempt at a fourth stanza, the poem was left, as follows:

London

I wander thro each dirty street
Near where the dirty Thames does flow
And mark in every face I meet
Marks of weakness marks of woe

In every cry of every man
In every infants cry of fear
In every voice in every ban
The german forged links I hear

How the chimney sweepers cry
Every blackning church appalls
And the hapless soldiers sigh
Runs in blood down palace walls

But most from wintry streets I hear
How the midnight harlots curse
Blasts the new born infants tear
And hangs with plagues the marriage hearse

Following this third stage of composition, the poem was left. The new stanza may be specific to Blake's immediate surroundings in Lambeth. The Westminster New Lying-in Hospital and Asylum for Orphan Girls were both close to Blake: 'You are acquainted with Mr Blake's direction?,' wrote John Flaxman to William Hayley, 'it is Nº. 13 Hercules Buildings near the Asylum, Surry [sic] Side of Westminster Bridge.'[27] The rules and regulations they published were exclusive and unbending. For the Asylum: 'III. No Negro or mulatto child can be admitted. IV. No diseased, deformed or infirm child can be admitted.'[28] Unwed pregnant women from the City and Westminster crossed Westminster Bridge to seek refuge in the Westminster New Lying-in Hospital. Presenting themselves, they were informed that 'No Patient shall be admitted without a Letter of Recommendation' and if found not 'clean in Person and Apparel, and free from any infectious disorder,' they were turned back into the road Blake travelled.[29]

When Blake returned to look through what he had written on N. 109 and N. 108, this time with a broader nib and black ink, he turned to 'London.' In the second stanza, line four, he deleted 'german' and above it wrote 'mind.' Overwriting 'ed' with 'd' he conflated 'forged.' He then scored through 'links I hear' twice and above it wrote 'manacles I hear.' Turning to the first line of his second attempt at writing a fourth stanza, he deleted 'from' and immediately above wrote 'thro.' In line four, he deleted 'hangs' and beneath it wrote 'smites.' Following this fourth stage of composition, 'London' read as follows:

London

I wander thro each dirty street
Near where the dirty Thames does flow
And mark in every face I meet
Marks of weakness marks of woe

In every cry of every man
In every infants cry of fear
In every voice in every ban
The mind forgd manacles I hear

How the chimney sweepers cry
Every blackning church appalls
And the hapless soldiers sigh
Runs in blood down palace walls

But most thro wintry streets I hear
How the midnight harlots curse
Blasts the new born infants tear
And hangs with plagues the marriage hearse

By this stage of revision, Blake had moved on in the *Manuscript Notebook* writing and revising other poems.

At the bottom right of N. 107, in dark grey ink, he entered the following poem, clearly with 'London' in mind if not to form a part of it:

> Remove away that blackning church
> Remove away that marriage hearse
> Remove away that place of blood
> Twill quite remove the ancient curse

Later, using an even darker, grey-black ink, Blake introduced the title 'An ancient Proverb,' distinguishing these four lines from 'London.' After he had completed writing and selecting poems for *Songs of Experience* in the *Manuscript Notebook*, these four lines were transferred to N. 99.

Using the same pen and dark grey ink with which he had written 'Remove away that blackening church,' Blake turned back to N. 109. Looking over 'London' and his earlier attempts at writing a fourth stanza, he tried once more:

> But most thro midnight &c
> How the youthful

The ampersand followed by the short form 'c' for 'etc.' at the end of the first line signals that Blake had worked out the final stanza. The poem, completed in the *Manuscript Notebook*, following this fifth stage of composition, read:

London

> I wander thro each dirty street
> Near where the dirty Thames does flow
> And mark in every face I meet
> Marks of weakness marks of woe
>
> In every cry of every man
> In every infants cry of fear
> In every voice in every ban
> The mind forgd manacles I hear
>
> How the chimney sweepers cry
> Every blackning church appalls
> And the hapless soldiers sigh
> Runs in blood down palace walls

> But most thro midnight streets I hear
> How the youthful harlots curse
> Blasts the new born infants tear
> And smites with plagues the marriage hearse

Further changes were made to 'London,' but not in the *Manuscript Notebook*.

On one of the last occasions that Blake selected poems for *Songs of Experience*, he rejected 'Why should I care for the men of thames' on N. 113, almost certainly because it had been supplanted by 'London.' But from the second line, 'Or the cheating waves of charterd streams,' Blake salvaged 'charterd' to use as an epithet for both 'street' and 'Thames' in the opening lines of 'London.' Before etching, in the final line of the poem Blake also deleted 'smites' and replaced it with 'blights.' Following this sixth stage of composition, 'London' was relief etched and printed as follows:

LONDON

> I wander thro' each charter'd street,
> Near where the charter'd Thames does flow.
> And mark in every face I meet
> Marks of weakness, marks of woe.
>
> In every cry of every Man,
> In every Infants cry of fear,
> In every voice: in every ban,
> The mind-forg'd manacles I hear
>
> How the Chimney-sweepers cry
> Every blackning Church appalls,
> And the hapless Soldiers sigh
> Runs in blood down Palace walls
>
> But most thro' midnight streets I hear
> How the youthful Harlots curse
> Blasts the new-born Infants tear
> And blights with plagues the Marriage hearse

For the design, Blake copied the emblem sketch of an old man on crutches being led by a child on N. 54 [PLATES 64, 65 & 66].

The Tyger

Using the same pen and dark grey ink that he had used for the final changes to 'London', Blake turned to the fair copy drafts of 'The Tyger' on N. 108. He made only one change. In the first stanza, third line, he overwrote 'or' with the ampersand '&,' initially to bring it into line with the first stanza on N. 109. Apparently, this was enough to make him realize that this version of the poem was not what he wanted. Using the same pen and ink, Blake cancelled the stanzas in fair copy on N. 108: with three sharp strokes of his pen the stanza upper left and, turning the nib on its side, the four stanzas on the right with a series of crossed strokes. These marks of deletion signal the beginning of the third stage of composition of 'The Tyger.' They are clearly distinguished from the single vertical pencil lines that Blake later drew through the poems on N. 109, including 'LONDON,' 'THE LILLY,' 'Are not the joys of morning sweeter' and 'The Tyger,' indicating selection.

Looking across to N. 109, Blake considered again his original working drafts of 'The Tyger' and began to make changes. In the first stanza, line three, he reversed the amendment he had just made to the fair copy of this line on N. 108 and overwrote the ampersand with 'or.' In front of line four he scored through 'Dare,' restoring 'Could' at the beginning of the line. In the second stanza, line one, he deleted the amendment written above the beginning of the line, 'Burnt in,' restoring the original beginning 'In what.' In doing so, he effectively restored 'Burnt' at the beginning of line two in place of the amendment, 'The cruel,' written before it in the margin. In stanza four, line one (beneath the five heavily scored lines), he deleted 'What' and above it wrote 'Where.' Further along in the same line, again he deleted 'what' and above it wrote 'where.' In line three, he deleted 'arm', had second thoughts and immediately following the deletion restored 'arm.' In the same line, he then replaced 'arm' with 'grasp,' deleted 'grasp' and following it wrote 'clasp', then deleted both and the definite article 'the' before the original deleted 'arm' and above and at the end of the line wrote 'dread grasp.' At the end of the fourth line, while working on the end of the third line, he deleted 'clasp', replaced it with 'grasp' and then restored 'clasp.' In the final stanza on N. 109, last line, he deleted 'form' and above it wrote 'frame.'

Blake then rearranged the stanzas on N. 109, from top to bottom 1, 2, 3, 4 and 6, and turning to the working draft of the stanza on N. 108 numbered it 5. Later, probably at the time that he went through the *Manuscript Notebook* selecting poems in pencil for *Songs of Experience*, in the fourth stanza, first line, in pencil he deleted 'Where' at the beginning of the line and 'where' further along, restoring the original reading of 'what' in both places. Revised and rearranged, the poem now read as follows (including the later amendments to stanza four, line one, in pencil):

The Tyger

Tyger Tyger burning bright
In the forests of the night
What immortal hand or eye
Could frame thy fearful symmetry

In what distant deeps or skies
Burnt the fire of thine eyes
On what wings dare he aspire
What the hand dare sieze the fire

And what shoulder & what art
Could twist the sinews of thy heart
And when thy heart began to beat
What dread hand & what dread feet

What the hammer what the chain
In what furnace was thy brain
What the anvil what dread grasp
Dare its deadly terrors clasp

When the stars threw down their spears
And waterd heaven with their tears
And did he smile his work to see
Did he who made the lamb make thee

Tyger Tyger burning bright
In thee forests of the night
What immortal hand & eye
Dare frame thy fearful symmetry

Fully reinstating the ambivalence and terror of the first drafts, Blake relief etched and printed this final version of 'The Tyger,' deleting 'And' in the penultimate stanza, line three, and in the last stanza, line three, replacing 'or' with '&' in order to repeat the first stanza verbatim.

In the late eighteenth century the tiger was described as 'Fierce without provocation, and cruel without necessity, its thirst for blood is insatiable: Though glutted with slaughter, it continues it carnage.' The description that continues in all eighteenth-century editions of the *Encyclopedia Britannica* is representative:

The tiger seems to have no other instinct but a constant thirst for blood, a blind fury which knows no bounds or distinction, and which often stimulates him to devour his own young, and to tear the mother to pieces for endeavouring to defend them. [30]

This perception of the tiger was commonly applied as a metaphor for the French Revolution in general and the behaviour of the Paris mobs in August and September 1792 in particular. On 10 September 1792, following reports of the massacres in Paris, Samuel Romilly wrote:

I observe that, in your letter, you say nothing about France, and I wish I could do so too, and forget the affairs of that wretched country altogether; but that is so impossible, that I can scarcely think of anything else. How could we ever be so deceived in the character of the French nation as to think them capable of liberty! wretches, who, after all their professions and boasts about liberty, and patriotism, and courage, and dying, and after taking oath after oath, at the very moment when their country is invaded and an enemy is marching through it unresisted, employ whole days in murdering women, and priests, and prisoners! Others, who can deliberately load whole waggons full of victims, and bring them like beasts to be butchered in the metropolis; and then (who are worse even than these) the cold instigators of these murders, who, while blood is streaming round them on every side, permit this carnage to go on, and reason about it, and defend it, nay, even applaud it, and talk about the example they are setting to all nations. One might as well think of establishing a republic of tigers in some forest in Africa, as of maintaining a free government among such monsters. [31]

On 12 September 1792, Horace Walpole wrote from Strawberry Hill to George Nicol:

I confess the horror I have felt on the late massacres shocked me so much, that I could think and speak of nothing else [. . .] Too much industry cannot be used by all friends to humanity, to spread horror for such atrocious deeds, while it is fresh, especially in the common people; for though every feeling breast must shudder, there are so many agents of the Parisian monsters in this country, who are endeavouring to propagate their bloody doctrines in alehouses and among the populace, that if they are not strictly watched, mischief may arise even in this good-hearted island. [32]

On 20 November 1792, the Association for the Preservation of Liberty and Property against Republicans and Levellers was founded at the Crown and Anchor Tavern in the Strand by John Reeves. Using the newspapers, declarations of loyalty and reports of anyone suspected of seditious behaviour were invited. The response was without precedent.

In a matter of weeks more than sixteen hundred local organizations were founded upon Reeves's model and had written to him declaring their support, including Lambeth [FIG. 29]. Requests for information leading to the identification and arrest of anyone found to be associated with the publication or distribution of seditious material, including pamphlets, posters, handbills or prints, was met with hundreds of letters, often anonymous, being sent to the Crown and Anchor Tavern and to local magistrates. That winter and the following spring and summer, the night sky was alight with burnings of Tom Paine in effigy. 'The Tyger' may be a metaphor for the forces of revolution in France. [33] For Blake, it may also apply to the forces of reaction in Britain, to the rise of the loyalist associations, Paine burnings and witch hunts of radical writers, artists, publishers and printmakers that took place that winter and throughout the following spring and summer as he revised and reworked the text of 'The Tyger' in the *Manuscript Notebook*. As often remarked, the image of the tiger that Blake reproduced on the plate belies the text of the poem [PLATE 67]. It differs little from the image of the tiger that juxtaposed the descriptions that have been cited [FIG. 30].

N. 107

On the first occasion that Blake turned to N. 107, he entered at the top left of the page in medium grey ink a couplet, which he deleted, followed by the start of another and the beginnings of a third, as follows [PLATE 12]:

> How came pride in Man
> From Mary it began
> How Contempt & Scorn

FIG. 29 Lambeth [Loyalist Association Declaration]. Published 10 December 1792. Size of original 310 × 160 mm. Add. MS 16,931, fol. 89ʳ. Reproduced by permission of the British Library Board.

> What a World is Man
> His Earth

All five lines were deleted to make a second attempt at writing a contrary state of 'The Divine Image' of *Songs of Innocence*, first attempted on N. 114 with the stanzas beginning 'I heard an Angel singing.'

The Human Abstract

Blake first wrote the title 'The human Image.' Salvaging only the last two lines of the third stanza, and the first two lines of the fourth stanza from 'I heard an Angel singing' on N. 114, Blake formed the first stanza on N. 107, establishing from the outset an explicit contrary relationship to 'The Divine Image' of *Songs of Innocence*. Halting only once, in the last line of the second stanza to delete 'nets' and replace it with 'baits', he wrote the following fair copy draft into the *Manuscript Notebook*:

> The human Image
>
> Mercy could be no more
> If there was nobody poor
> And Mercy no more could be
> If all were as happy as we
>
> And mutual fear brings Peace
> Till the selfish Loves increase
> Then Cruelty knits a snare
> And spreads his [nets *del.*] baits with care
>
> He sits down with holy fears
> And waters the ground with tears
> Then humility takes its root
> Underneath his foot
>
> Soon spreads the dismal shade
> Of Mystery over his head
> And the catterpiller & fly
> Feed on the Mystery

And it bears the fruit of deceit
Ruddy & sweet to eat
And the raven his nest has made
In its thickest shade

The Gods of the Earth & Sea
Sought thro nature to find this tree
But their search was all in vain
Till they sought in the human brain

Looking over the poem, Blake overwrote the first word in the first line, 'Mercy', with 'Pity.' He deleted the second line with a stroke and above it wrote 'If we did not make somebody poor.' In place of the first word of the fourth stanza, 'Soon,' he started to write to the left of it 'Spr,' but smudged it out and overwrote 'Soon,' reinstating the opening. Blake then moved up to the blank space in the right column opposite the first stanza and wrote the following four lines:

There souls of men are bought & sold
There cradled infancy is sold
And youths to slaughter houses led
And maidens for a bit of bread

As he wrote, he made the following alterations. In the second line he changed 'There' to 'And,' 'cradled' (underneath) for 'milk fed' and 'is sold' for 'for gold.' In the next line, he altered 'youths' to 'youth' and in the final line 'maidens' to 'beauty' which he wrote above it.

The SICK ROSE

Using the same pen and ink, Blake moved further down the right side of the page, leaving room for more work on 'The human Image.' With another contrary in mind, this time 'The Blossom' of *Songs of Innocence*, Blake wrote the following two stanzas:

O rose thou art sick
The invisible worm
That flies in the night
In the howling storm

Hath found out thy bed
Of crimson joy
A dark secret love
Doth life destroy

Below that, he continued to write the following four lines, using the same pen and ink:

I walked abroad in a snowy day
I askd the soft snow with me to play

She playd & she melted in all her prime
Ah that sweet love should be thought a crime

Both poems were left without alteration.

On the next occasion that Blake worked on N. 107, this time using extremely thin pale grey ink, in the space above 'O rose thou art sick' Blake wrote the following five lines:

> As I wandered the forest
> The green leaves among
> I heard a wild thistle
> Singing a Song
> I slept in the dark &c

Leaving these lines, Blake went to the poem below and above it wrote the title 'The Sick rose' and above the poem below that he wrote the title 'Soft Snow,' using the same pale grey ink.

On the next occasion he turned to N. 107, Blake was using pencil. In the space at the top of the right column, he wrote four lines beginning 'Love to faults is always blind,':

> Love to faults is always blind
> Always is to joy inclind
> Always wingd & unconfind
> And breaks all chains from every mind

In the third line, Blake drew a line beneath 'Always' and before it wrote 'Lawless', then wrote above the lines the title 'How to know Love from Deceit,' which he then scored out.

Moving down the page to 'The Sick rose,' in the second stanza he crossed out the last two lines and, to the right, wrote two new lines:

> And his dark secret love
> Does thy life destroy

The metaphor and its mystery are gone. In their place, the personal pronoun and definite article identify the principals in this causal relationship between innocence and corruption. Amended, with its new title, the poem now reads:

The Sick rose

> O rose thou art sick
> The invisible worm
> That flies in the night
> In the howling storm
>
> Hath found out thy bed
> Of crimson joy
> And his dark secret love
> Does thy life destroy

These would not be the last changes that Blake would make to 'The Sick rose.' Moving further down the right column, Blake read through 'Soft Snow,' deleted the last line and below it wrote 'And the winter calld it a dreadful crime.'

The Human Abstract

Using the same pencil, Blake then went to the bottom of the left column and to the last line of 'The human Image' and drew a line through 'Till they sought in the human brain.' Below it, he wrote 'There grows one in the human brain.' The stanza at the top right appears to have been abandoned at this point. This is confirmed when Blake drew a vertical line in pencil down through all of the stanzas from the title to the bottom of the page, including the two lines carried over from the drafts of 'THE LILLY' on N. 109, but did not score through this stanza. With the new line written in pencil, and incorporating all of the changes that had been made, 'The human Image' now read:

The human Image

> Pity could be no more
> If we did not make somebody poor
> And Mercy no more could be
> If all were as happy as we
>
> And mutual fear brings Peace
> Till the selfish Loves increase
> Then Cruelty knits a snare
> And spreads his baits with care

He sits down with holy fears
And waters the ground with tears
Then humility takes its root
Underneath his foot

Soon spreads the dismal shade
Of Mystery over his head
And the catterpiller & fly
Feed on the Mystery

And it bears the fruit of deceit
Ruddy & sweet to eat
And the raven his nest has made
In its thickest shade

The Gods of the Earth & Sea
Sought thro nature to find this tree
But their search was all in vain
There grows one in the human brain

With the exception of punctuation, capitalisation and a single but important change to the title and, in the first line, 'could' to 'would', Blake transferred this draft to copper for relief etching as 'The Human Abstract.' Beginning on N. 114, with the drafts of 'I heard an Angel singing,' 'The Human Abstract' is one of the first examples that show how difficult Blake found it to work out 'contrary' states of *Songs of Innocence* to his satisfaction. 'A cradle song,' also on N. 114, was another. 'A cradle song' was finally abandoned. 'The Human Abstract' nearly so. Before this second attempt on N. 107, 'LONDON' and 'The Tyger' had been written on the previous page together with 'NURSES Song' and 'THE LILLY.' The writing of these poems appears to have sharpened the focus and provided impetus for the development of *Songs of Experience* on N. 107, with 'The human Image' deepening its perception.

The SICK ROSE

Later, Blake returned to N. 107, this time using dark charcoal grey ink. On this fourth occasion that he worked on 'The Sick rose' he altered one word, the personal pronoun in the first of the two new final lines that had been written earlier in pencil. In the second stanza, third line, Blake crossed through

'his' and above it wrote 'her.' The poem now read as follows:



The Sick rose

O rose thou art sick
The invisible worm
That flies in the night
In the howling storm

Hath found out thy bed
Of crimson joy
And her dark secret love
Does thy life destroy'



This revision, as Elizabeth Langland has pointed out, shows Blake 'to be keenly aware of gender in the poem—not identifying the rose but rather the worm as female—which unseats traditional literary assumptions.'[34] This also provides another example of how the drawings facing these pages in illustration of *Paradise Lost* served as a constant point of reference and influence upon writing. The drawing on N. 102 is in illustration of Adam and Eve as described in Book IV, 'Two of far nobler shape, erect and tall [. . .] hand in hand they passed, the loveliest pair,' as, unseen, they are seen by Satan, 'what do mine eyes with grief behold' (ll. 288–358).

Blake's ambivalence in assigning responsibility for mankind's corruption, first to man and then to woman, and therefore for making the nature of the 'dark secret love' even darker, did not change. When he copied the text from the *Manuscript Notebook* onto copper, before relief etching and printing the poem for inclusion in the *Songs of Innocence and of Experience* in 1794, the first reading was restored. This final change to 'his dark secret love' represents the fifth stage of composition of 'The SICK ROSE.'

An Ancient Proverb

In the bottom right corner of the page, using the same dark charcoal grey ink, Blake wrote the last poem on N. 107, a possible continuation of or response to 'LONDON' on N. 109:

Remove away that blackning church
Remove away that marriage hearse
Remove away that place of blood
Twill quite remove the ancient curse

In darker charcoal black ink, Blake wrote the title 'An ancient Proverb' above these four lines, over-writing part of the first line. Then, in the third line, he deleted 'place,' above it wrote 'man' and, in the last line, deleted the first word 'Twill' and below it wrote 'You'll.' The poem now read:

An ancient Proverb

Remove away that blackning church
Remove away that marriage hearse
Remove away that man of blood
You'll quite remove the ancient curse

On 18 December 1792, Thomas Paine was convicted *in absentia* for seditious libel for writing the Second Part of the *Rights of Man*. In the months that followed, writers, publishers, lawyers and print publishers identified with seditious views were hounded, arrested and imprisoned. Blake's reference to the 'man of blood' could mean any one of several figures or a collective term for them all: the Prime Minister, William Pitt, his Home Secretary, Henry Dundas, the head of the secret service, Evan Nepean, even the King. What the addition of the title makes clear is that these lines were now independent of 'LONDON.' Much later, 'An ancient Proverb' will be transferred from the pages of the *Manuscript Notebook* occupied with the creation of *Songs of Experience*, past the 'Motto to the Songs of Innocence & of Experience' that marks the end of this section, to N. 99. There, written in pencil, 'An Ancient Proverb,' reads as follows:

An ancient Proverb

Remove away that blackning church
Remove away that marriage hearse
Remove away that —— of blood
Youll quite remove the ancient curse

Here even the oblique reference has been expunged, perhaps reflecting Blake's growing fear of imprisonment as a result of being reported and indicted as a radical printmaker, author and publisher; registered in June 1793 in his memorandum of that date, at the very beginning of the *Manuscript Notebook*. Transferred to N. 99, 'An ancient Proverb' forms part of a sequence of similar proverbial sayings under the heading 'Several Questions Answerd' that have been written in the vein of the 'Proverbs of Hell' of *The Marriage of Heaven and Hell*. They will help make clear the distinction between the poems that were written for *Songs of Experience* and the poems and prose that followed.

On the last occasion that Blake worked through this part of the *Manuscript Notebook*, using pencil, he drew a vertical line through 'The human Image,' 'The Sick rose' and 'Soft Snow' indicating, at this stage, their selection, presumably for etching as *Songs of Experience*. 'Soft Snow' was later abandoned. These vertical pencil lines clearly indicate some form of selection, but a selection that is not finally borne out in the plates that were etched and printed. This is another clear sign of the halting progress of the work as a whole and how it evolved in stages over many months, if not longer.

N. 106

To my Mirtle

When Blake first turned to N. 106, it was to find space to write 'To my Mirtle' that had grown out of his drafts of 'INFANT SORROW' on N. 113 and N. 111 [PLATE 13]. Using thin medium grey ink Blake wrote the following two lines in the top left corner of N. 106 taken from the bottom left of N. 111:

O how sick & weary I
Underneath my mirtle lie

Smudging these out, he then introduced the title 'To my Mirtle.' Turning again to N. 111, he copied the first stanza at the bottom right and, for the second stanza, copied the two deleted lines followed by the last two lines at the bottom left of N. 111, and wrote them on N. 106 as follows:

To my Mirtle

Why should I be bound to thee
O my lovely mirtle tree
Love free love cannot be bound
To any tree that grows on ground

To a lovely mirtle bound
Blossoms showring all around
Like to dung upon the ground
Underneath my mirtle bound

Scoring through the last two lines, in their place he wrote the lines that he had originally written at the top of the page, taken from the bottom left corner of N. 111, as follows:

O how sick & weary I
Underneath my mirtle lie

He then deleted lines three and four of the first stanza and numbered the surviving lines from top to bottom, 5 and 6, 1 and 2 and 3 and 4. The poem now read:

To my Mirtle

To a lovely mirtle bound
Blossoms showring all around
O how sick & weary I
Underneath my mirtle lie
Why should I be bound to thee
O my lovely mirtle tree

Blake then drew a line beneath where he had worked, marking off the rest of the page. 'To my Mirtle' was left and later abandoned.

A Little BOY Lost

On the next occasion that Blake turned to N. 106, using a slightly darker medium grey ink, he wrote in a different, more open hand the following stanzas, first down the space remaining in the left column and then, at the bottom, across and in the right column:

Nought loves another as itself
Nor venerates another so
Nor is it possible to Thought
A greater than itself to know

Then father I cannot love you
Nor any of my brothers more
I love myself so does the bird
That picks up crumbs around the door

The Priest sat by and heard the child
In trembling zeal he siezd his hair
The mother followd weeping loud
O that I such a fiend should bear

Here Blake stopped, deleted the last two lines, and started again:

Then led him by the little coat
To show his zealous priestly care

Scoring through the last line, he wrote a new line concluding the third stanza and carried on writing:

And all admird his priestly care

The weeping child could not be heard
The weeping parents wept in vain
They bound his little ivory limbs
In a cruel Iron chain

Blake then moved immediately across and to the bottom of the right column to write a fifth stanza. As he wrote, in the first line he deleted 'fire' and after it wrote 'place.' Then, in the last line, he deleted 'are' in the middle of the line, after he had written it, and placed it at the beginning of the line, as follows:

They burnd him in a holy [fire *del.*] place
Where many had been burnd before
The weeping parents wept in vain
Are Such things [are *del.*] done on Albions shore

Before further revision, the poem read:

Nought loves another as itself
Nor venerates another so
Nor is it possible to Thought
A greater than itself to know

Then father I cannot love you
Nor any of my brothers more
I love myself so does the bird
That picks up crumbs around the door

The Priest sat by and heard the child
In trembling zeal he siezd his hair
Then led him by the little coat
And all admird his priestly care

The weeping child could not be heard
The weeping parents wept in vain
They bound his little ivory limbs
In a cruel Iron chain

They burnd him in a holy place
Where many had been burnd before
The weeping parents wept in vain
Are such things done on Albions shore

Blake read through the poem. In the second stanza, first line, using the same pen and ink, he deleted 'Then' and in front of it wrote 'And.' Further on, in the same line, he crossed through 'I cannot' and above it wrote 'how can I.' In the second line, he deleted the first word 'Nor' and before it wrote 'Or.' In the third line, he deleted 'myself so does the bird' and following it wrote 'you like the little bird.' He then read the third and fourth stanzas. Here he stopped, and in the right column across from these two stanzas, drafted a new fourth stanza:

And standing on the altar high
Lo what a fiend is here said he
One who sets reason up for judge
Of our most holy mystery

Turning to the stanza below it, the last stanza of the poem, first line, Blake deleted 'They' at the beginning of the line and above it wrote 'And.' Just to the left of this change, Blake scored out the last two lines. Then, in roman lettering, possibly to see the

lines written in a form approximating the semi cursive script that he would use on the plate, Blake wrote the following two lines:

And strip't him to his little shirt
& bound him in an iron chain

Before setting down his pen, in the first of these lines he crossed through 'And' and before it wrote 'They.' Following these revisions and drafting of a new fourth stanza, the poem read as follows:

Nought loves another as itself
Nor venerates another so
Nor is it possible to Thought
A greater than itself to know

And father how can I love you
Or any of my brothers more
I love you like the little bird
That picks up crumbs around the door

The Priest sat by and heard the child
In trembling zeal he siezd his hair
He led him by the little coat
And all admird his priestly care

And standing on the altar high
Lo what a fiend is here said he
One who sets reason up for judge
Of our most holy mystery

The weeping child could not be heard
The weeping parents wept in vain
They strip'd him to his little shirt
& bound him in an iron chain

And burnd him in a holy place
Where many had been burnd before
The weeping parents wept in vain
Are such things done on Albions shore

With only the addition of capitalisation and punctuation, the poem was relief etched and printed for the first separate issue of *Songs of Experience* as 'A Little BOY Lost,' making explicit its contrary relationship to 'The Little Boy lost' and 'The Little Boy found' of *Songs of Innocence* [PLATE 69].

In the creation of 'A Little BOY Lost,' Blake has taken the warning to children in Isaac Watts's 'Song XXIII. Obedience to Parents' to its logical conclusion:

> Have you not heard what dreadful Plagues
> Are threat'ned by the Lord
> To him that breaks his Father's Law
> Or mocks his Mother's Word?[35]

In 'A Little BOY Lost,' the frisson of fear evoked in 'The Little Boy lost' is set against the shock of human sacrifice, and the benign rescue of 'The Little Boy found' mocked by parental collusion in the horrors of priesthood.

Deceit to secresy confind

On the next occasion that Blake turned to N. 106, it was with pencil. Space remained on most of the right side of the page from the top down. This had preserved the main part of Blake's first, very rough drawing that was later adapted to illustrate Macbeth's lines beginning 'Pity like a new born babe' in a sequence of pencil, pen and wash drawings leading to one of the large colour-prints or monotypes first produced in 1795. Now it was disregarded, and in the top right corner Blake wrote the following lines:

> Deceit to secresy inclind
> Modest prudish & confind
> Never is to interest blind
> And chains & fetters every mind

In the first line, Blake deleted 'inclind' and following it wrote 'confind.' He deleted the second line and above it wrote 'Lawful cautious changeful and,' deleted 'changeful and' and finished the line by writing '& confind.' In the third line he scored through 'Never is to' and above it wrote 'To every thing but.' Crossing through the whole of the fourth line, below it he wrote 'And forges fetters for the mind.' Rewritten, the poem now read:

> Deceit to secresy confind
> Lawful cautious & refind
> To every thing but interest blind
> And forges fetters for the mind

The poem was taken no further, but the final line may have contributed to Blake's revision of 'LONDON' on N. 109.

THE Chimney Sweeper

Also in pencil, Blake wrote a second poem below 'Deceit to secresy confind,' as follows:

> The Chimney Sweeper
>
> A little black thing among the snow
> Crying weep weep in notes of woe
> Where are they father & mother say
> They are both gone up to Church to pray

Blake made no changes to this fair copy of the title and first stanza of 'The Chimney Sweeper.' Later, on N. 103, he completed the poem in dark charcoal grey ink. The presence of fair copy of just the first stanza on N. 106 suggests that Blake is confident of the way forward. This stanza will serve as a reminder to complete the poem later, as he will by writing fair copy of the remaining stanzas on N. 103.

Looking back, 'The Human Abstract' and 'The SICK ROSE' have been written on the facing page, 'LONDON,' 'NURSES Song,' 'THE LILLY' and 'The Tyger' on the preceding page-opening and now 'A Little BOY Lost' and 'THE Chimney Sweeper' on N. 106. In these few pages we are seeing a concentration of successful poems. In using pencil, it is also likely that Blake is beginning to look back through the entire sequence, making final amendments in pencil, as we have seen, and beginning to select the poems that he intends to etch. Only one other poem is written on this page, over the centre of the drawing that hitherto has been protected. For this reason it may have been introduced after *Songs of Experience* had been completed.

Merlins prophecy

In fine very dark charcoal ink and using a finely sharpened nib, Blake wrote the following couplets and title over the central and most clearly defined part of the drawing on this page, as follows:

Merlins prophecy

The harvest shall flourish in wintry weather
When two virginities meet together
The King & the Priest must be tied in a tether
Before two virgins can meet together

The gnomic wit and epigrammatic style of these two couplets are more suggestive of the Proverbs of Hell of *The Marriage of Heaven and Hell* than the lyric concentration of *Songs of Experience*. Like 'An Ancient Proverb' on the previous page, together with several other poems that have been written in the same vein in the pages that follow, it did not contribute to *Songs of Experience* and was left. When Blake returned to this page for the last time, again with pencil, it was to select 'A Little BOY Lost' and the title and first stanza of 'The Chimney Sweeper,' by drawing a vertical line through both.

N. 105

Day

On the first occasion that Blake turned to the next page opening, N. 105 and the facing drawing on N. 104, it was to write another explicit contrary to one of the *Songs of Innocence*, in this instance 'Night,' in pale grey ink [PLATES 14 & 15]:

Day

The day arises in the East
Clothd in robes of blood & gold
Swords & spears & wrath increast
All around his ancles rolld
Crownd with warlike fires & raging desires

Using the same pen and ink, in the first line Blake scored through 'day' and above it wrote 'Sun,' but

smudged it out, and in the penultimate line deleted 'ancles' and above it wrote 'bosom.' The poem was left and evidently abandoned as a false start.

The Fairy

In the same pale grey ink, but in a more concentrated hand, Blake wrote a second poem, at first possibly with 'The Blossom' of *Songs of Innocence* in mind:

The Marriage Ring

Come hither my sparrows
My little arrows
If a tear or a smile
Will a man beguile
If an amorous delay
Clouds a sunshiny day
If the tread of a foot
Smites the heart to its root
Tis the marriage ring
Makes each fairy a king

So a fairy sung
From the leaves I sprung
He leapd from the spray
To flee away
And in my hat caught
He soon shall be taught
Let him laugh let him cry
Hes my butterfly & Ive pulld out the Sting
And a marriage ring
Is a foolish thing

On this occasion, Blake made only one change to this fair copy draft. In line seven, he deleted 'tread' and over it wrote 'step.' Later, using a finely sharpened quill and black ink, probably following his writing and revising of 'THE FLY' on N. 101, in line five of the second half of the poem, he deleted 'And' and over it wrote 'But.' Below it, in the eighth line, he deleted '& Ive pulld out the Sting' and above it wrote 'For I've pulld out the Sting.' In the next line he overwrote 'And a' with 'Of the' and then heavily scratched out the last line. The last four lines now read:

Let him laugh let him cry
Hes my butterfly
For I've pulled out the Sting
Of the marriage ring

On yet another occasion, this time using pencil, the original title was deleted and alongside it written 'The Fairy.' The poem was abandoned.

Gratified desire

On the next occasion, using noticeably darker medium-grey ink and a sharper nib, Blake introduced two poems each of four lines further down the left column, as follows:

> The sword sung on the barren heath
> The sickle on the fruitful field
> The sword he sung a song of death
> But could not make the sickle yield
>
> Abstinence sows sand all over
> The ruddy limbs & flaming hair
> But Desire Gratified
> Plants fruits of life & beauty there

Later, using different matt or flat dark grey ink, clearly distinguishable in natural light, in the first set of lines, second line, Blake overwrote 'on' with 'in.' These lines were left and later abandoned.

Using the same ink, Blake went on to develop the second set of four lines by writing the following three lines immediately below them:

> In a wife I would desire
> What in whores is always found
> [The del.] linaments of Gratified desire

Like 'An ancient Proverb' at the bottom right of N. 107, these lines will also be transferred to N. 99, after first being rewritten on N. 103, and numbered under the general heading 'Several Questions Answer,' clearly for a project unrelated to *Songs of Experience*. The same ink was used to write the final draft of the fourth stanza of 'LONDON' on N. 109.

On the next occasion, using pencil, Blake turned to the right column and wrote two more sets of lines in the same vein:

> If you catch the moment before its ripe
> The tear of repentance youd certainly wipe
> But if once you let the ripe moment go
> Youll never wipe off the tears of woe

In the first line Blake altered 'catch' to 'trap' and in the last line 'Youll never' to 'You can never.' Drawing a line underneath, he wrote the second set:

> He who binds himself to a joy
> Does the winged life destroy
> But he who just kisses the joy as it flies
> Lives in an eternal sun rise

Altering 'himself to' to 'to himself' in the first line and in the last line replacing 'an eternal' with 'eternity's,' Blake underscored these lines. Later, in the same ink used to write the three lines on 'Gratified desire' bottom left, he added the title 'Eternity' and in line three deleted 'just.' These lines will also be transferred to N. 99 under the heading 'Several Questions Answer.'

Below the line, Blake entered the following shorthand for a third composition:

The Kid

> Thou little Kid didst play
> [D del.] &c

The '&c' written beneath the title and first line of this poem offers another indication of Blake's writing practice. As the fair copy drafts in the *Manuscript Notebook* have suggested, Blake first worked out many of his poems elsewhere, on scraps of paper or possibly in his head. In relation to these fair copy drafts, the poems that have been extensively composed and revised in the *Manuscript Notebook*, like 'INFANT SORROW,' 'LONDON' and 'The Tyger,' reveal the difficulty he could have and probably did have before they were entered. In the absence of manuscript evidence for the other

books produced in illuminated printing, his writing practice in the *Manuscript Notebook* is of singular importance if we are to appreciate how his works were made.

The Little Vagabond

Blake may have continued to use the same pencil to write the next poem in the right column on N. 105, although the weight is darker and the hand more concentrated, suggesting another occasion. Beneath the line drawn under 'The Kid,' the next poem was written, without a title, as follows:

[O *overwritten*] Dear Mother Dear Mother the
 church is cold
But the alehouse is healthy & pleasant & warm
Besides I can tell when I am usd well
Such usage in heaven makes all go to hell

But if at the Church they would give us some Ale
And a pleasant fire our souls to regale
We'd sing and we'd pray all the livelong day
Nor ever once wish from the Church to stray

Then the parson might preach & drink & sing
And wed be as happy as birds in the spring
And Modest dame Lurch who is always at
 Church
Would not have bandy children nor fasting nor
 birch

Then God like a father that joys for to see
His children as pleasant & happy as he
Would have no more quarrel with the Devil or
 the Barrel
But shake hands & kiss him & thered be no more
 hell

Blake deleted the last line immediately, scoring it out and in the adjacent left column at the bottom of the page wrote 'But kiss him & give him both food & apparel.' Looking back through the poem, he entered the title 'A pretty Vagabond' above it, but deleted 'A pretty' and wrote 'The little [overwriting 'A'] Vagabond'. In the third line, he then changed 'when' to 'where' and in the new last line, bottom left, deleted 'food' and above it wrote 'drink'. The poem now read:

The little Vagabond

Dear Mother Dear Mother the church is cold
But the alehouse is healthy & pleasant & warm
Besides I can tell where I am usd well
Such usage in heaven makes all go to hell

But if at the Church they would give us some Ale
And a pleasant fire our souls to regale
We'd sing and we'd pray all the livelong day
Nor ever once wish from the Church to stray

Then the parson might preach & drink & sing
And wed be as happy as birds in the spring
And Modest dame Lurch who is always at Church
Would not have bandy children nor fasting nor
 birch

Then God like a father that joys for to see
His children as pleasant & happy as he
Would have no more quarrel with the Devil or the
 Barrel
But kiss him & give him both drink & apparel

Later, at a second stage of revision, Blake returned to the poem with a finely sharpened pen and medium grey ink. He deleted the last line of the first stanza and above it wrote 'The poor parsons with wind like a blown bladder swell.' In the first line of stanza four, he deleted 'that joys for' and over it wrote 'rejoicing.' Finally revised, the poem was left to read:

The little Vagabond

Dear Mother Dear Mother the church is cold
But the alehouse is healthy & pleasant & warm
Besides I can tell where I am usd well
The poor parsons with wind like a blown bladder
 swell

But if at the Church they would give us some Ale
And a pleasant fire our souls to regale
We'd sing and we'd pray all the livelong day
Nor ever once wish from the Church to stray

Then the parson might preach & drink & sing
And wed be as happy as birds in the spring
And Modest dame Lurch who is always at Church
Would not have bandy children nor fasting nor
 birch

Then God like a father rejoicing to see
His children as pleasant & happy as he
Would have no more quarrel with the Devil or the
 Barrel
But kiss him & give him both drink & apparel

Two changes were made when the text was transferred to copper in preparation for relief etching. In the first stanza, line four was replaced with 'Such usage in heaven will never do well' and, in the last stanza, first line, 'Then' was altered to 'And.' Finally revised, relief etched and printed, the poem read as follows:

The Little Vagabond

Dear Mother, dear Mother, the Church is cold,
But the Ale-house is healthy & pleasant & warm;
Besides I can tell where I am use'd well,
Such usage in heaven will never do well.

But if at the Church they would give us some Ale.
And a pleasant fire, our souls to regale;
We'd sing and we'd pray, all the live-long day;
Nor ever once wish from the Church to stray.

Then the Parson might preach & drink & sing.
And we'd be as happy as birds in the spring:
And modest dame Lurch, who is always at Church
Would not have bandy children nor fasting nor
 birch.

And God like a father rejoicing to see,
His children as pleasant and happy as he:
Would have no more quarrel with the Devil or the
 Barrel
But kiss him & give him both drink and apparel.

Like 'The GARDEN of LOVE', 'The SICK ROSE' and 'INFANT SOROW', 'The Little Vagabond' was not selected and relief etched for the first issue of *Songs of Experience* in 1793. Only later, like the other three poems, when Blake returned to the *Manuscript Notebook*, was it chosen to be relief etched and printed for the first combined issue of *Songs of Innocence and of Experience* in 1794.

N. 103

The Question Answerd

When Blake turned to the next page opening, N. 103, it was to pick up and develop the three lines that he had written at the bottom left of N. 105 in matt or flat dark grey ink, beginning 'In a wife I would desire.' Here, under the heading 'The Question Answerd', this time using pale grey ink, in the top left corner he wrote the following lines [PLATE 16 & 17]:

The Question Answerd

What is it men of women do require
The lineaments of Gratified Desire
What is it women do of men require
The lineaments of Gratified Desire

He then drew a line beneath these lines. Later, in pencil, Blake made two adjustments. In the first line, he deleted 'of' and above it wrote 'in,' and in the third line made the same change and started to write 'd[esire]' over 'require,' but stopped and confirmed the first letter 'r.' Possibly, at the time that he made these changes in pencil, he transferred these lines, incorporating these revisions, to the top left corner of N. 99 to join the other sets of lines under the general heading of 'Several Questions Answerd.'

THE Chimney Sweeper

On the second occasion that Blake turned to N. 103, using dark charcoal black ink, it was to complete 'The Chimney Sweeper' started in pencil on N. 106. Following the title and first stanza on N. 106 [repeated in brackets], are the two stanzas written in the left column on N. 103 below 'The Question Answerd':

[The Chimney Sweeper

A little black thing among the snow
Crying weep weep in notes of woe
Where are they father & mother say
They are both gone up to Church to pray]

Because I was happy upon the heath
And smild among the winters wind
They clothed me in the clothes of death
And taught me to sing the notes of woe

And because I am happy & dance & sing
They think they have done me no injury
And are gone to praise God & his Priest & King
Who wrap themselves up in our misery

In the second stanza, second line, Blake deleted 'wind' and after it wrote 'snow'. He then scored through the whole of the last line and beneath it wrote 'Who make up a heaven of our misery' and drew a line beneath it. Revised, the poem now read:

The Chimney Sweeper

A little black thing among the snow
Crying weep weep in notes of woe
Where are they father & mother say
They are both gone up to Church to pray

Because I was happy upon the heath
And smild among the winters snow
They clothed me in the clothes of death
And taught me to sing the notes of woe

And because I am happy & dance & sing
They think they have done me no injury
And are gone to praise God & his Priest & King
Who make up a heaven of our misery

When Blake selected 'The Chimney Sweeper' for *Songs of Experience*, signalled on both N. 106 and N. 103 by a vertical pencil line drawn through the stanzas, no further revision was made before relief etching apart from altering 'they' to 'thy' in the third line and adding punctuation. 'THE Chimney Sweeper' was included in the first separate issue of *Songs of Experience*, 1793.

Lacedemonian Instruction, Riches & An answer to the parson

Drawing a line beneath the new final line of 'THE Chimney Sweeper,' using the same pen and ink Blake wrote two more lines:

Come hither my boy tell what thou seest there
A fool tangled in a religious snare

He then drew a line beneath these two lines. Without stopping, Blake went on to write another set of lines, working out the first line as he wrote, as follows:

The [we weal count *del.*] countless gold of a
 merry heart
The rubies & pearls of a loving eye
The idle man never can bring to the mart
Nor the cunning hoard up in his treasury

Blake then went back through the poem and in the third line deleted 'idle man' and above it wrote 'indolent' and in the last line deleted 'cunning' and, running out of ink, above it wrote 'secret.' Later, using coal black ink, Blake overwrote 'secret' confirming his amendment. He then introduced two titles. Above the first set of lines he wrote 'Lacedemonian Instruction' and above the second 'Riches.'

On the third occasion that Blake worked on N. 103, this time using fine pale grey ink, he drew a line beneath the last poem written in the left column, and wrote the following title and two lines:

An answer to the parson

Why of the sheep do you not learn peace
Because I dont want you to shear my fleece

He then drew a line beneath these lines. On N. 101, top right, Blake will make a note in pencil for arranging 'Riches' and 'An answer to the parson' on one copper plate together with 'O Lapwing' on N. 113 and 'If you trap the moment before its ripe' on N. 105.

HOLY THURSDAY

A line was drawn under these lines before proceeding to write the next poem, in fair copy at the bottom of the page, left and right, using the same pale grey ink:

Holy Thursday

Is this a holy thing to see
In a rich & fruitful land
Babes reducd to misery
Fed with cold & usurous hand

Is that trembling cry a song
Can it be a song of joy
And so great a number poor
Tis a land of poverty

And their sun does never shine
And their fields are bleak & bare
And their ways are filld with thorns
Tis eternal winter there

But whereeer the sun does shine
And whereeer the rain does fall
Babe can never hunger there
Nor poverty the mind appall

Blake made only three changes to this fair copy of 'Holy Thursday' when it was transferred to copper plate in mirror writing to be relief etched and printed for the first issue of *Songs of Experience*. In the second stanza, third line, he altered 'And so great a number poor' to 'And so many children poor,' and in the fourth line changed 'Tis' to 'It is' as in the third stanza, last line. In the fourth stanza, first line, he altered 'But' to 'For' and, at the end of a number of lines, on the copper plate introduced question and exclamation marks. Relief etched and printed, the contrary to 'HOLY THURSDAY' of *Songs of Innocence* read as follows [PLATES 38–41]:

HOLY THURSDAY

Is this a holy thing to see,
In a rich and fruitful land,
Babes reducd to misery,
Fed with cold and usurous hand?

Is that trembling cry a song?
Can it be a song of joy?
And so many children poor?
It is a land of poverty!

FIG. 31 Manuscript Ledger of J. Swabey, Accounts with the Parish of Lambeth, 6 October 1789 to 26 October 1805, p. 17, February 1793. Press Mark: P85/ MRY 1/165. Reproduced by permission of London Metropolitan Archive, Corporation of London.

And their sun does never shine.
And their fields are bleak & bare.
And their ways are fill'd with thorns.
It is eternal winter there.

For wher-e'er the sun does shine,
And where-e'er the rain does fall:
Babe can never hunger there,
Nor poverty the mind appall.

The catalyst for the bitter irony of Blake's railing satire may have been the discovery of a child found dead recorded in the Lambeth parish accounts for 26 February 1793 [FIG. 31]:

26. Paid Advertisement of a Child unknown found
 Dead – 4 –
And two days later:

28. Paid 3 Advertisements after the the the⎫
 Inquest offering a Reward --------⎬ – 13 6[36]

The ledger makes clear that on four occasions ad-
vertisements were placed where they would be seen
by the residents of Lambeth, on three of these occa-
sions, as noted in the entry for 28 February, offering
a reward for information regarding the child found
dead and abandoned. The scene of discovery, as
well as the probable circumstances that brought it
about, of a mother forced to abandon her children,
is depicted on Blake's plate. The woman shocked to
see a dead child at her feet is taken from the draw-
ing at the centre top of N. 74, immediately to the left
of the portrait drawing of the face of Tom Paine
[PLATE 61].

The Angel

On the next occasion that Blake worked on N. 103,
this time using pencil, he entered another fair copy
draft, the contrary to 'A Dream' of *Songs of
Innocence*:

> I dreamt a dream what can it mean
> And that I was a maiden queen
> Guarded by an angel mild
> Witless woe was neer beguild
>
> And I wept both night & day
> And he wiped my tears away
> And I wept both day & night
> And hid from him my hearts delight
>
> So he took his wings & fled
> Then the morn blushd rosy red
> I dried my tears & armd my fears
> With ten thousand shields & spears
>
> Soon my angel came again
> I was armd he came in vain
> But the time of youth was fled
> And grey hairs were on my head

FIG. 32 Drawing used for 'The Angel,' *Songs of Experience*,
from emblem drawings of *For Children The Gates of
Paradise*, 1793. Detail, *Manuscript Notebook*, N. 65.
Reproduced by permission of the British Library Board.

Later, using softer pencil, Blake wrote the title 'The
Angel' above the first stanza and in the last stanza,
penultimate line, crossed out 'But' and before it
wrote 'For.' Adding punctuation and capitalisation,
the poem was relief etched and printed for the first
issue of *Songs of Experience* using the pen and ink
wash drawing on N. 65 for the design [FIG. 32].

The last two lines of 'The Angel' had been taken
without change from the final two lines of the fair
copy draft of 'in a mirtle shade' on N. 111, bottom
right. On N. 111, a vertical pencil line had been
drawn through 'in a mirtle shade' together with
'Thou hast a lap full of seed' and 'Earths answer,' in-
dicating some form or stage of selection for *Songs of
Experience*. 'Thou hast a lap full of seed' and 'in a
mirtle shade,' after another attempt at writing the
poem under 'To my Mirtle' on N. 106, were finally
abandoned. This clearly suggests that 'The Angel'
must have been written after it had been decided to
abandon 'in a mirtle shade' and therefore after
poems in the earlier parts of the *Manuscript
Notebook* had gone through at least one stage of
selection in pencil.

The look of love alarms &
Soft deceit & idleness

In the space remaining in the right column, below 'The Angel' and above the third and fourth stanzas of 'Holy Thursday,' Blake wrote two sets of lines, again in pencil, facing the earlier drawing of Adam and Eve in illustration of *Paradise Lost* [PLATE 17]:

> The look of love alarms
> Because tis filld with fire
> But the look of soft deceit
> Shall win the lovers hire

Underscoring these lines Blake wrote two more, as follows:

> Which are beauties sweetest dress
> Soft deceit & idleness

A line was drawn beneath the second line. Looking over what he had just written, Blake crossed out the first line, first with a single sharp line and then with the side of the pencil. Over the underline, he wrote 'These are beauties sweetest dress.' The two lines now read:

> Soft deceit & idleness
> These are beauties sweetest dress

'The look of love alarms' and 'Soft deceit & Idleness' will be transferred to N. 99 together with 'The Question Answerd' from the top left of N. 103. There they will be grouped together and numbered with 'An ancient Proverb' from the bottom right of N. 107 and 'He who binds to himself a joy' from N. 105, under the general heading 'Several Questions Answerd.' Finally, on N. 103, vertical pencil lines were drawn through the two stanzas of 'THE Chimney Sweeper,' together with the first stanza on N. 106, indicating selection, but not through 'Holy Thursday,' which suggests that it was not written on N. 103 until after this stage of selection had been made.

N. 101

THE FLY

On N. 101, coming from opposite ends of the volume, manuscript poems for *Songs of Experience* and drawings for *The Gates of Paradise* meet [PLATE 18]. Ultimately, the drawing on N. 101 was not selected for *The Gates of Paradise*, but at the time that Blake wrote on this page it is clear that he wished to protect it. With a finely sharpened nib and coal black ink, Blake wrote the following stanza, clearly with Gray's 'Ode on the Spring' (ll. 21–50) in mind:

> Woe alas my guilty hand
> Brushd across thy summer joy
> All thy gilded painted pride
> Shatterd fled

Realising that he has used the same late Augustan poetic diction that he had condemned ten years earlier in 'To the Muses' in *Poetical Sketches* (1783), Blake scored through all four lines and started again, trying to prune the language:

> Little fly
> Thy summer play
> My guilty hand
> Hath brushd away

Blake crossed through 'summer play' and following it wrote 'thoughtless hand.' Concentrating upon his choice of expression, even more, and almost certainly bearing the language of the Authorised Version of Proverbs in mind, he drafted the next stanza:

> The cut worm
> Forgives the plow
> And dies in peace
> And so do thou

Blake also deleted these four lines, but for a different reason.

'The cut worm forgives the plow' is one of the Proverbs of Hell that Blake published in *The Marriage of Heaven and Hell*, a work that is undated. Opinion is divided as to when *The Marriage of Heaven and Hell* was produced. Recent opinion insists that it was completed during the early months of 1790, as opposed to the long-standing view that it was produced sporadically between 1790 and 1793 when it was first advertised for sale in the prospectus of 10 October 1793.[37] While composing 'THE FLY,' one of two things has happened. Either Blake has recalled the proverb that he published three years earlier, or he is working on *The Marriage of Heaven and Hell* at the time and has decided that these lines are more appropriate for the Proverbs of Hell, where they were used on Plate 7. Plate 7 also shows unconventional leftward leaning serifs on the letter 'g.' First noticed by David V. Erdman, this is an idiosyncratic feature of Blake's engraved script that he only used between 1791 and 1803.[38]

From this point, the direction and syllogistic structure of the poem becomes clear, and Blake's choice of language as spare as anything written since the seventeenth century, apart, perhaps, from the *Jubilate Agno* of Christopher Smart:

> Am not I
> A fly like thee
> Or art not thou
> A man like me
>
> For I dance
> And drink & sing
> Till some blind hand
> Shall brush my wing
>
> Then am I
> A happy fly
> If I live
> Or if I die
>
> Thought is life
> And strength & breath
> But the want [of *del.*]
> Of thought is death

Blake read through the poem and renumbered the stanzas 1, 2, 3, 5 and 4. Realising that stanza 4 was not right, he crossed it out and wrote and renumbered a new fourth stanza below it, as follows:

> If thought is life
> And strength & breath
> And the want [of *del.*]
> Of Thought is death

Following these cancellations, revisions and reordering, the poem read as follows:

> Little fly
> Thy summer play
> My thoughtless hand
> Hath brushd away
>
> Am not I
> A fly like thee
> Or art not thou
> A man like me
>
> For I dance
> And drink & sing
> Till some blind hand
> Shall brush my wing
>
> If thought is life
> And strength & breath
> But the want
> Of Thought is death
>
> Then am I
> A happy fly
> If I live
> Or if I die

With the addition of punctuation and three minor changes, in the first stanza, line two, 'summer' to 'summers', line four 'Hath' to 'Has', and, in the fourth stanza, line three, 'But' to 'And', the text as composed on the page was relief etched and printed as 'THE FLY' in the first issue of *Songs of Experience*. [PLATE 51] Using the same finely sharpened nib and coal black ink, at the top right Blake wrote 'Who shall claim the', but stopped and left the line unfinished.

As described, Blake went through the *Manuscript Notebook* with pencil, selecting poems for etching by drawing a single vertical line through them. This did not always result in the poem being etched. For example, 'Why should I care for the men of thames' on N. 113 and 'Thou hast a lap full of seed' on N. 111 were marked but not relief etched. And other poems that have not been marked were finally selected, relief etched and printed, like 'HOLY THURSDAY' at the bottom of N. 103 and 'THE FLY' on the present page.

Another example of Blake's process of selection is present on N. 101. Here, written in pencil in the top right half of the page and years later over written in pen and ink with lines of *The Everlasting Gospel*, Blake has made a selection of poems from earlier pages in the *Manuscript Notebook* for relief etching on a single plate:

	O lapwing &c
	An answer to the Parson
On 1 Plate	Experiment
	Riches
	If you trap &c

All of these short titles can be identified, except one. 'O lapwing thou fliest around the heath' is on N. 113, 'An answer to the parson' on N. 103, 'Riches' on N. 103 and 'If you trap the moment before its ripe' on N. 105. Editors have speculated as to the identity of the poem referred to as 'Experiment,' suggesting, for example, that it could be 'Thou hast a lap full of seed' on N. 111.[39] A vertical pencil line has been drawn through 'Thou hast a lap full of seed,' but none of the other poems have been marked for selection. There is no evidence that the plate was ever etched. The only single plate in *Songs of Experience* that contains more than one poem, 'My Pretty ROSE TREE', 'AH! SUN-FLOWER' and 'THE LILLY,' indicates what Blake was thinking about, but in this case failed to carry out. 'Experiment' means what it says. When Blake did experiment, and noted the number of lines and particularly the disparate nature of the four poems, unlike the plate containing 'My Pretty ROSE TREE', he evidently decided that it was not practical to go on and the plate and the poems were abandoned.

Of greater importance is what this memorandum may be telling us about the progress in the *Manuscript Notebook* of the creation of *Songs of Experience*, specifically, about the next stage, writing text and design in reverse on copper in preparation for relief etching. It makes clear that work is now underway in selecting poems for relief etching and indicates that the end of the section devoted to drafting *Songs of Experience* has been reached, with 'THE FLY' to the left the last poem in the sequence. It also offers our only glimpse in the creation of the *Songs* into the process of Blake arranging word and image on copper, and is all the more valuable for being a negative example. This is an experiment in arrangement and design that failed. As such, it suggests that as much trial and error took place at this stage in production as the writing of the poems in the *Manuscript Notebook* themselves disclose.

One other poem has been written at the bottom of the page, in a distinctive charcoal grey ink, different from the pen and ink used to write 'THE FLY,' as follows:

Motto to the Songs of Innocence & of Experience

The Good are attracted by Mens perceptions
And Think not for themselves
Till Experience teaches them to catch
And to cage the Fairies & Elves

And then the Knave begins to snarl
And the Hypocrite to howl
And all his good Friends shew their private ends
And the Eagle is known from the Owl

The 'Motto to the Songs of Innocence & of Experience' marks the conclusion to the section in the *Manuscript Notebook* that has been occupied with drafting *Songs of Experience*, but it may have been written even later. As we shall see, during the late spring and summer of 1793 four copies of *Songs of Experience* were produced containing seventeen plates. On 10 October 1793, Blake separately listed in a prospectus of his works for sale *Songs of Innocence* and *Songs of Experience*, each volume 'in Illuminated Printing. Octavo, with 25 designs

price 5s.' A combined issue was not advertised. It was not until after October 1793 that Blake altered the *Songs*. Sometime after that date, a general title-page and a tail-piece were added and, together with a number of other changes, in 1794 the first issue of the combined *Songs of Innocence and of Experience Shewing the Two Contrary States of the Human Soul* was produced. This was the first occasion the conflated title was used and it would appear that the 'Motto to the Songs of Innocence & of Experience' was written for the occasion, but never used. The 'Motto to the Songs of Innocence & of Experience' stands apart in another way in the *Manuscript Notebook*. It is the first example of Blake writing down the centre of the page, marking a departure from the economical use he has made of each page so far by writing *Songs of Experience* in left and right columns.

The *Manuscript Notebook* drafts between N. 115 and N. 101 have revealed how complex and uncertain the process of creation and selection of *Songs of Experience* was for Blake over a period, possibly, of nearly two years, but from December 1792 into the spring and early summer of 1793 with growing intensity. On every page different textures, colours and shades of ink, different pen nibs and pencil are suggestive of the times that Blake returned to the *Manuscript Notebook* to enter new poems and then turned back through the pages to revise what he had written on earlier occasions. Many have been entered in fair copy, indicating work that has taken place before turning to the pages of the *Manuscript Notebook*. Within it, the evidence of various stages of composition makes plain how difficult many of the poems were to compose and reveals how those in fair copy may belie the work that went into their making before they were transcribed for safe keeping into the *Manuscript Notebook*.

On N. 101, the attempt at arranging several poems 'On 1 Plate' shows that trial and error did not stop with writing. Blake drew a vertical line indicating some form of selection through many poems, perhaps to mark those that had been copied on to copper plate for relief etching. Again, the fact that poems marked in this way were not always relief etched, and others that remained unmarked

were, is indicative of further uncertainty or difficulty. What the *Manuscript Notebook* makes clear is that *Songs of Experience* were not composed autographically, directly on to copper plate ready for etching, as it has been argued it later became characteristic of Blake's practice in creating his illuminated books.[40] The absence of other manuscripts should not persuade us that *Songs of Experience* is the exception that proves the rule, quite the reverse.

N. 100

Facing N. 101, is one of the last drawings in the *Manuscript Notebook* in illustration of Milton, in this instance, as David V. Erdman has suggested, probably in illustration of the line 'The opening eyelids of the morn' from *Lycidas* [PLATE 19].[41] The last appears on N. 96, in illustration of *Paradise Lost* VII. 225 ff., and will be used for the design of the frontispiece to *Europe a Prophecy*, the image known as the Ancient of Days. On N. 100, the reclining figure with its hands overshadowing its eyes looks out in the direction of the viewer. The drawing is still distinctive and very fine. We need to imagine it, like the drawings on a number of the preceding folio rectos, largely safeguarded by Blake at the time that he was writing *Songs of Experience* on the facing versos. In this case, the drawing on N. 100 was still preserved when Blake was writing 'THE FLY,' the memorandum about the poems to be etched 'On 1 Plate' and the 'Motto to the Songs of Innocence & of Experience' on N. 101. The poems on N. 100 were written later, when the drawing was no longer regarded.

At the top of N. 100, using fine dark charcoal black ink, Blake wrote the following epigram, possibly in response to reading Wordsworth's 'A Perfect Woman, nobly planned' marked in the copy of *Poems* 1815 that he borrowed from Henry Crabb Robinson in the last year of his life[42]:

Her whole Life is an Epigram smack smooth &
 [nea *del.*] nobly pend
Platted quite neat to catch applause with a sliding
 noose [on *del.*] at the end

Here also, by writing down the middle of the page, Blake has disregarded the way he carefully and consistently entered poems when writing *Songs of Experience*, in left and right columns. Similarly in the poem that follows, that has been written in a large sprawling hand using black ink with no attempt being made to protect the drawing:

> O I cannot find
> The undaunted courage of a Virgin Mind
> For [soon *del.*] Early I in love was crost
> Before my flower of love was lost
>
> An old maid early eer I knew
> Ought but the love that on me grew
> And now Im coverd oer & oer
> And wish that I had been a Whore

Later, in pencil, Blake reversed the stanzas, numbering the first 2 and the second 1. The lines written at the bottom of the page, with the *Manuscript Notebook* the right way round, are also later, being part of the drafts of the unpublished *The Everlasting Gospel* of *c*.1818, also found on N. 98.

N. 99 & N. 98

This is the last page opening where poems have been entered into the *Manuscript Notebook* with it turned around [PLATES 20 & 21]. It has been assumed that the poems on these pages, beginning on N. 115 and ending on N. 98, were written consecutively with the last entered on these two pages. For this reason, and because of the historical reference identified in the poem beginning 'Fayette beside King Lewis stood,' this page opening has been used to establish when the last of the *Songs of Experience* were written in the *Manuscript Notebook*.

In 1957, F. W. Bateson noted that 'the only poem in the Experience group that can be dated at all precisely is the last of the series.' He continued:

This describes in ballad form Lafayette's final betrayal, as it seemed to Blake, of the cause of the Revolution and the ironical reward of immediate imprisonment meted out to him by the Austrians when he crossed their border in August 1792. The news of Lafayette's fate did not reach

England until the end of October, and Blake's poem would still have been topical in November or December 1792, though hardly later. This is a solid *terminus ad quem*. [43]

In his edition of the *Manuscript Notebook*, David V. Erdman agreed:

A terminal date for this inscribing—not of course for revision—is supplied by Poem 58, the climax of which is the Austrian jailing of La Fayette, an item of news that reached London on 25 October 1792 and must have elicited this kind of chiding, prophetic response fairly promptly. [44]

This dating is based upon the assumption that Blake worked continuously beginning on N. 115 and when he reached the page opening N. 99 and N. 98 it was late October or November 1792. Within days or a few weeks of hearing the news of La Fayette's jailing by the Austrians, but not later, Blake was moved to write this last poem in the sequence.

This assessment fails to recognise that Blake may have allocated the end of the *Manuscript Notebook* for the creation of *Songs of Experience* ending where the emblem drawings for *The Gates of Paradise* stopped, on N. 101. It is on N. 101 that the last poem of *Songs of Experience* is written, facing the last emblem drawing. Blake did not write on the next page, N. 100, until much later, as we have seen. What has blurred the distinction between the sections separated by N. 100 is the fact that on the next two pages Blake has also written in the *Manuscript Notebook* with it turned around. This indicates that the poems were written at the same time that he was writing *Songs of Experience*, but no more than that.

Before writing on N. 99, Blake rubbed out a pencil drawing in the centre of the page. All that remains is the number 5. Turning the *Manuscript Notebook* right way round, the number 5 is clearly visible below the bottom right corner of the drawing, where a pencil line has been drawn through it to separate the second and third sets of lines of 'Several Questions Answerd'. This identifies it as one of the emblem drawings originally intended for *The Gates of Paradise*. Like the other numbered drawings in the series, this drawing went through

Blake's selection process leading to the final choice of images for engraving. It would not have been erased and overwritten until it was no longer needed, possibly not until the images had been engraved and published in May 1793. The composition in pencil in the left column, 'Several Questions Answered,' overwrites the erased image. The poem written in the right column, 'Let the Brothels of Paris be opened', also overwrites part of the erased image. The verses at the bottom of the page, left and right, beginning 'Fayette beside King Lewis stood,' avoid the area occupied by the drawing. They may have been written earlier, but the same pen and ink has been used to write 'Let the Brothels of Paris be opened' and, as David V. Erdman has suggested, the two poems appear to have been developed together.[45]

The verses of 'Fayette beside King Lewis stood' continue on N. 98 and, as on this page, they overwrite part of another drawing intended for *The Gates of Paradise*. The drawing on N. 98 is of a seated figure directly facing the viewer, with its elbows resting on its knees, its knees and lower legs in the foreground and its hands cupped over its eyes as it peers out. This drawing is repeated on a smaller scale on N. 94 and there more clearly defined and worked up in water colour wash. Next to the wash drawing, it is drawn again, slightly altered, in preparation for being engraved as plate 4 of *The Gates of Paradise*, published 17 May 1793. Like the drawing erased on N. 99, when Blake wrote on this page the drawing was no longer needed.

Several Questions Answered

On N. 99, after the drawing was erased, the following sets of lines were salvaged from the discarded drafts of *Songs of Experience*, and written in pencil:

Several Questions Answerd

What is it men in women do require
The lineaments of Gratified Desire
What is it women do in men require
The lineaments of Gratified Desire

The look of love alarms
Because tis filld with fire
But the look of soft deceit
Shall Win the lovers hire

Soft deceit & idleness
These are Beautys sweetest dress

He who binds to himself a joy
Doth the winged life destroy
But he who kisses the joy as it flies
Lives in Eternitys sun rise

An ancient Proverb

Remove away that blackning church
Remove away that marriage hearse
Remove away that ——— of blood
Youll quite remove the ancient curse

Blake underscored each set of lines before turning back in the *Manuscript Notebook* to copy the next set. When they had all been copied, he numbered each set in the left margin, beginning with 'What is it in men in women do require,' first as number 3, which he then overwrote with the number 4, and then the verses below, 2, 3, 1 and 5 respectively. 'What is it men in women do require' was copied unchanged from N. 103 together with 'The look of love alarms' and 'Soft deceit & Idleness.' 'He who binds to himself a joy' was taken from N. 105 and 'An ancient Proverb' from N. 107. In the case of 'An ancient Proverb,' on this occasion, in line three, the identity of the person to be removed has been left blank; a sign, perhaps, of Blake's growing fear of indictment. What is clear, is that these verses were transferred to N. 99 for another purpose after the final selection of *Songs of Experience*, conceivably, like the stanza from 'THE FLY', to be used in the *Marriage of Heaven and Hell*.

Let the Brothels of Paris be opened

On another occasion, this time using dark charcoal ink, Blake entered drafts of first one poem and then another on N. 99, apparently beginning in the top right column opposite 'Several Questions Answerd,' as follows:

Let the Brothels of Paris be opened
With many an alluring dance
To awake the [Pestilence *del.*] Physicians thro
 the city
Said the beautiful Queen of France

The King awoke on his couch of gold
As soon as he heard these tidings told
Arise & come both fife & drum
And the [Famine *del.*] shall eat both crust &
 crumb

Then old Nobodaddy aloft
Farted & belchd & coughd
And said I love hanging & drawing & quartering
[So *del.*] Every bit as well as war & slaughtering

Damn praying & singing
Unless they will bring in
The blood of ten thousand by fighting
 or swinging

Blake scored through the last three lines and con-
tinued writing, as follows:

Then he swore a great & solemn Oath
To kill the people I am loth
But if they rebel, they must go to hell
They shall have a Priest & a passing bell

The Queen of France just touchd this Globe
And the Pestilence darted from her robe
But the bloodthirsty people across the water
Will not submit to the gibbet & halter

Crossing out the last two lines, he continued:

But our good Queen quite grows to the ground
There is just such a tree at Java found

Crossing out the last line, alluding to the deadly
upas tree recently described in Erasmus Darwin's
Lives of the Plants (1789), Blake finished the stanza
with a new line, transforming the simile into a com-
plex and uncompromising political metaphor for
the monarchy:

And a great many suckers grow all around

Blake drew a line beneath the last line. Looking
over what he had written in the right column, he
carefully selected and renumbered the lines, but
instead decided to change the order of the
stanzas. Reorganised, the poem was left to read as
follows:

Let the Brothels of Paris be opened
With many an alluring dance
To awake the Physicians thro the city
Said the beautiful Queen of France

Then old Nobodaddy aloft
Farted & belchd & coughd
And said I love hanging & drawing & quartering
Every bit as well as war & slaughtering

Then he swore a great & solemn Oath
To kill the people I am loth
But If they rebel they must go to hell
They shall have a Priest & a passing bell

The King awoke on his couch of gold
As soon as he heard these tidings told
Arise & come both fife & drum
And the shall eat both crust & crumb

The Queen of France just touchd this Globe
And the Pestilence darted from her robe
But our good Queen quite grows to the ground
And a great many suckers grow all around

The opening of the last stanza alludes to Edmund
Burke's celebrated description of the Queen of France
in *Reflections on the Revolution in France* (1790):

It is now sixteen or seventeen years since I saw the queen
of France, then the dauphiness, at Versailles, and surely
never lighted on this orb, which she hardly seemed to
touch, a more delightful vision.[46]

Blake has transformed Burke's vision of Marie
Antoinette into a monstrous epitome of the French
monarchy.

Fayette beside King Lewis stood

A second poem, apparently developed from the
first, was started at the bottom of the left column,

below the pencil line underscoring 'An ancient Proverb,' as follows:

> Fayette beside King Lewis stood
> He saw him sign his hand
> And soon he saw the famine rage
> About the fruitful land
>
> Fayette beheld the Queen to smile
> And wink her lovely eye
> And soon he saw the pestilence
> From street to street to fly
>
> Fayette beheld the King & Queen
> In tears & iron bound
> But mute Fayette wept tear for tear
> And guarded them around

Blake drew an arching line from right to left starting beneath the last line of the stanza beginning 'The Queen of France just touchd the Globe' and ending beneath the last of the verses in pencil of 'Several Questions Answerd.'

Having marked off this poem, in the space created at the bottom right he wrote another stanza, as follows:

> Fayette Fayette thourt bought & sold
> For well I see thy tears
> Of Pity are exchangd for those
> Of selfish slavish fears

He then crossed through these lines, and deleted the first two stanzas at the bottom left, leaving only one stanza at the bottom of the page. With this stanza in mind, he moved across to the top left of the facing page and started to write again, as follows:

> Fayette beside his banner stood
> His captains false around
> Thourt bought & sold

Crossing through these three lines, he started again:

> Who will exchange his own fire side
> For the steps of anothers door

> Who will exchange his wheaten loaf
> For the links of a dungeon floor

He started a third stanza:

> Who will exchange his own hearts blood
> For the drops of a harlots eye

But these lines he also crossed out, and tried again:

> Will the mother exchange her new born babe
> For the dog at the wintry door
> Yet thou dost exchange thy pitying tears
> For the links of a dungeon floor

> Fayette Fayette thourt bought & sold
> And sold is thy happy morrow
> Thou gavest the tears of Pity away
> In exchange for the tears of sorrow

Blake then drew a line beneath the last stanza.

Later, using what appears to be a sharper nib and black ink, Blake numbered the surviving stanza 1 at the bottom of N. 99 and the second and third stanzas on N. 98, 3 and 2, having first assigned the fourth stanza number 2 but crossing it out. Unhappy with this arrangement, and with the stanzas themselves, Blake crossed through the number 1 before the stanza on N. 99, on N. 98 drew a line around two of the stanzas and crossed them out, and crossed through the number 3 of the stanza at the top left.

Moving down to the space at the bottom left on N. 98, he wrote two of the stanzas again, then a third at the top right, made two changes and renumbered these stanzas 2, 1 and 3. With the first readings in brackets, the poem now read as follows:

> Who will exchange his own fire side
> For the [steps del.] stone of anothers door
> Who will exchange his wheaten loaf
> For the links of a dungeon floor

> Fayette beheld the King & Queen
> In [tears del.] curses & iron bound
> But mute Fayette wept tear for tear
> And guarded them around

O who would smile on the wintry seas
[Or *del*.] & Pity the stormy roar
Or who will exchange his new born child
For the dog at the wintry door

Nothing further was done. As suggested, the poem may have been written when Blake heard the news of La Fayette's imprisonment. It could also have been written later.

At the beginning of August 1792, La Fayette was in charge of the French forces in the north fighting against the combined armies of Germany and Prussia led by the Duke of Brunswick. In Paris, he was accused of organising a force to return and secure the safety of the King and the royal family, which he denied. On 13 August, it was reported that the National Assembly had acquitted La Fayette of this accusation by a majority of 182 on the morning of the 10th. This decision, it was claimed by the defeated Jacobins, led the people of Paris in protest to the Tuilleries, that in turn precipitated the storming of the palace and eventual slaughter of the King's Swiss Guard. When the news reached him, La Fayette publicly condemned the massacre. On 18 August, it was reported that the Jacobin Club demanded that La Fayette be impeached. In the National Assembly, to applause, Robespierre called for those who were guilty of causing the massacres to be punished, naming La Fayette. The next day, the National Guard was directed to apprehend La Fayette. When reports reached London on 28 August of his escape and capture by the Austrians, the reporter for *The Star* wrote:

It is impossible to describe to you the virulence of the invectives thrown out against him, since the certainty of his having escaped from the plans for his destruction came to be known. All that we have been able to learn of the event is, that he and the officers who accompanied him intended to retire to Holland, by crossing the country of Liege. With this view they endeavoured to pass, unobserved, behind the Austrian Army, but at ten o'colock at night of the 19th they fell in with a piquet guard of seven men, [. . .] The soldiers presented their pieces, and M. La Fayette and his officers making no resistance, were all taken prisoners.

In the British press, La Fayette is presented as the victim of a conspiracy, latterly a conspiracy led by Robespierre. His loyalty to the ideals of the revolution remain unshaken and his denunciation of the anarchy of the Paris mob uncompromising. He is portrayed as the first notable victim of the new order under Robespierre.

In Book the First of *The French Revolution*, printed but unpublished by Joseph Johnson in 1791, Blake describes La Fayette in heroic terms, 'inspir'd by liberty [. . .] like a flame of fire,' at the dawn of the revolution taking charge of the army and securing peace for the people of Paris.[47] In the midst of the horrific descriptions of the Paris massacres of August 1792, the reports of La Fayette's persecution and escape uphold this image. As the ideals of 1789 became the arbitrary terror of 1793, the significance for Blake of the image of La Fayette in chains would not have diminished.

To Tirzah & A DIVINE IMAGE

Until recently, 'A DIVINE IMAGE' was known only from a few examples in sets of posthumous impressions of the *Songs,* with one exception, possibly a proof, in the collection of the late Sir Geoffrey Keynes. As it was not known to be present in any copy issued by Blake, it was considered rejected, with the plate preserved as a result of being etched on the back of one of the copper plates of *Songs of Innocence* like other plates of *Songs of Experience*. It was argued that 'A DIVINE IMAGE' was a first effort at writing and relief etching a direct contrary or perversion of *Songs of Innocence*. Blake then worked out his ideas for the poem in the manuscript drafts of 'I heard an Angel singing' N. 109 and 'The human Image' N. 107, producing a more subtle and penetrating analysis of man's fallen nature in 'The Human Abstract.'[48] Later, evidence from the style of lettering on the plate was said to confirm a date of 1790 or 1791.[49]

However, in May 1980 a copy of the *Songs* that had not been seen since 1830 appeared at auction, Copy BB, containing fifty-five plates instead of the known maximum of fifty-four.[50] The additional plate was 'A DIVINE IMAGE' [FIG. 22]. Copy BB is printed in black on fifty-five leaves of undated wove paper. Each plate has been discreetly finished in

charcoal wash, occasionally, with touches of pale grey. Blake had numbered the plates in pale grey ink with 'A DIVINE IMAGE' number 35, placed before 'NURSES Song' and followed by 'HOLY THURSDAY' of *Songs of Experience*. Copy BB is typical of Blake's later style of illuminated book production: each plate is printed on a separate leaf, with the plate edges inked and printed to frame the text and design. Uncharacteristic, is the dense charcoal wash that has been used to complete the printed plate edges and other relief areas, helping to frame, sharpen and give depth to each image. There are no framing lines, often found in late copies. The lighter grey wash has been used to introduce subtle shading and relief, contributing to the dark but compelling aura of this copy and anticipating the printing and finishing of copies A, C and D of *Jerusalem*, also printed in black, of c.1818–1820.

Traces of blue-grey paper wrapper are present on the inner margin of the general title-page and on the back of plate 55, 'INFANT SORROW.' As we have seen, it was Blake's practice to stitch the leaves of his illuminated books into paper wrappers for sale to his customers. These traces suggest that is how this copy of the *Songs* was 'Bought of Blake May 1816' by Robert Balmanno, who noted his purchase in pencil on the title-page of *Songs of Innocence* [PLATE 72]. There are also clear off-sets of each plate on the verso of the preceding leaf, suggesting the possibility that the leaves of this copy, numbered by Blake in an order not found in any other copy, were assembled not long after they had been printed, possibly, especially for Balmanno. Robert Balmanno also owned Copy U of *Songs of Innocence*. Copy U, as we have seen, is a trial copy, also printed in black on one side of each leaf [PLATES 34 & 36]. Placed side by side, these two copies presented a unique opportunity to compare and appreciate the skill involved in Blake's relief printing. But what made Copy BB exceptional is the inclusion of 'A DIVINE IMAGE.'

No manuscript drafts of 'A DIVINE IMAGE' survive. The text has been relief etched using roman lettering with the letter 'g' showing a serif leaning conventionally to the right. For all the plates of *Songs of Innocence*, Blake used roman lettering,

with the exception of 'The Voice of the Ancient Bard', with the serif on the letter 'g' facing conventionally to the right. In contrast, the plates of *Songs of Experience* have been written in an italic script, with the exception of 'The Tyger', 'AH! SUNFLOWER', 'LONDON' and 'A POISON TREE' that have been written in roman, all with the serif on the letter 'g' leaning unconventionally to the left; with one exception, the late addition of 'To Tirzah,' where the letter 'g' is found with the serif leaning to the right. David V. Erdman first noticed the significance of this idiosyncratic letter 'g' formation. He found that Blake used a conventional letter 'g' in all of his writings and engravings up to 1790–1791. During 1790–1791, Blake started to write the letter 'g' with the serif facing to the left, then consistently wrote a left-facing serif until about 1803, when he reverted to using a conventional right-facing serif. As 'A DIVINE IMAGE' was etched with right-facing serifs, this indicated to Erdman that the plate was 'transitional,' that it must have been etched in 1790–1791 and therefore was closer to the production of *Songs of Innocence* in 1789 than to that of *Songs of Experience* in 1793–1794. In the case of 'To Tirzah,' also not present in early copies of *Songs of Experience*, Erdman, again on the basis of lettering style, considered the plate to have been produced after 1803.[51] This theory has now been brought into question, particularly with regard to the dating of the plates of *The Marriage of Heaven and Hell*, where both forms of the letter g are present.[52]

'To Tirzah' is the last poem thought to be written and included in the *Songs* by Blake. The name, taken from Canticles vi.4, is first used in the manuscript revisions of *The Four Zoas* and appears in both *Milton* and *Jerusalem*.[53] It is not found in any of the first copies of *Songs of Experience* or *Songs of Innocence and of Experience* produced respectively in 1793 and 1794, nor was it included in *Songs* Copies A and R that were printed together in 1795 on large paper. As demonstrated by Joseph Viscomi, both copies were printed using the same pale grey and olive inks. *Songs* Copy A was sold to George Romney without 'To Tirzah' and in *Songs* Copy R, 'To Tirzah,' together with two other plates printed in black, one on paper with an 1808

watermark, was inserted sometime before being sold in August 1819 to John Linnell.[54] It first appears in Copies I, J, K, L, M, N, O and S of the *Songs*. It is also present in *Songs* Copy BB.

All of these copies, like Copy BB, have been printed on one side of unmarked wove paper, the plate borders have been left unwiped or deliberately inked and printed and Blake has numbered each set of plates, though not in the same order. If, as Joseph Viscomi has argued, these copies were printed during the same printing session, in 'ca.1795,' it seems odd that 'To Tirzah' was included in all of these copies and 'A Divine Image' in only one.[55] If, however, Copy BB was printed later, perhaps for sale to Robert Balmanno, this may explain why 'A DIVINE IMAGE' is only found in his copy. If this is what happened, 'A DIVINE IMAGE' may have been the last song of experience to be reproduced.

V. Colour-Printing *Songs of Experience*

I N 1793, Blake developed further his method of Illuminated Printing. Instead of printing each impression in monochrome and colouring it by hand with water colour, after printing the monochrome impression the copper plate was lifted from the bed of the press, cleaned and opaque colour pigments applied to the areas of design with small stubble brushes. The plate was then returned to the press and the impression printed a second time. The plates of *Songs of Innocence* had been hand coloured in transparent water colour wash. In marked contrast, the first copies of *Songs of Experience* were colour-printed using opaque pigments that had been tempered to create mottled and reticulated surfaces that appear like wet plaster. 'The whole of these plates are coloured in imitation of fresco,' was how J. T. Smith described the impressions of one of these first colour-printed copies of *Songs of Experience*, Copy H.[1] It is a method of colour-printing that has rarely been explored and that remains unexplained. When considered at all it has been summarily dismissed. This failure to appreciate Blake's achievement, and the time and skill that it required to accomplish, has not only led to a misapprehension regarding his intentions as a graphic artist, it has also left undefined the audience for whom he produced these works. *Songs of Experience* was the first of his works to be published using this revolutionary technique.

In the eighteenth century colour-printing was accomplished by one of two methods. Either, by printing from a series of intaglio copper plates with each plate inked in a different colour. Or, by applying different colours of ink to different areas of the same plate and printing only once, a method known as *à la poupée* from the term applied to the small doll-like daubers used to apply the different colours of ink to the plate. Blake was thoroughly familiar with colour-printing *à la poupée*. For his commercial work during the 1780s, including the

work he produced for his own publishing venture in partnership with James Parker, he produced fashionable furniture prints, as they were known, intended for framing. Using stipple finished with line engraving, these prints after paintings by Watteau, Stothard, Cosway and Morland were printed either in monochrome, usually in sanguine or sepia, or, for wealthy buyers prepared to pay substantially more, in colours, *à la poupée*.[2] In 1788, Blake produced two prints after paintings by George Morland, *The Idle Laundress* and the *Industrious Cottager*. Reproduced is a copy of the first state of *The Idle Laundress* in stipple engraving (the roulette can be seen running down below the image) finished in line that has been colour-printed in red brown, dark brown and blue with flesh tones in red [PLATE 43]. Tonality has been achieved by varying depth of engraving and thus density of inking and by using the ground or white of the paper. Shades of colour are the result of how heavily the area of the plate has been engraved, inked and then wiped. The pink skin tones, for example, are the result of very little red ink being left in the recesses made in the surface of the plate by the points of the roulette. Blake's skilled use of this technique was carried out in the same year that he was first developing his own method of Illuminated Printing.

The most celebrated exponent of colour-printing from a sequence of copper plates was Jacob Christoph Le Blon (1667–1741), who from 1715 established a successful print company in London before moving to Paris at the end of his life. Inspired by Newton's *Optics* (1704), Le Blon applied Newton's theory of colour separation to an examination of the ways in which painters mixed pigments to create their colours. In *Coloritto; Or the Harmony of Colouring in Painting: Reduced to Mechanical Practice* (n.d. *c*.1725), he published his discovery:

Painting can represent all *visible* Objects with three colours, *Yellow*, *Red*, and *Blue*; for all other Colours can be compos'd of these *Three* which I call *Primitive*; [. . .] a *Mixture* of those *Three* Original Colours makes a *Black*, and all *other* Colours whatsoever; as I have demonstrated by my Invention of *Printing* pictures *and* Figures *with their* natural *Colours*.[3]

Using the flat tints and tonal values made possible by mezzotint, Le Blon printed parts of the same image from a sequence of three plates inked respectively in blue, yellow and red. The results, particularly his studies of anatomy and those of his successors, were sensational.[4] Four plates are reproduced of Le Blon's portrait of Cardinal de Fleury [PLATES 44, 45, 46 & 47]. These are printed respectively in blue, yellow, in blue over-printed in yellow and in red as proofs that were sold at the time to enable the public to understand how Le Blon had achieved his result. To colour-print an impression from three separate copper plates the precision of the registration had to be absolute.

In the small village of Battersea, while courting Catherine and living there for a month before they could be married in the parish church, Blake might well have learned of another innovative printmaker who mastered the art of multiple plate colour-printing, John Baptist Jackson (1701–c.1777). In *An Essay on the Invention of Engraving and Printing in CHIARO OSCURO, as Practised By Albert Durer, Hugo Di Carpi., &c* [. . .] *By Mr. JACKSON, of Battersea* (1754), the author distinguishes his method from that of Le Blon:

It is not improbable, that Gentlemen acquainted with Mr. *Le Blond's* [sic.] Manner of Printing Engravings on Copper in Colours, may imagine it to be the same with this of Mr. *Jackson*, and that from the former he borrowed the Design; but whoever will take the least Pains to enquire into the Difference, will find it impossible, that cutting on Wood Blocks, and printing the Impressions in various Colours from them, can be done in the same Way that is done with Copper Plate in the Metzotinto or Fumo Manner. [. . .] On the contrary, this method discovered by Mr. *Jackson* is in no Degree subject to the like Inconveniency; almost an infinite Number of Impressions may be taken off so exactly alike, that the severest Eye can scarcely perceive the least Difference amongst them. Added to this, Mr. *Jackson* has invented ten positive Tints

in Chiaro Oscuro; whereas Hugo di Carpi knew but four; all which Tints can be taken off by four Impressions only.

Blake's heart must have warmed to Jackson, if he read on:

This Attempt when he proposed it first at *Paris* was treated as romantic and visionary by Mess. *Caylus, Coypel, Mariette,* and *Le Seur*, especially when he proposed a Method by which Blocks of Wood might stand the Powers and Pressure of the Rolling Press, and which Metals would scarcely sustain.[5]

After 1789 Blake may have been introduced in person to another artist, also a poet, skilled in multiple plate colour-printing, Henry Tresham (1750/1–1814). Tresham was one of Henry Fuseli's circle at Rome.[6] At the time of Tresham's return to London, Fuseli, who had returned himself in 1787, was probably Blake's closest friend. Tresham had published a series of colour-printed plates, *Le Avventure di Saffo* (1784), produced by using two copper plates, the first printed the image followed by a second etched in aquatint that superimposed an effect of pale green wash.

Whether by using intaglio copper plates or relief wood blocks, multiple plate colour-printing demanded exact registration, normally using pins to bring the sheet of paper and each plate or block into register before it was printed. A set of Tresham's colour-prints in the Department of Prints and Drawings at the Hunterian Art Gallery, University of Glasgow, has survived with the margins left untrimmed. They reveal pin holes at the top left and bottom right corners of the plate mark, indicating where pins have been used to bring the sheet of paper into register with each of the two plates. In the same collection is a set of chiaroscuro prints by John Baptist Jackson, that also show pin holes used to bring each block into register, in this case at the centre top and bottom of each sheet. Following registration, the pins were withdrawn before the plate and paper were passed between the rollers. If registration is not exact, the image overlaps producing a doubling effect. Blake's method of colour-printing drew upon both *à la poupée* and multiple plate techniques to produce his most remarkable graphic

images. His method involved two stages of printing, but using only one plate. Blake's method also required precise registration. As we shall see, Blake created yet a further innovation by finding a way of dispensing with the traditional method of registration. In turn, this was followed by the development of a planographic or primarily surface printing method he used in the last illuminated books and in the production of the great monotypes or large colour-prints.

During the spring and summer of 1793, Blake completed the drafts of *Songs of Experience* in the *Manuscript Notebook*. For the first printing, he selected seventeen poems to be relief etched and printed on fifteen plates, together with a Frontispiece and title-page. This amounted to the same number of leaves as the first printings of *Songs of Innocence*. For these first copies, the plates of *Songs of Experience* were made up as follows:

Frontispiece
Title-page
Introduction
EARTH's Answer
The CLOD & the PEBBLE
A POISON TREE
THE FLY
HOLY THURSDAY
THE Chimney Sweeper
LONDON
The Tyger
A Little BOY Lost
The Human Abstract
The Angel
My Pretty ROSE TREE, AH! SUN-FLOWER,
 THE LILLY
NURSES Song
A Little GIRL Lost

This was the order of the plates in *Songs of Experience* Copy H, described in 1828 by J. T. Smith, that has been preserved stitched in buff paper wrappers as it left Blake's hands.[7]

Blake used the backs of the plates of *Songs of Innocence* to etch the plates of *Songs of Experience*. The varying dimensions of plates of *Songs of Innocence* match those of *Songs of Experience*, with the exception of the title-page and 'Introduction.'[8] Both are slightly larger and measure exactly 124 × 72 mm. Blake had cut a new plate and etched the Introduction on the front and the title-page on the back where part of the plate maker's mark '[SHOE] LANE LONDON' is visible in the upper right corner in posthumous impressions. As they are relief plates, the backs could be safely worked on and etched. Slight scratches do not affect relief printing surfaces. Unlike intaglio plates, when inked the printing surface of relief plates is not wiped. Using the backs of the plates was convenient and aesthetically appropriate, but it is unlikely that it was done to save money. It has been calculated that the cost of materials to produce twenty-one copies of *Songs of Innocence* may have amounted to thirty-one shillings, including the cost of paper, copper plate, pigments and oils, in relation to a selling price as advertised in the Prospectus of 10 October 1793 of 5s.[9] But this takes no account of Blake's considerable time and labour involved in writing, relief etching, printing and then finishing in water colour each copy for sale. It is clear that in relation to what was involved, his purpose in producing the *Songs* was not financial gain.

Although it was fitting that the new volume should in size match its companion, the plates of *Songs of Experience* were designed to express their contrary, inverse relationship to *Songs of Innocence*. For Martin Butlin, 'the rectilinear rather than curvilinear composition tended both to detach the illustrations from the text and to endow them with a gravity that adds to the pessimism of the book as a whole.'[10] Anthony Blunt compared the two title-pages [Plates 27 & 29]:

Two dead bodies, an aged man and a woman, laid out on a bier, form the central motive, while two younger mourning figures move round them. The gay, curved forms of *Innocence* are replaced by severe horizontals in the dead figures, which are laid out like the effigies on a Gothic tomb, and the lower half of the page is completed by the simple rectilinear pattern of the architectural background. Even the script chosen for the words of the title reflects the change of tone: unadorned Roman capitals, as opposed to the fantastic vegetable-curls of the earlier letters.[11]

For Robert Rosenblum the implications of Blake's choice of design were clear, when he compared the title-page of *Songs of Experience* to the stark parallels and perpendiculars of George Romney's drawing of the *Death of Cordelia*.[12] On 31 July 1790, together with the Revd. Thomas Carwardine and William Hayley, Romney travelled to Paris and there visited the studio of Jacques-Louis David. Romney was one of Blake's closest friends at the time, supported his work and doubtless shared with him his impressions of David's studio. Hayley later recorded how David's 'death of Socrates, his Paris and Helen, and his Horatii, the picture on which he was then engaged, imprest us with considerable respect for his talents.'[13] As Rosenblum describes, David's stark Neo-Classical forms now marked the 'irreparable cleavage between an old and a new world.'[14] The blighted trees and parched landscapes, inhospitable streets swept with sleet and austere scenes of supplication and mourning depicted on the plates of *Song of Experience*, reflecting the poems themselves, leave no doubt that similar conditions of hardship, suffering and intolerance cry out for an equally fundamental change. Nor would the republican style adopted for the title-page have passed unnoticed in the late summer and early autumn of 1793.[15]

The backs of the plates of *Songs of Innocence* now provided the surfaces to be etched. First, the plates had to be polished and degreased in preparation for copying text and design in the acid resistant varnish. In the same manner as *Songs of Innocence*, a quill pen was used to copy the text from the *Manuscript Notebook* onto the copper plate in reverse or mirror writing. This provided the last opportunity to make changes. As we have seen, a number of drawings in the *Manuscript Notebook* were also copied freehand onto the plate, left to right, in the same direction as the original. A protective wall of wax was then built up around the edges of the plate and the relief etched backs protected. To ensure a shallow first bite, a weak acid was probably first poured into the well that had been created by the wax walls. Careful to avoid underbiting, after an initial bite the acid was removed and the plate cleaned. Acid-resistant varnish or stopping out liquid was then applied covering entire words and areas of design to form protective plateaus, as seen in the fragment of the cancelled plate of *America a Prophecy* also etched in relief at this time. After a second and deeper bite, the protective wax wall was removed and the plate was cleaned and made ready for printing.

For the first printing of *Songs of Experience*, each impression was first printed monochrome in one of more than seven colours of ink, including brick red, charcoal black, charcoal green, blue-green, blue and golden brown ochre. This number of inks indicates more than one printing session. Some of these colours were also being used to print other works in illuminated printing around this time, including *The Marriage of Heaven and Hell*, *Visions of the Daughters of Albion* and *America a Prophecy*. Blake selected four plates for his first experiments, the title-page, 'Introduction', 'EARTH'S Answer' and 'LONDON.' Colour-printed impressions of these four plates are now in the collection of the National Gallery of Canada. They are apparently the earliest surviving examples of Blake's first attempt to produce one of his works by printing in two stages. In all four copies there is a pinhole in the upper left corner just outside of the plate image [PLATES 49 & 66]. This reveals that Blake used the traditional method of registration for printing a single sheet from more than one plate, but that he adapted the technique so that he could print twice from the same plate.

A sheet of heavy paper or pasteboard the size of those to be printed was first laid on the bed of the press. Before inking, the plate was placed in position on it and firmly along the outside plate edges a line was drawn around it [FIG. 33]. The plate was then taken from the bed of the press and inked in the same manner as the plates for *Songs of Innocence*. When the plate edges and shallows had been carefully wiped, it was taken back to the bed of the press, probably by being carried on a sheet of tissue paper for ease of handling. The inked plate was registered to the outline on the sheet of paper or pasteboard on the bed of the press. Using paper guards, or with Catherine's assistance, a sheet of paper that had been torn to size, soaked, blotted

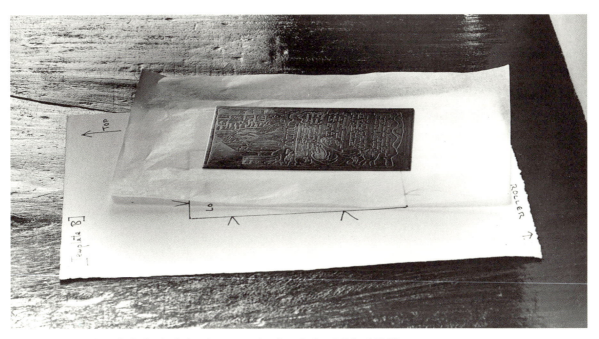

Fig. 33 Registration of relief etched plate in preparation for printing. Michael Phillips.

and prepared for printing, was placed in position over the plate. The blankets were laid over the paper and plate. Turning the star wheel slowly and evenly, plate and paper passed between the rollers.

After printing the impression in monochrome in one of the coloured inks, the blankets were turned back and laid over the roller. Using a long pin or etching needle, a small hole was pierced through the upper left corner of the paper and into the sheet of paper or pasteboard underneath. Only one pin-hole has been made, in the same location, in each of the four impressions in the collection of the National Gallery of Canada. Geoffrey Morrow, Senior Conservator of Prints and Drawings at the National Gallery of Canada, explained that Blake has used a 'swivel' technique, 'where the single registration point in the top left corner allowed him to somehow swivel the paper sideways for the addition of colour to the plate and then back into registration for a second printing.'[16] The pin remained in place, making clear that the application of pigment in preparation for the second, colour, printing was carried out while the monochrome ink and paper were still damp and on the bed of the press.

An understanding of the binder that Blake used to mix and blend his pigments is essential if we are to appreciate the extraordinary effects that he achieved when colour-printing his illuminated books and separate plates. J. T. Smith described Blake's preparations for colouring his temperas in the manner of fresco, the same term he used to describe the colour-printed plates of Ozias Humphry's copy of *Songs of Experience*, Copy H, as they have much in common:

Blake's modes of preparing his ground, and laying them over his panels for painting, mixing his colours, and manner of working, were those which he considered to have been practised by the earliest fresco-painters, whose productions still remain, in numerous instances, vivid and permanently fresh. His ground was a mixture of whiting and carpenter's glue, which he passed over several times in thin coatings: his colours he ground himself, and also united them with the same sort of glue, but in a much weaker state. [. . .] Blake preferred mixing his colours with carpenter's glue, to gum, on account of the latter cracking in the sun, and becoming humid in moist weather. The glue mixture stands the sun, and change of atmosphere has no effect upon it.[17]

Also referring to the paintings, John Linnell amplified Smith's account of the binder that Blake used in a 'Supplementary' chapter to Gilchrist's *Life*:

He evidently founded his claim to the name *fresco* on the material he used, which was water-colour on a plaster ground (literally glue and whiting); but always called it either fresco, gesso, or plaster. [...] They come nearer to *tempera* in process than to anything else, inasmuch as white was laid on and mixed with the colours which were tempered with common carpenter's glue.[18]

Fresco was the term Blake identified with the art of the ancients, Apelles and Protogenes, and, supremely, with Raphael and Michelangelo. 'The Art has been Lost: I have recovered it,' he wrote in the advertisement to his exhibition of pictures in 1809. As he announced, his 'invention' was of a 'portable fresco,' using water colours.[19] Cennino Cennini's handbook was the classic manual recording the techniques and recipes used by the artists that Blake revered.

Writing to Anne Gilchrist, 10 December 1862, Linnell noted that 'the first copy of Cennino Cennini seen in England was the copy I obtained from Italy & gave to Blake who soon made it out & was gratified to find that he had been using the same materials & methods in painting as Cennini describes—particularly the Carpenters glue.'[20] *Di Cennino Cennini Trattato Della Pittura* was first published in Rome in 1821, but, as Joan K. Stemmler established, Blake had known about the *Trattato* since the early 1790s.[21] While travelling in Italy, Blake's close friend George Cumberland had read the fifteenth-century manuscript 'at Florence, in the private collection of the *Grand Duke*, who, for some days, very condescendingly indulged me with the loan of it.'[22] In 1790, Cumberland returned to London. During the next few years, Cumberland and Blake worked together intermittently on several of Cumberland's books including his *Thoughts on Outline*.[23] Blake instructed his friend in printmaking, encouraging him 'to execute a great part of the plates myself' as Cumberland thanked Blake in his Appendix. Finally, in preparation for publication, the plates were copied by Blake, printed and published in the book in which they are dated 5 November 1794 and 1 January 1795. In *Thoughts on Outline*, Cumberland remarks on the value of Cennini's treatise, 'on account of the exact directions which it gives for the painting in fresco of those times.'[24] Through Cumberland, Cennini may have supplied Blake with formulas he used for mixing his pigments. Discussion of the manuscript would certainly have prompted him to find ways of mixing his colours that would create the appearance of painting on plaster that he developed for colour-printing at this time.

Blake's use of carpenter's glue as a binding agent has been investigated by Anne Maheux.[25] Maheux suggests that Blake may have used 'dilute animal size instead of gum because size colours, unlike gum water, cannot be redissolved easily nor can corrections be made once they have dried.' As Maheux makes clear, 'this permitted Blake to add subsequent layers of size colours, or pen and ink work without smearing the underlying washes.' Blake finished many of his colour-printed plates in just this way, by adding details in water colour and pen and ink after the colour-printed impression had dried. Maheux also considered the microscopic sample of one of Blake's tempera paintings submitted for analysis by Robert N. Essick.[26] It was found that a vegetable exudate gum rather than a glue made from animal parts had been used as a binder. This gum, unlike gum arabic, is also insoluble in water after it has been mixed, applied and dried. Maheux concluded that whatever binding agent Blake used it had to have 'viscosity when warm, permitting easy handling with a brush, the ability to hold pigments in a suspension, and a high level of insolubility.' In other words, Blake may not have known what the chemical make-up of his binder was as long as it behaved in a manner that met his requirements. He may have described what he wanted to his colourman and assumed that he had been given a type of animal glue similar to carpenter's glue.

Joyce Townsend, analysing Blake's early tempera paintings produced in the late 1790s in the collection of the Tate Gallery, London, also found the presence of karaya and tragacanth gums together with unrefined sugar in the glue that Blake used. As she points out: 'Karaya gum was used by printers

and engravers, and though it seems unusual to find it used as a painting medium, it would have been a readily available material for Blake.' Sarah L. Vallance and her colleagues, using a gas chromatographic method of analysis, also found evidence of mixed gum media in Blake's temperas, including gums tragacanth, karaya and arabic. The investigations carried out by Essick, Maheux, Townsend and Vallence clearly show that Blake used a variety of binding media. These mixes of gums have behavioural properties that could easily be likened to or mistaken for 'carpenter's glue' as they require soaking and heating to be used and once they have dried they do not dissolve when water is applied.[27]

In her analysis at the National Gallery of Art, Washington, D. C., of the materials Blake used to colour-print separate plates in the Rosenwald Collection, including examples from the small and large books of designs (c.1794–96), Rebecca Donnan found that the 'whiting' referred to by Linnell was in fact lead white occasionally mixed with chalk. The addition of lead white and chalk would have been used to dilute expensive pigments. It would also provide bulk and density. Blake's binding medium was used to seal the pigment and make it insoluble in water once it had dried. When printed, the addition of lead white and chalk would have created the dense reticulated surfaces described by J. T. Smith as 'in imitation of fresco,' that characterise Blake's colour-printed plates including the first copies of *Songs of Experience*. But, as we shall see, the use of lead white could also cause problems.

After cleaning the slab of statuary marble that he used to mix his colours, described by Gilchrist, Blake prepared his palette of colours for colour-printing by mixing each pigment or mix of pigments with warm binder and a bulking agent such as chalk or lead white. As described, the impression was first printed in monochrome. The copper plate was then taken to the workbench and wiped clean of ink. Using small stubble brushes, the colours were applied to the plate *à la poupée*, to the areas of the design and interlinear decoration, both in the shallows and on the relief plateaus. Under magnification, minute hairs from these brushes can be

found lodged in the dried reticulated pigments of colour-printed impressions. The plate was then taken and registered to the outline of the plate on the sheet fixed to the bed of the press. The monochrome impression was turned on the axis of the pin back into position, the corners of the impression carefully aligned with those of the registration sheet and the impression let down onto the plate. The needle was withdrawn. The blankets were laid back over the plate and impression ready for printing.

The four impressions in the collection of the National Gallery of Canada, title-page, 'Introduction' 'EARTH'S Answer' and 'LONDON,' are the only examples that I have found that have been registered by using a pin. All of the remaining colour-printed impressions have no visible sign of registration. This includes two complete copies each with the same set of seventeen plates and nearly all the plates of two more copies also made up of the same seventeen plates, including the four plates in the National Gallery of Canada. If Blake later made the registration holes in the outer edges of the margin they could have been trimmed away. Registration holes can also be repaired. At the printmaking Atelier Lacourière et Frélaut in Paris, I was shown how a string passed back through the pin hole after registration, but before printing, pulls the edges of the hole back into place. Under the pressure of the rollers, the dampened and swollen paper is then closed leaving no trace.

Blake may have found a simpler method. Following the first printing in monochrome, Blake could have stopped turning the star wheel of the press just short of the margin of the impression passing out from between the rollers [FIG. 33]. This would have left both the margin of the impression and the registration sheet nipped between the rollers. The blankets would then have been turned back over the roller and the impression turned back from the plate. This would have left the plate free to be lifted away, cleaned, prepared with colour pigments, returned to the bed of the press and registered for the second printing. The impression could then have been let down onto the plate in precisely the same position, with neither the registration sheet nor the impression having moved.

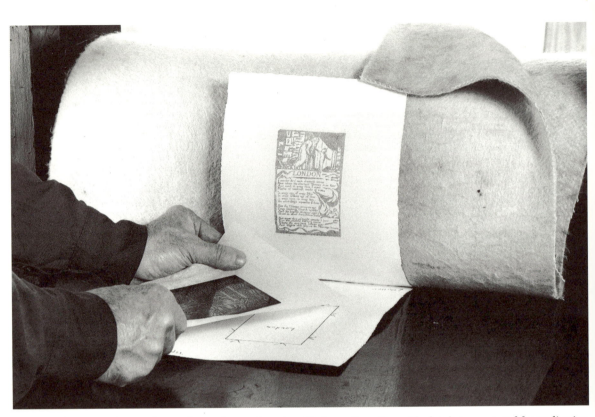

FIG. 34 Registration sheet and monochrome impression nipped between the rollers with plate being removed for application of colour pigments. Michael Phillips.

Ready for the second printing, the blankets would then have been laid back over the impression and plate.

The plate and impression could have been passed through a 'loose press', as Frederick Tatham described Blake printing the large colour-prints in a letter to William Michael Rossetti in 1862. However, in 1804–1805, when, following the discovery of 1804 watermarks, it is thought that Blake printed some of the large colour-prints, Tatham was only a year old.[28] It is possible that Blake did not pass the plate and impression through the rollers a second time. He may have achieved his effects by carefully applying pressure with the tips of his fingers in order to maintain maximum control over the glutinous pigments in the shallows and on the relief surfaces. This would also prevent the risk of any slight movement that can result when the paper and plate are passed back between the rollers. By carefully bonding the plate and impression, whether in a 'loose press' or by hand, and then gently pulling them apart, the glue or gum based pigments appear to pull away leaving the colour-printed surfaces raised and mottled. To finish, once the impression had dried, securing the colour-printed pigments, fine details have been highlighted using water colour and pen and ink. As with the first copies of *Songs of Innocence*, the plate borders have been wiped of ink before printing and the text has been printed in monochrome and left free of colour. But the pastel hues of *Songs of Innocence* have been forsaken. For these first copies of *Songs of Experience*, Blake's palette is rich, characteristically with autumnal, dark and brooding colours [PLATES 26–29 & 38–41].

The title-page of *Songs of Experience* in the collection of the National Gallery of Canada demonstrates Blake's two printing stages, the first of the

text and elements of the design in monochrome and the second in opaque colour pigments. Reproduced together, the title-page has been photographed in natural light and then under ultra violet light [PLATES 49 & 50]. By comparing the two images, and looking in particular at the top of the column on the lower right side, the date '1794' can be seen printed in monochrome under ultra violet light. But looking at the plate photographed in natural light, the date is not visible. This is a result of the plate first being printed monochrome with the date and then colour-printed, when the date was covered. Under magnification, in many examples it is possible to see in colour-printed impressions of *Songs of Experience*, and of *The Marriage of Heaven and Hell*, *Europe a Prophecy*, *The First Book of Urizen* and other works including separate colour-printed plates, colour-printed pigments lying on top of the first monochrome printing. To the naked eye, it is clearly visible in the plate of 'THE FLY' in *Songs*, Copy C, in the Lessing J. Rosenwald Collection in the Library of Congress. In the first line of text, printed in yellow ochre, the word 'Fly' has been overprinted when the design above the line was subsequently colour-printed in opaque red [PLATE 51].

These examples make clear that the current view of Blake's illuminated book production is based upon a fundamental misunderstanding of his method; in particular, of the care, time and skill required to carry it out. Joseph Viscomi, in *Blake and the Idea of the Book* (1993), is firm in his belief that, with a single exception, Blake's colour-printed plates were produced as a result of a single pass through the press.[29] In *William Blake Printmaker* (1980), Robert N. Essick also cites this single example as an aberration, an isolated experiment that went badly wrong and was never repeated.[30] In the twentieth century, only W. Graham Robertson and Martin Butlin have been convinced that Blake's colour-printed illuminated books and separate plates were printed twice, but until now how this was accomplished has remained unexplained.[31]

The example cited by both Essick and Viscomi is the plate of the 'Nurses Song' of *Songs of Experience* found in *Songs* Copy E, now in the collection of the H. E. Huntington Library [PLATE 55]. The plates contained in *Songs* Copy E are a composite of plates printed at different times with a number of plates printed very lightly or poorly in monochrome. The complete set of both *Songs of Innocence* and *Songs of Experience* was then heavily and uniformly hand coloured, the text of many poems overwritten in colours in order to make it legible and sold to Thomas Butts on 9 September 1806 for £6.6.0.[32] In *Songs* Copy E, many of the plates of *Songs of Experience* were originally colour-printed in 1794 at the same time that Blake printed the first combined issue of *Songs of Innocence and of Experience*, *Songs* Copies B, C and D. In relation to the first four colour-printed copies of *Songs of Experience*, *Songs* Copies F, G, H and T[1], the plates of *Songs of Experience* in these copies, including *Songs* Copy E, are distinguished by being printed on both the recto and verso of each leaf, apart from the Frontispiece and title-page. However, only Copy C contains a significant number of colour-printed plates of *Songs of Experience*, Copy D few and Copy B possibly none at all. The colour-printed plates that are present in these copies have been colour-printed using very little pigment, sometimes making it difficult to be sure if they have been colour-printed. This was probably done to meet the problems that would arise when leaves colour-printed on both sides faced each other when bound. The colour-printed plates in *Songs* Copy E are clearly remnants from this printing session in 1794 that had been rejected for use in *Songs* Copies B, C and D. After 1794, Blake no longer colour-printed copies of *Songs of Experience*. By heavily hand colouring and overwriting the texts of the plates in *Songs* Copy E, Blake justified his price to Butts. He also disguised their differences and attempted to disguise their faults. In addition to the misregistration of 'Nurses Song', small failures of registration in colour-printing can also be seen in *Songs* Copy E in the plates of 'A Little GIRL Lost', 'The Little Vagabond', 'EARTH'S Answer', 'The Angel' and the plate containing 'My Pretty ROSE TREE', 'AH! SUN-FLOWER' and 'THE LILLY.'

'Nurses Song' in *Songs* Copy E clearly shows what occurs when a plate is printed out of register. If

Blake was using a technique of nipping the impression and registration sheet between the rollers, it would have been easy to miscalculate and turn the star wheel just an inch too far, freeing the margin of the impression. The tendrils in the upper areas of the plate also greatly exaggerate the slightest failure to register precisely. Four colour-printed impressions of this plate are extant from the first set of colour-printed copies printed on one side of the leaf, *Songs* Copies F, G, H and T^1, together with the very lightly colour-printed copy from *Songs* Copy C printed in 1794. When reproduced side by side, they show how normally cautious and economical with pigment Blake was when applying it to the upper areas of this plate before colour-printing [PLATES 56–60]. Even so, it is still possible to see minor failures of registration in the tendrils of some of these plates. It is also noticeable how each example has been colour-printed using a completely different palette, ruling out any suggestion that in these first examples Blake was able to print more than once from a plate prepared for colour-printing.

The four copies of the first printing of *Songs of Experience* may be identified, as follows. Copy F was originally owned by George Cumberland and is now in the Yale Center for British Art. It is complete and until recently bound in contemporary quarter calf over marble papered boards together with Cumberland's copy of *Songs of Innocence*, described earlier as one of the first copies printed in green ink. It is clear that the copies of *Songs of Innocence* and *Songs of Experience* owned by Cumberland were originally separate and probably obtained by him at the time each volume was issued, shortly after his return from Italy in 1790 and in the late summer or early autumn of 1793. There is no general title-page or tail-piece, both of which were first included in the first combined issue of the *Songs of Innocence and of Experience* issued in 1794. Also, Cumberland's signature is not present in the volume of *Songs of Innocence*, bound first. But, bound after it, slightly shaved at the top of the blank recto of the Frontispiece to *Songs of Experience*, is found Cumberland's signature 'G. Cumberland.' Copy H is also complete. It was originally owned by the miniature painter Ozias Humphry and is now in the private collection of Maurice Sendak. This volume is the only copy of *Songs of Experience* to survive as it was obtained from Blake, stitched untrimmed into buff paper wrappers, although the leaves are now loose and preserved with the wrappers into which they were originally sewn [PLATES 24 & 25].

Two other copies were dispersed in the nineteenth century and consequently a few plates remain untraced. However, the extant plates from these two copies correspond with the same seventeen plates that are present in *Songs* Copies F and H. Copy G contains twelve plates. Ten of these plates were collected by Sir Geoffrey Keynes and are now in the Fitzwilliam Museum, Cambridge. One plate, 'A POISON TREE,' appeared from an anonymous source and was sold at Sotheby's on 1 December 1988. It is now in a private collection. The plate of 'THE FLY' is now in the collection of Robert N. Essick. Copy T^1 is missing only one plate, 'THE Chimney Sweeper.' Of the sixteen extant plates, twelve are found as part of a composite volume of the combined *Songs*, containing both very early and late impressions and colouring styles, that was put together by the London dealer R. H. Evans and sold to the British Museum on 9 February 1856. The remaining four plates were sold by E. Parsons and Sons of London to the National Gallery of Canada, Ottawa, in 1923, also as part of a composite set of early and late impressions and colouring techniques. As the Table shows, each copy contains a mix of plates printed monochrome using a different coloured ink on each plate [FIG. 35].

More revealing is the fact that no two examples of the same plate have been colour-printed from the same palette of colours, making clear that each plate was printed separately, first in monochrome and then colour-printed. This also suggests that these first copies may have been printed in stages, beginning with the first experimental plates now in the collection of the National Gallery of Canada. This is consistent with the early history of *Songs of Experience* leading to the first combined issue of the *Songs*, set out in the next chapter. It is also

	Copy F	Copy G	Copy H	Copy T¹
1.	Frontispiece brick red (?)	*untraced*	Frontispiece brick red (?)	Frontispiece brick red (?)
2.	Title-page golden brown ochre	*untraced*	Title-page golden brown ochre	Title-page golden ochre
3.	'Introduction' charcoal	'Introduction' charcoal green	'Introduction' charcoal	'Introduction' light charcoal green
4.	'EARTH's Answer' blue green	'EARTH's Answer' dark blue green	'EARTH's Answer' dark blue green	'EARTH's Answer' dark charcoal green
5.	'The CLOD & the PEBBLE' dark blue green	'The CLOD & the PEBBLE' pale blue green	'The CLOD & the PEBBLE' golden brown ochre	'The CLOD & the PEBBLE' medium blue green
6.	'NURSES Song' blue green	'NURSES Song' pale blue green	'NURSES Song' golden ochre	'NURSES Song' light golden brown ochre
7.	'HOLY THURSDAY' pea green	*untraced*	'Holy Thursday' pea green	'Holy Thursday' light golden brown ochre
8.	'LONDON' pale blue green	*untraced*	'LONDON' charcoal green	'LONDON' light grey blue
9.	'The Angel' light golden brown ochre	*untraced*	'The Angel' pea green	'The Angel' golden brown ochre
10.	'A POISON TREE' golden brown ochre	'A POISON TREE' golden brown ochre	'A POISON TREE' light golden brown ochre	'A POISON TREE' golden brown ochre
11.	'The Tyger' blue	'The Tyger' blue green	'The Tyger' pea green	'The Tyger' blue green
12.	'A Little BOY Lost' dark blue green	'A Little BOY Lost' blue (green)	'A Little BOY Lost' light golden brown ochre	'A Little BOY Lost' pale blue green
13.	'A Little GIRL Lost' golden brown ochre	'A Little GIRL Lost' pale blue green	'A Little GIRL Lost' light golden brown ochre	'A Little GIRL Lost' golden brown ochre
14.	'THE Chimney Sweeper' dark charcoal green	'THE Chimney Sweeper' light golden brown ochre	'THE Chimney Sweeper' light golden brown ochre	*untraced*
15.	'The Human Abstract' dark blue green	'The Human Abstract' pale blue green	'The Human Abstract' light golden brown ochre	'The Human Abstract' medium blue green
16.	'My Pretty ROSE TREE', 'AH! SUN-FLOWER', 'THE LILLY' dark blue green	'My Pretty ROSE TREE', 'AH! SUN-FLOWER', 'THE LILLY' golden brown ochre	'My Pretty ROSE TREE', 'AH! SUN-FLOWER', 'THE LILLY' blue green	'My Pretty ROSE TREE', 'AH! SUN-FLOWER', 'THE LILLY' golden brown ochre
17.	'THE FLY' blue green	'THE FLY' light golden brown ochre	'THE FLY' golden brown ochre	'THE FLY' blue green

FIG. 35 The First Issue of *Songs of Experience*

borne out by the fact that, after his first experiments in colour-printing the plates in the National Gallery of Canada, Blake found a method of registration that did not require a pin to keep the impression in register. Time may also have been needed to better understand his materials.

Until it was rectified, blackened lead white was found on the title-page of *Songs of Experience* in the National Gallery of Canada, Copy T¹, the first title-page to be printed. Lead white pigment used on the faces and hands had converted to black lead sulphide. With the application of hydrogen peroxide it was converted to lead sulphate, a white compound [Plates 52, 53 & 54]. Blackening of lead white often occurs when it is exposed to the atmosphere as a result of not being adequately sealed by the binder. Evidence of this condition is also present on plates in the colour-printed copy of *Songs of Experience*, *Songs* Copy F, originally owned by George Cumberland. Blake used the same paper stock to colour-print two copies of the *Marriage of Heaven and Hell*, Copy E now in the collection of the Fitzwilliam Museum and Copy F in the Pierpont Morgan Library. Plates in both copies show evidence of the same problem.[33] According to Vincent Daniels, Principal Conservation Scientist in the Conservation Research Group at the British Musem, if pollutants in the atmosphere were of sufficient concentration, blackening of lead white could take place within a few weeks.[34] Hercules Buildings was located less than half a mile northeast of some of the worst concentrations of noxious industries in London, including distilleries, starch manufactories and nine potteries that exuded hydrochloric acid fumes from their kilns. During etching, chemical fumes would also have been present in Blake's studio.

In the other colour-printed copies of *Songs of Experience*, and in Blake's later colour-printed works, this problem has largely been resolved, suggesting that it was not long before he recognised what was happening.[35] This is another indication that the first copies of *Songs of Experience* may not have been printed all at once and that they were certainly not colour-printed using the same mix of pigments and binder. Blake arrested the problem by one of two methods. Either, he used the ground, or natural colour of the paper, as a base for skin tones. In this practice, Blake adapted an innovation introduced in miniature painting by his friend and supporter at this time, Richard Cosway.[36] Or, he learned to mix his pigments using greater concentrations of glue or gum. Glue could be used in greater concentrations than gum arabic and, according to Daniels, is more of a film-forming polymer and retains its flexibility better than gum. This agrees with the accounts of both J. T. Smith and John Linnell, that when mixing his colours to paint in the manner of fresco they were always 'tempered with common carpenter's glue.' It is clear that Blake quickly took steps to avoid this problem either by using the ground as a base for skin tones or by using a binder that would more securely seal the pigments. The experience left a vivid impression upon him:

All Frescoes are as high finished as miniatures or enamels, and they are known to be unchangeable; but oil, being a body itself, will drink or absorb very little colour, and changing yellow, and at length brown, destroys every colour it is mixed with, especially every delicate colour. It turns every permanent white to a yellow and brown putty, and has compelled the use of that destroyer of colour, white lead; which, when its protecting oil is evaporated, will become lead again.[37]

Blake's experience with that 'destroyer of colour,' white lead, may have been shared with and helped by Ozias Humphry, who, like Cosway, was also an accomplished miniature painter. In his unpublished memorandum book in the British Library, Humphry comments upon the problem and how to rectify it [FIG. 36]:

> Recipe to recover white
> That has faild in Miniatures
> _____
>
> with Spirit of Salt
> depriv'd of its phlogiston
> lightly touch the white that
> with a camel hair pencil
> has faild ₍∧₎ w^ch will soon recover
> it. _____ O:H: 1795 __ [38]

FIG. 36 Ozias Humphry MS. Memorandum Book, Add. MS 22,950, folio 16ᵛ. Reproduced by permission of the British Library Board.

It was Ozias Humphry who purchased the second of the two complete colour-printed copies of *Songs of Experience*, Copy H, and sets of both the colour-printed large and small books of designs.[39] Copy H shows no sign of blackening of lead white, nor do Humphry's sets of the colour-printed designs.

With the development of his colour-printing method, Blake moved into an exclusive market for his works. Monochrome impressions were about half the price of an impression coloured by hand, and a quality decorative print colour-printed *à la poupée* more. In 1794, Thomas Macklin advertised two of Blake's commercial engravings, first published in 1783, in *Poetic Description of Choice and Valuable Prints, Published by Mr. Macklin, at the Poet's Gallery, Fleet Street*, including *The Fall of Rosamond*, as follows:

The Fall of Rosamond. Painted by T. Stothard, R.A. and Engraved by W. Blake. Size 12 inches, circle; Price 7s. 6 d. Plain, and 15s. in Colours.[40]

A monochrome print colour-printed *à la poupée* that was then finished in another medium commanded an even greater price, reflecting the skill and time that was required in producing such a print, a price beyond the reach of all but the most dedicated connoisseur. Blake's method was even more exacting, requiring registration, a first printing in monochrome, followed by a second, colour-printing and then detailed finishing by hand in water colour often followed by pen and ink. Blake may have hoped to reach a public market with his colour-printed illuminated books and plates. But the market that we know he found for them was essentially private, composed of friends and acquaintances who appreciated his work, who were able to pay a commensurate price for it and by doing so assist Blake. They included the miniature painter Ozias Humphry and the connoisseur and amateur printmaker George Cumberland, both of whom obtained one of the original colour-printed copies of *Songs of Experience* as well as other examples of Blake's colour-printed works.[41]

Within a year of colour-printing the first copies of *Songs of Experience*, Blake appears to have found a more flexible method of registration, a way that made it possible for him to remove one impression and insert another. This also made it possible for him to print a second time from the plate, and to add or even partly change the colour pigments before taking a second impression. The method that Blake found may have been by simply holding together the registration sheet and impression by placing a weight at the margin of both. After colour-printing one impression, the weight could be removed, the first impression lifted away and the next registered to the sheet below the plate. This would not provide the precision needed to colour-print details, like the tendrils on the plate of 'NURSES Song', but simpler designs composed of distinct areas of colour would be possible that could then be given definition later when finished in water colour and pen and ink.

Evidence of Blake colour-printing twice from the same preparation of pigments may be seen in the two impressions of 'The Accusers of Theft Adultery Murder.' The first to be colour-printed is the impression in the collection of the Department of Prints and Drawings of the British Museum and the second in the Lessing J. Rosenwald Collection at the National Gallery of Art, Washington, D.C. When the second impression was printed, less pigment remained on the plate to be transferred revealing traces of the underlying printing in monochrome. Both prints were then finished individually in water colour and possibly pen and ink.[42] Similarly, heavy embossing on the verso of some colour-printed plates, like that of Plate 21 of the *First Book of Urizen* in the National Gallery of Victoria, Melbourne, may be evidence of increasing the pressure of the rollers in order to pick up residual colour pigments when colour-printing a second impression.[43] Blake also began to design his plates so that the area to be colour-printed was either distinct from the text or without any text at all, noticeably in *The First Book of Urizen*. Colour-printing an image in broad areas of colour to be given definition later greatly reduced the need to relief etch the plate. By 1795, the way was clear to print planographically from the plate, from largely unetched surfaces, the technique he used in the last illuminated books and to print the large colour-prints often found dated '1795.'

Blake's experiments in colour-printing his illuminated books did not end in the 1790s. Apart from the large colour-prints, which are found on paper watermarked 1804, colour-printed trial impressions of plates 19 and 38 of *Jerusalem* are in the Rosenwald Collection in the Library of Congress, first printed in Prussian blue and then in black. On plate 38, a failure of registration between the two stages of printing is evident in the bottom right corner.[44] Plates of Copy D of *Milton*, in the same collection, on Ruse & Turners paper watermarked 1815, have also been colour-printed, first in an opaque variety of orange inks that appear to be vermilion mixed with differing amounts of black pigment with an opaque bulking agent, then in Prussian blue that has been daubed at irregular intervals with black and then over painted with layers of water colour. Gold leaf has then been crushed into areas of the surface reflecting the reticulated texture.[45] The separate impression of plate 13 in the Philadelphia Museum of Art, showing Milton divesting himself of his robe, shows how the plates in Copy D were colour-printed before the application of water colour and gold leaf, by first being printed in orange, then in Prussian blue and then daubed at the bottom of the plate with matt black.[46] Blake's colour-printed works represent his supreme achievement as a graphic artist, set in train by his experiments and extraordinary innovations employed in the production of the first copies of *Songs of Experience*.

VI. *Songs of Innocence and of Experience*

As originally published, both *Songs of Innocence* and *Songs of Experience* contained seventeen plates printed on seventeen leaves. If we think in terms of the number of leaves per volume, instead of the number of plates or 'designs', this indicates that the original issue of *Songs of Experience* was not only complete but that it was also produced as a companion volume for *Songs of Innocence*. *Songs* Copy F, bound together for George Cumberland, brings the two volumes together in just this way, each with seventeen leaves.

On 10 October 1793, Blake advertised *Songs of Innocence* and *Songs of Experience* separately, each 'with 25 designs, price 5s.' This suggests that the original issue of *Songs of Experience* of seventeen plates was produced before the prospectus was issued. It also makes clear that at this date the two volumes had not been combined or Blake would have offered a combined issue. The '25 designs' specified for each volume is six designs less than the thirty-one contained in the original issues of *Songs of Innocence*; and eight designs more than the seventeen contained in the first issue of *Songs of Experience*. To accomplish the balance advertised, Blake apparently proceeded as follows. From the recent printing of *Songs of Innocence*, Blake removed two leaves each printed recto and verso, as follows:

A Dream *recto*
The Little Girl Lost *verso*
The Little Girl Lost/The Little Girl Found *recto*
The Little Girl Found *verso*

Songs of Innocence Copy K, in the Pforzheimer Library, New York Public Library, lacks the three plates that make up 'The Little Girl Lost' and 'The Little Girl Found.' It is printed in raw sienna with the exception of 'On Anothers Sorrow.' 'On Anothers Sorrow' has been printed in brown ink on a separate leaf on a lighter weight of wove paper. It may have been added later when the copy was coloured in what appears to be a slightly later style. If it was, then this copy originally contained twenty-seven plates instead of the conventional thirty-one found in copies issued up to this date. *Songs of Innocence* Copy Z, recently discovered in the Bayerische Staatsbibliothek, Munich, also contains twenty-seven plates printed on both sides of the leaf, except for the Frontispiece, title-page and Introduction, like copy K. These plates have also been printed in raw sienna.[1] The three plates that make up 'The Little Girl Lost' and 'The Little Girl Found' are also lacking together with 'On Anothers Sorrow,' again reducing the established number from thirty-one to twenty-seven plates. In Copy Z, Blake has foliated the plates beginning with the 'Introduction' one to twenty-five, matching the description of *Songs of Innocence* in the prospectus as containing '25 designs.'[2] These are the only two copies of *Songs of Innocence* that appear to match the description in the prospectus.

If we look ahead to the composition of the first combined issue of *Songs of Innocence and of Experience* we can see how Blake may have made up copies of *Songs of Experience* amounting to '25 designs' as advertised in the prospectus. From copies of *Songs of Innocence* in stock, as with copies K and Z, Blake removed the following two leaves printed recto and verso, as follows:

A Dream *recto*
The Little Girl Lost *verso*
The Little Girl Lost/The Little Girl Found *recto*
The Little Girl Found *verso*

Three sets of these plates were transferred to a corresponding number of copies of a new, second printing of *Songs of Experience*, *Songs* copies B, C and D. For this second printing of *Songs of Experience*, Blake relief etched four new plates using drafts of poems in the *Manuscript Notebook* that had not been used before, as follows:

The SICK ROSE
The GARDEN of LOVE
The Little Vagabond
INFANT SORROW

Together with the four plates transferred from *Songs of Innocence*, *Songs of Experience* now numbered '25 designs.' If copies of *Songs of Experience* were available for sale separately in this form at the time that Blake issued his prospectus, they appear to have been those that were incorporated into the first combined issue of the *Songs* published in 1794.

All of the plates of the second printing of *Songs of Experience* were printed both recto and verso, with the exception of the Frontispiece, title-page and the 'Introduction,' just as Blake had printed the first issues of *Songs of Innocence*. All of the plates have been printed monochrome in yellow ochre, with the exception in Copy C of 'The Human Abstract,' that has been printed monochrome in green and, uncharacteristically for this volume, heavily colour-printed. This plate appears to have been left from the first colour printed sets of *Songs of Experience* and then used to print 'The Little Vagabond' in yellow ochre on the back. Only Copy C contains a significant number of colour-printed plates of *Songs of Experience*, Copy D few and Copy B possibly none at all. The colour printed plates that are present in these copies have been colour-printed using very little pigment, making it difficult to be certain if they have been colour-printed. Instead, colouring was carried out in the copies of *Songs of Innocence* and *Songs of Experience* predominantly in water colour with occasional strengthening in pen and ink or fine pencil brushwork. The dramatic contrast in palette and colouring technique used respectively in the original issues of *Songs of Innocence* and *Songs of Experience* has been sacrificed to achieve a more uniform appearance.

With the addition of a general title-page and a tail-piece, the latter unique to *Songs* Copies B, C and D, Blake produced the first combined issue of the *Songs of Innocence and of Experience* in 1794. As described, it contained fifty-four plates printed on thirty leaves. The poem 'To Tirzah' was evidently not composed, relief etched and added to *Songs of Experience* until after 1795, when it is included in all copies produced after that date.[3] 'A DIVINE IMAGE' is only found in *Songs* Copy BB, 'Bought of Blake May 1816' by Robert Belmano. It is the only copy to contain fifty-five plates. In 1818, Blake made a final change. Beginning with *Songs* Copies U and T[2], 'The School Boy' and 'The Voice of the Ancient Bard' were transferred from *Songs of Innocence* to *Songs of Experience*. This change is also incorporated in a memorandum that Blake wrote to Thomas Butts at about this time listing the 'Order in which the Songs of Innocence & of Experience ought to be paged & placed.'[4] But if a final order of the plates of the *Songs* was ever established in Blake's mind it was probably represented by *Songs* Copy R, that was printed before 1800 but not sold by Blake until 1819 to John Linnell. Copy R appears to have been used as a model for ordering the plates in several copies printed in the last years of Blake's life.[5]

Sadly, Blake was never again to produce copies of the *Songs* where the method of colouring and its adaptation so perfectly complemented his vision as in the original issues of *Songs of Innocence* and *Songs of Experience*. In the translucent water colour wash of *Songs of Innocence*, and the opaque colour printing of *Songs of Experience*, Blake's conception of the 'Two Contrary States of the Human Soul' is most fully realised.

Conclusion

THIS study of the creation of Blake's *Songs* challenges current scholarship on several fronts. The manuscript drafts, both in *An Island in the Moon* and the *Manuscript Notebook*, make clear that Blake did not write autographically, unpremeditated or from any form of dictation divine or otherwise. On the contrary, when composing he often ran into difficulty and only rarely was satisfied to leave fair copy unaltered. When poems were successfully completed in draft, the pencil notation 'On 1 Plate' found on N.101 makes clear that composing on the copper plate could also falter and fail. The view that Blake could ink and print monochrome impressions from his relief etched plates in substantial numbers quickly and without difficulty is also questioned. John Jackson is witness to the fact that it was difficult for Blake to avoid smudging the shallows of his relief etched plates during inking. As it was necessary to wipe these areas clean before printing, the preparation of his plates for printing 'was necessarily slow.'[1] This is supported by comparing the trial impressions of *Songs of Innocence* with those Blake inked, wiped and printed with care for sale.

The present study also questions whether all the copies of a particular print run were hand-coloured together. The view that the same few pigments and mixes of colour have been used to colour by hand all of the copies of a print run is set against the fact that during the 1790s Blake's palette was limited to those same few colours. When it is acknowledged that no two copies from the same printing have been hand coloured in exactly the same way, the suggestion that William and Catherine set up a production line in which more than five hundred impressions were coloured at once must be cast in doubt. It was not necessary, with the *Songs* or any of his works produced in Illuminated Printing. It was also contrary to the personal nature of Blake's relationship with those we know obtained copies from him, like Samuel Rogers, John Flaxman and George Romney, where they were either 'executed,' 'coloured' or specially produced on large paper for them.

With regard to the *Manuscript Notebook*, it has been shown that a *terminus ad quem* of November or December 1792 for writing the sequence of poems beginning on N.115 and concluding on N. 98 is no longer adequate, and that the sequence itself is not continuous. Since 1968 it has been accepted that 'Why should I care for the men of thames,' on N.113, with its reference to the Ohio, was composed in response to Blake reading Gilbert Imlay's *A Topographical Description of the Western Territory of North America*.[2] The present study has shown that Imlay's account was first advertised for sale on 12 December 1792. This means that we must consider that the great majority of poems leading to *Songs of Experience* were written after this date.

'Why should I care for the men of thames' marks another turning point. In the sequence of manuscript drafts of *Songs of Experience* it is the first poem of overt political protest. From this point Blake becomes increasingly outspoken against social, political and religious injustice and repression. 'A Little BOY Lost,' 'THE Chimney Sweeper,' 'Merlins Prophecy' and 'The Little Vagabond' are unreserved in their declaration against god, his priest and king. 'HOLY THURSDAY' verges upon rage. Dating these poems between December 1792 and October 1793, when *Songs of Experience* is listed in the prospectus, also corresponds with a profound change in the political climate in Britain. Reports of the massacres in Paris in August and September 1792, followed by the decisive victory at Jemappes on 6 October and the National Convention offering support to other nations willing to revolt, led directly to a counter-revolutionary movement in Britain backed by government authority. During late November and throughout December more than sixteen hundred loyalist

associations were founded, including associations at Lambeth, the borough of Southwark and the surrounding parishes south of the Thames.[3] On 18 December the trial and conviction of Tom Paine *in absentia* enforced the Royal Proclamation of 21 May 1792 and effectively licensed the harassment, indictment and imprisonment of anyone accused of seditious activity, including print publishers like William Holland.[4] In June Blake's fear was palpable: 'I say I shant live five years and if I live one it will be a Wonder June 1793.'[5]

On 10 October 1793 Blake dated and printed a prospectus addressed '*To the Public*' that listed his works for sale available at No. 13 Hercules Buildings, including *America a Prophecy*, *Visions of the Daughters of Albion* and, separately, *Songs of Innocence* and *Songs of Experience*. The same day loyalist meetings were held in the immediate vicinity. The crowds and burning in effigy of Tom Paine, Joseph Priestley and others that characterised these meetings may explain why we have no record of anyone attending Hercules Buildings to see or purchase work from Blake that day or in the months that followed.[6] From N. 113, the writing of *Songs of Experience* marks this train of events, reflecting both the causes of social and political unrest in Britain and, in 'The Tyger,' a nation in the grip of reactionary paranoia.

The challenge presented to the prevailing theory of Blake's illuminated book production, in particular the emphasis placed here upon the care and time that was required at each stage in production, may not be unrelated to these same events. The development of Blake's method of colour printing first used to produce *Songs of Experience* in the late summer or early autumn of 1793 has been demonstrated to require registration and two printing stages, in one instance using ultra-violet light to expose the underlying image over-printed during colour printing. This highly innovative method, drawing upon aspects of both traditional multiple plate and *à la poupée* colour printing techniques, took time to develop and simplify, as we have seen. As failures of registration betray, it never demanded less than skill and patience to accomplish successfully. It is a method that cannot be used to produce dozens of finished impressions in a few hours, much less six copies of *The First Book of Urizen* in two days.[7] Foremost in Blake's mind during the development of this method may have been the idea of producing copies of *Songs of Experience* that were in every respect contrary to *Songs of Innocence*. The light reflected off the paper and back through the transparent watercolours used to finish the first copies of *Songs of Innocence* is, appositely, benighted by the opaque reticulated pigments that were used to colour-print the first copies of *Songs of Experience*. The development of his method of colour printing coincided with, and latterly was almost certainly encouraged by, the political circumstances in which Blake found himself.

By the late spring and summer of 1793 Blake had at his disposal distinct means of producing his graphic works. The separate intaglio etching entitled *Our End is come*, printed in monochrome and 'Published June 5: 1793 by W Blake Lambeth', was capable of being inked, wiped and printed quickly, in numbers, and sold cheaply. *A Song of Liberty*, Plates 25, 26 and 27 of *The Marriage of Heaven and Hell*, Copy M, has been printed in monochrome on a single leaf folded in half to make a small three-plate octavo pamphlet. It has been printed so that the first side is blank. Only when it is opened can the title be seen and the first two plates read. The narrow inside margins make clear that it was not intended for binding, and that it may have been a trial copy for a separate issue intended to be sold cheaply or given away.[8] In this respect, *Our End is come* and *A Song of Liberty*, printed in the manner of Copy M, may be the only examples of Blake's graphic works intended to engage publicly in the political debate brought about and inflamed by the Revolution in France. But there is no record of Blake publishing either.

In contrast, Blake now had available a means of production that was at the opposite end of the commercial scale. Colour-printed works commanded the highest prices if they were finished in another medium. A monochrome print colour-printed *à la poupée* like James Northcote's *Le triomphe de la Liberté en l'elargissment de la Bastille, dedie a la Nation Françoise*, published 12 July 1790 by

R. Wilkinson, engraved, colour-printed *à la poupée* and finished in water colour and body colour by James Gillray, was priced '25/-' [25 shillings].[9] This was beyond the reach of all but the most dedicated connoisseur. Blake's method of colour printing was even more exacting, requiring registration, a second printing as well as detailed finishing by hand. But because of the skill and time required to produce and finish a print in this way, production was limited to a few copies. Prints that required this level of skill and individual artistic finish to produce posed no threat politically because their cost precluded circulation to all but the very few who could afford them.

William Godwin's *Enquiry Concerning Political Justice*, published February 1793 in two volumes quarto at £1. 16s., is analogous. In spite of Godwin's fear expressed in his manuscript diary on 25 May, 'Prosecution of P. J. debated this week,' he was not prosecuted.[10] This is precisely the distinction made at Paine's trial: the concern of the government was the circulation in an inexpensive format of ideas that were considered seditious. Sir John Scott, appointed Attorney General in 1793, explained the government's policy in his warning to Thomas Cooper, author of *A Reply to Mr. Burke's Invective*, published by Joseph Johnson in 1792:

Continue if you please to publish your reply to Mr. Burke in an octavo format form, so as to confine probably to that class of readers who may consider it coolly: so soon as it is published cheaply for dissemination among the populace, it will be my duty to prosecute.[11]

For Blake, even the ten copies of *America a Prophecy* printed monochrome and advertised for sale in the prospectus in October 1793, according to the records of first owners, appear to have been withdrawn from sale to the public.[12] For the next two years Blake's illuminated books and separate prints were colour-printed, including *Europe a Prophecy*, *The First Book of Urizen*, *The Book of Los*

and the small and large books of designs, in very small numbers or specially produced and finished by hand. In 1795, following the simplification of his method, Blake produced the even more limited and exclusive large colour prints or monotypes. If printing cheaply and in numbers either *Our End is come* or *A Song of Liberty* was considered seriously, it was set to one side, for Blake's own safety and doubtless for Catherine's.

Instead, Blake turned to an audience for his works with whom he could feel secure and of whom he could assume informed appreciation. The only copies recorded that were obtained directly from Blake during this period are those bought by the amateur printmaker and connoisseur George Cumberland, the poet and collector of illuminated manuscripts, Samuel Rogers, and the artists Ozias Humphry, John Flaxman and George Romney. On 9 June 1818, Blake wrote to Dawson Turner, who had enquired after the illuminated books and separate colour prints produced in the 1790s. Reflecting, Blake wrote: 'The few I have Printed & Sold are sufficient to have gained me great reputation as a Artist, which was the chief thing Intended.' With an understanding of what Blake's method of colour printing involved, his emphasis upon recognition as an artist can now be more fully understood and appreciated.

With the *Songs*, uniquely, we are in a position to be able to appreciate nearly every stage in their creation from writing to reproduction. In particular, we have seen how difficult, often uncertain and demanding each stage in the creative process has been, from drafting the text, composing text and design on the copper plate, inking and wiping the plate, printing the plates in monochrome, hand colouring and colour printing. That we are unable to trace this progress in the making of any other of his published illuminated books, should not lead us to believe that their creation came about more easily.

Notes

Preface

1 Michael Phillips, 'William Blake's *Songs of Innocence* and *Songs of Experience* From Manuscript Draft to Illuminated Plate', *The Book Collector*, Vol. 28, No. 1, Spring, 1979, pp. 17–59. Superseded by the present study.

2 Michael Phillips, 'Printing Blake's *Songs* 1789–94', *The Library*, Sixth Series, Vol. XIII, No. 3, September, 1991, pp. 205–37. *William Blake Recherches Pour Une Biographie Six Etudes*, Preface d' Yves Bonnefoy, Traduction d' Antoine Jaccottet, Documents et Inedits Du Collège De France, Paris, 1995. Superseded by the present study.

3 *The Poetical Works of William Blake*, ed. John Sampson, 1905, Joseph Wicksteed, *Blake's Innocence and Experience A Study of the Songs and Manuscripts*, 1928, *The Complete Writings of William Blake, With All the Variant Readings*, ed. Geoffrey Keynes, 1957, *The Complete Poetry and Prose of William Blake*, New Revised Edition, ed. David V. Erdman, Berkeley and Los Angeles, 1982, and *The Notebook of William Blake A Photographic and Typographic Facsimile*, ed. David V. Erdman with the assistance of Donald K. Moore, Oxford, 1973; revised edition, 1977.

4 William Blake *An Island in the Moon, A Facsimile of the Manuscript Introduced, Transcribed and Annotated*, by Michael Phillips, Cambridge, 1987.

Introduction

1 The most cogent discussion of Blake's autographic mode of graphic composition is Robert N. Essick, *William Blake and the Language of Adam*, Oxford, 1989, chapter 4, 'Language and Modes of Production,' esp. pp. 167–70. Cf. Joseph Viscomi's qualified acceptance, *Blake and the Idea of the Book*, Princeton, New Jersey, 1993, pp. 29–31.

2 See, for example, the 'Introduction' to *Songs of Innocence*, 'Preludium' to *The First Book of Urizen*, Plate iii of *Europe A Prophecy* and Blake's letter to Thomas Butts, 25 April 1803, 'I have written this Poem from immediate Dictation, twelve or sometimes twenty or thirty lines at a time, without Premeditation & even against my Will [. . .]'. *Complete Poetry and Prose*, pp. 728–9, *Complete Writings*, p. 823.

3 For a full account of the manuscript, see *An Island in the Moon, A Facsimile*, ed. Phillips, 1987.

4 For a full account of the manuscript, see *The Notebook of William Blake*, ed. Erdman, 1973; revised edition, 1977.

5 See, for example, Marcia Pointon, 'Milton and the Precursors of Romanticism 1764–1800,' *Milton & English Art*, Manchester, 1970, pp. 73–137, and Lucy Newlyn, *Paradise Lost and the Romantic Reader*, Oxford, 1993, esp. 97–104.

6 Michael Phillips, 'Blake and the Terror 1792–93', *The Library*, Sixth Series, XVI.4, December 1994, pp. 263–97.

I. Intimations

1 Benjamin Heath Malkin, *A Father's Memoirs of His Child*, 1806, pp. xviii–xix; repr., *Blake Records*, Oxford, 1969, pp. 421–22.

II. *Songs of Innocence*

1 John Thomas Smith, *A Book For A Rainy Day: Or, Recollections of the Events of the Last Sixty-Six Years*, second edition, 1845, pp. 81–2; repr. *Blake Records*, p. 26.

2 *Blake Records*, pp. 27–8. See, Michael Phillips, 'William Blake and the "Unincreasable Club" The Printing of *Poetical Sketches*,' *Bulletin of the New York Public Library*, LXXX, 1976, pp. 6–18.

3 William Blake, *An Island in the Moon, A Facsimile*, 1987.

4 Martha W. England, 'The Satiric Blake: Apprenticeship in the Haymarket?,' *Bulletin of the New York Public Library*, LXXIII, 1969, pp. 6–18.

5 *A Father's Memoirs of His Child*, p. xxviii; repr., *Blake Records*, p. 426. *The European Magazine*, June, 1782, p. 388. Cf. M. G. Jones, *The Charity School Movement*, 1964, pp. 60 ff., and Thomas E. Connolly, 'The Real "Holy Thursday" of William Blake,' *Blake Studies*, VI.2, 1975, pp. 179–87.

6 Stanley Gardner, *Blake's Innocence and Experience Retraced*, 1986, p. 36.

7 See, for example, Jonathan Swift, 'Description of the Morning', *The Tatler*, No. 9, Thursday April 28 to Saturday April 30, 1709, and 'Description of a City Shower', *The Tatler*, No. 238, Saturday October 14 to Tuesday October 17, 1710, and John Gay, *Trivia: Or, The Art of Walking the Streets of London*, 1715.

8 *Blake's Innocence and Experience Retraced*, pp. 6–7, 15–18 & 27–9.

III. Illuminated Printing *Songs of Innocence*

1 *Complete Poetry and Prose*, pp. 692–3, *Complete Writings*, pp. 207–8.

2 Studies of Blake's graphic techniques include Robert N. Essick, *William Blake Printmaker*, Princeton, New Jersey, 1980, and Joseph Viscomi, *Blake and the Idea of the Book*. See also, *The Visionary Hand Essays for the Study of William Blake's Art and Aesthetics*, ed. Essick, Los Angeles, 1973, Essick, *William Blake's Relief Inventions*, Los Angeles, 1978, and Viscomi, *The Art of William Blake's Illuminated Prints*, Manchester, 1983.

3 Robert Dossie, *The Handmaid to the Arts*, 2 vols, second edition, 1764, II.76–7.

4 *Nollekens and His Times*, p. 461; repr. *Blake Records*, p. 460.

5 Linnell collaborated with Blake on a portrait engraving of James Upton, 1818–1819. See Robert N. Essick, *The Separate Plates of William Blake A Catalogue*, Princeton, New Jersey, 1983, pp. 186–88.

6 *Blake Records*, p. 460 n.

7 George Cumberland, 'Hints on various Modes of Printing from Autographs,' *Journal of Natural Philosophy, Chemistry, and the Arts*, XVIII, January, 1811, pp. 56–9; repr. G. E. Bentley, Jr., *Blake Records Supplement*, Oxford, 1988, p. 65.

8 *Blake and the Idea of the Book*, p. 56.

9 See, for example, *The Handmaid to the Arts*, II, pp. 151–53.

10 *William Blake Printmaker*, p. 115.

11 *Valuable Secrets Concerning Arts and Trades: Or, Approved Directions, from the best Artists*, Dublin, 1778, p. 2.

12 *The Notebook of William Blake*, ed. Erdman, pp. 48–50.

13 Reproduced in Martin Butlin, *The Paintings and Drawings of William Blake*, 2 vols., 1981, For 'Sketches for 'The Book of Thel', see Plate 249; for *America a Prophecy*, 'A Figure Bending over a Corpse in the Rain', Plate 253; 'Sketch for a Title–page , probably first idea for 'America'' Plate 255, see also Plates 261 and 263A; for *Europe a Prophecy*, see Plates 371–74. Other examples include sketches for the title page of *The Song of Los*, Plate 267, the frontispiece of *The Book of Ahania*, Plate 268, and *The Book of Los*, Plate 269.

14 G. E. Bentley, Jr., *Blake Books, Annotated Catalogues of William Blake's Writings*, Oxford, 1977, p. 68.

15 *Blake Books*, pp. 381–82, n.4.

16 *Blake Books*, p. 145. Jones, copper plate maker, is recorded as being in business from 1785 until 1793 at numbers 47 and 48 Shoe Lane, off Fleet Street, London. In 1793 he joined in partnership with William Pontifex, advertising from number 47 Shoe Lane. Trade cards representing the two forms are in the Heal Collection, British Museum Department of Prints and Drawings, accession numbers 85.167 and 85.168. I am grateful to David Alexander for directing me to these sources.

17 See, for example, the lower right edge of the plate of 'The Human Abstract' printed from an electrotype made from Blake's original relief etched copper plate, reproduced in Alexander Gilchrist, *Life of William Blake*, 1863, 2 vols., bound at the end of volume two as plate 14.

18 British Library press mark: C. 43. d. 15.

19 Cf. Joseph Viscomi, 'The Evolution of *The Marriage of Heaven and Hell*,' *Huntington Library Quarterly*, Vol. 58, nos. 3 and 4, 1997, pp. 281–344.

20 *The Handmaid to the Arts*, II, pp. 48–53.

21 *The Handmaid to the Arts*, II, pp. 162–66.

22 See Robert N. Essick, *William Blake's Relief Inventions*, pp. 24–5, and Viscomi, Chapter 9 'Etching the Plate,' *Blake and the Idea of the Book*, pp. 78–88. See also, E. S. Lumsden, 'Mordants,' *The Art of Etching*, pp. 50–8, and Ruthven Todd, '"Poisonous Blues," and Other Pigments', *Blake An Illustrated Quarterly*, Vol. 14, No. 1, Summer, 1980, pp. 31–2. I am grateful to Anthony Dyson and to Christopher Bacon for advice with regard to the action of different mordants used in etching before 1800.

23 *William Blake Printmaker*, pp. 92–3.

24 John Jackson, *A Treatise on Wood Engraving, Historical and Practical*, 1839, pp. 716–17. The ink roller was not available until after 1800. C. H. Bloy, *A History of Printing Ink, Balls and Rollers*, 1967, pp. 54–7.

25 *Blake and the Idea of the Book*, p. 243–46.

26 Viscomi suggests that the 'first twenty-two copies of *Innocence*, which appear to have been printed very near to one another in time . . . represent nearly seven hundred impressions. Technically, this represents about a week's worth of printing, assuming that Blake inked two plates at a time and Mrs Blake worked the press.' *Blake and the Idea of the Book*, p. 250.

27 *Blake Books*, p. 365.

28 R. Johnson, *New Duty on Paper. The Paper-Maker and Stationers Assistant, Containing [...] The Dimensions [and] The Whole Duty as altered by the late Act of Parliament*, 1794. See also, Philip Gaskell, 'Notes on Eighteenth-Century British Paper,' *The Library*, XII, 1957, pp. 34–42; James Balston, *James Whatman Father & Son*, 1957, pp. 129–38 and Table D, p. 61; Richard L. Hills, *Papermaking in Britain 1488-1988 A Short History*, 1988, pp. 45–79; Peter Bower, *Turner's Papers A Study of the Manufacture, Selection and Use of his Drawing Papers 1787-1820*, 1990; and John Balston, *The Whatmans and Wove Paper Its Invention and Development in the West*, West Farleigh, Kent, 1998, pp. 116–26 and 250-2.

29 *The Handmaid to the Arts*, II, pp. 198–9. My experience, using a heavy weight of J. Whatman laid paper watermarked 1801, is that soaking over night and keeping the

damp sheets in piles pressed between boards for twenty four hours, after blotting the paper is ready for printing.

30 Cf, Viscomi, *Blake and the Idea of the Book*, pp. 107–10 and p. 243.

31 Cf. George Cumberland's account written in his Commonplace Book: '*Blakes* Instructions to Print Copper Plates [. . .] Wipe the surface of the [intaglio] Plate, till it shines all over – then roll it through the Press with 3 blankets above the Plate, and pasteboards beneath it next the Plank—Paper may be used instead of Pasteboard.' *Blake Records Supplement*, p. 11.

32 On 18 August 1827, the day after Blake was buried, John Linnell went to see Catherine regarding the sale of Blake's rolling press, with a letter from the printer of *Job*, J. Lahee, 'In answer to your note as to Mrs Blakes press [. . .] the fact is that wooden presses are quite gone by now & it would not answer me to give much if any Cash.' *Blake Records*, p. 350. Anthony Dyson discusses the slow decline of the wooden rolling press in the nineteenth century in his chapter 'The Rolling-Press,' and identifies many of the items in the diagrams in Berthiau and Boitard, *Nouveau Manuel Complet de L'Imprimeur en Taille-Douce* (1831), in *Pictures to Print, The Nineteenth Century Engraving Trade*, 1984, pp. 88–9, 91–2, 97 and 102–6.

33 Twelve plates are in the collection of the National Gallery of Victoria, Melbourne, as listed in G. E. Bentley, Jr., *Blake Books Supplement*, Oxford, 1995, p. 120. The two plates of 'The Little Black Boy,' also printed recto verso in green ink, part of the Keynes Family Trust on deposit at the Fitzwilliam Museum, Cambridge, appear to belong to the same copy.

34 *Blake and the Idea of the Book*, pp. 114–15.

35 Cf. *Blake and the Idea of the Book*, pp. 107–10.

36 *Nollekens and His Times*, II, p. 461; repr. *Blake Records*, p. 460.

37 *Life of William Blake*, I, pp. 69–70; repr. *Blake Records*, p. 33.

38 See, A. F. Maheux, 'An Analysis of the Watercolour Technique and Materials of William Blake', *Papers Presented by Conservation Students at the Eighth Annual Conference of Art Conservation Training Programmes*, May 1982, Queen's University, Kingston, Ontario, pp. 49–64, see esp. p. 50.

39 Marjorie B. Cohn, *Wash and Gouache A Study of the Development of the Materials of Watercolor*, Cambridge, Mass, 1977, p. 32.

40 Cf. Viscomi, *Blake and the Idea of the Book*, pp. 135–42.

41 For advice in describing Blake's step-stitch binding, I am grateful to Bernard C. Middleton.

42 Geoffrey Keynes, 'Some Uncollected Authors XLIV George Cumberland 1754-1848,' *The Book Collector*, Vol. 19, No. 1, Spring 1970, pp. 31–57.

43 *Blake Books*, p. 405. For Samuel Rogers, see *Dictionary of National Biography*, XVII, pp. 139–42.

44 *Blake Books*, p. 405.

45 D. Irwin, *John Flaxman 1755-1826*, 1979, p. 53 and p. 224 n.73 & 74;. and BL Add. MS. 39781, f. 382 and f.386. Cf. Viscomi, *Blake and the Idea of the Book*, p. 416 n.23.

46 Mrs [Ann] Flaxman's Journal 1787–1788 'Journey to Rome', British Library Add. MS 39,787; David Irwin, *John Flaxman 1755-1826*, pp. 29–53; and *Blake Records*, pp. 45 and 48.

47 Add. MS 39,784 G, folio 3v.

48 Viscomi, *Blake and the Idea of the Book*, pp. 298–99.

49 Joseph Viscomi, 'The Myth of Commissioned Illuminated Books: George Romney, Isaac D'Israeli, and "ONE HUNDRED AND SIXTY designs . . . of Blake's." *Blake An Illustrated Quarterly*, Vol. 23, No., Autumn, 1989, pp. 48–74.

50 Keri Davies, 'Mrs Bliss: a Blake Collector of 1794,' *Blake in the Nineties*, ed. Steve Clark and David Worrall, 1999, p. 216.

51 See, Philip Gaskell, *A New Introduction to Bibliography*, Oxford, 1972, pp. 5–185.

52 II.i.2.

53 Annotations to *The Works of Sir Joshua Reynolds*, 1798, *Complete Poetry and Prose*, pp. 660–61, *Complete Writings*, p. 476.

54 Annotations to *The Works of Sir Joshua Reynolds*, 1798, *Complete Poetry and Prose*, p. 656, *Complete Writings*, p. 471. Quotations from the first edition of Locke's *An Essay Concerning Human Understanding*, 1690, have been collated with the fifteenth (1760) and sixteenth (1768) editions in the British Library.

55 In seeking to explain 'the progress of the Mind, in its Apprehension and Knowledge of Things,' Locke calls upon the following simile: 'to help us apprehend this matter. If the Organs, or Faculties of Perception, like Wax over-hardened with Cold, will not receive the Impression of the Seal, from the usual impulse wont to imprint it; or, like Wax of a temper too soft, will not hold it well, when well imprinted; or else supposing the Wax of a temper fit, but the Seal not applied with sufficient force, to make a clear Impression: In any of these cases, the print left by the Seal, will be obscure.' He concludes: 'This I suppose, needs no application to make it plainer.' II.xxvii; II,xxix.3 in later editions.

56 Marjorie B. Cohn, *Wash and Gouache*, p. 40.

·

IV. *Songs of Experience*
The Manuscript Notebook

1 This drawing is also related to the design used on the title-page of *The Book of Thel*.

2 *Blake Records*, p. 44. See also, Cristoph Becker and Beitragen von Hattendorff, *Johann Heinrich Fussli Das Verlorene Paradies*, Stuttgart, 1998.

3 *Blake Records*, pp. 46–7.

4 Stanley Gardner, *The Tyger The Lamb and the Terrible Desart*, 1998, p. 130, citing *Survey of London*, XXVI, 1956, p. 71.

5 Geoffrey Keynes, 'An Undescribed Copy of Blake's Songs of Innocence and of Experience,' *The Book Collector*, Vol. 30, No.1, Spring, 1981, p. 39.

6 Robert F. Gleckner, 'William Blake and the Human Abstract,' *PMLA*, Vol. 76, No. 4, 1961, pp. 373–9.

7 See Vivian de Sola Pinto, 'William Blake, Isaac Watts, and Mrs Barbauld,' *The Divine Vision Studies in the Poetry and Art of William Blake*, ed. V. de Sola Pinto, 1957, pp. 67–87.

8 See Michael Phillips, 'Blake and the Terror 1792–93', *The Library*, Sixth Series, XVI.4, December 1994, pp. 263–97.

9 Nancy Bogen, 'Blake on "The Ohio"', *Notes and Queries*, XV, No.1, January 1968, pp. 19–20. The second edition of Imlay's *A Topographical Description* was first advertised as published on 3 June 1793.

10 Gerald p. Tyson, *Joseph Johnson: A Liberal Publisher*, Iowa City, Iowa, 1979, p. 119.

11 J. P. Brissot de Warville, *New Travels in the United States*, trans. Joel Barlow, 1792, p. 480. See, *New Travels*, trans. Mara Soceana Vamos and Durand Echeverria, Cambridge, Mass., 1964, pp. xxvi–xxvii.

12 *Selected Poems of William Blake*, 1957, p. 107.

13 *The Notebook of William Blake*, ed. Erdman, p. 7.

14 Edmund Burke, *Reflections on the Revolution in France* (1790), ed. J. G. A. Pocock, Indianapolis, Indiana, 1987, p. 29. E. P. Thompson, 'London', *Interpreting Blake*, ed. Michael Phillips, Cambridge, 1978, pp. 5–31.

15 Thomas Paine, *Rights of Man*, ed. Gregory Claeys, Indianapolis, Indiana, 1992, p. 15

16 Identification of the portrait drawing on N. 74 is based upon the portrait of Paine by George Romney painted in 1792, now in the Thomas Paine National Historical Association, and engraving after it by William Sharp. See John Keane, *Tom Paine A Political Life*, 1995, plate facing p. 426 and p. 595 n. 212. The portrait is reproduced on the cover of Keane's biography. On 29 May 1792, Fuseli reported to William Roscoe that Romney's portrait of Paine had been 'nearly these two months' with William Sharp for engraving. *Blake Records*, p. 46. Blake was a friend of both Romney and Sharp. For Blake's friendship with Paine and Tatham's account of his warning him of imminent arrest, see *Blake Records*, pp. 530–31 n.2.

17 *Rights of Man*, ed. Claeys, pp. 180–81.

18 John Thelwall, *The Peripatetic; or, Sketches of the Heart, of Nature and Society in a Series of Politico-Sentimental Journals*, 1793, pp. 37–41. 'The Bird Catchers' also contains a poem addressed to 'The Daughters of Albion.' *The Peripatetic* was 'Printed for the Author, and Sold by him, No. 2 Maze Pond, Southwark.' According to the Preface,

dated 29 April 1793, the manuscript was completed some months before and held back by a publisher because of its political views.

19 For earlier discussion of the drafts of 'Infant Sorrow', see Max Plowman, *TLS*, 18 November 1926, and his edition of the *Poems & Prophecies of William Blake*, 1927, pp. 377–8; Joseph Wicksteed, *Blake's Innocence and Experience, A Study of the Songs and Manuscripts*, 1928, pp. 229–34; and especially, Donald K. Moore, 'Blake's Notebook Versions of *Infant Sorrow*,' *Bulletin of the New York Public Library*, Vol. 76. 1976, pp. 209–19, summarised in 'Appendix 1: Longer Notes on Poems,' *The Notebook of William Blake*, ed. Erdman, pp. 67–9; and *Complete Poetry and Prose*, pp. 797–98.

20 Isaac Watts, *Divine Songs Attempted in Easy Language for the Use of Children*, 1715, p. 6; facsimile ed. J. H. P. Pafford, 1971. See esp. Alicia Ostriker, 'Appendix A. Blake Versus Watts: Some Divine and Moral Rebuttals,' *Vision and Verse in William Blake*, Madison and Milwaukee, Wisconsin, 1965, pp. 210–14; and pp. 43–91 *passim*. See also, Vivian de Sola Pinto, 'William Blake, Isaac Watts, and Mrs Barbauld,' *The Divine Vision*, pp. 67–87; Martha Winburn England, 'Blake and the Hymns of Charles Wesley: Wesley's Hymns for Children and Blake's *Songs of Innocence and of Experience*,' *Bulletin of the New York Public Library*, LXX, 1966, pp. 7–26; Zachary Leader, 'Children's Books, Education and Vision,' *Reading Blake's Songs*, 1981, pp. 1–36; and Heather Glen, 'Poetic 'Simplicity': Blake's *Songs* and Eighteenth-Century Children's Verse,' *Vision and Disenchantment: Blake's Songs and Wordsworth's Lyrical Ballads*, Cambridge, 1983, pp. 8–32.

21 Robert Willan, *Reports on the Diseases in London, Particularly During the Years 1796, 97, 98, 99 and 1800*, 1801, p. 255.

22 George Romney to William Hayley, September 1793. William Hayley, *The Life of George Romney, Esq.*, Chichester, 1809, p. 204.

23 Charles Stanger, *Remarks on the Necessity and Means of Suppressing Contagious Fever in the Metropolis*, 1802, pp. 7–8.

24 *An Essay Concerning Human Understanding*, Book III chaps. i–ii, ff.

25 E. P. Thompson, 'London,' *Interpreting Blake*, pp. 11–14. See also, Michael Ferber, '"London" and its Politics,' *English Literary History*, Vol. 48, No. 2, Summer, 1981, pp. 310–38.

26 *Selected Poems*, p. 126.

27 John Flaxman to William Hayley, 26 March 1800. *Blake Records*, p. 64.

28 'Description of the objects of the Charity, and Rules for their Admission,' *An Account of the Institution and Regulations of the Guardians of the Asylum or House of Refuge situate in the Parish of Lambeth, in the County*

of Surrey, For the Reception of Orphan Girls, 1793, pp. 34–5. British Library press mark: RB.23.a.95543.

29 *Laws, Rules, and Orders, of the Government of the Westminster New Lying-In Hospital, Near Westminster Bridge*, 1793, pp. 13–8, 31–7. I am particularly grateful to Stephen J. Greenberg of the National Library of Medicine, Bethesda, Maryland, for making the only recorded copy available.

30 This description of the tiger remained unaltered from the first through the third editions, 1771 to 1797. *Encyclopedia Britannica; Or, A Dictionary of the Arts and Sciences, Compiled Upon a New Plan.*, 3 vols., Edinburgh, 1771, II, p. 585; Second edition, 1779, IV, p. 2966; Third edition, 1797, VII, p. 192.

31 *Memoirs of the Life of Sir Samuel Romilly, written by himself; with a selection from His Correspondence.* Edited by his Sons, 3 vols., 1840, II, pp. 4–5.

32 *The Yale Edition of Horace Walpole's Correspondence*, ed. W. S. Lewis, Vol. 42, 1980, pp. 375–76.

33 See Martin K. Nurmi, 'Blake's Revisions of *The Tyger*,' *PMLA*, Vol. LXXI, September, 1956, pp. 669–85, and Ronald Paulson, 'Blake's Lamb-Tiger,' *Representations of Revolution (1789-1820)*, New Haven, 1983, pp. 88–110. See also, David V. Erdman, *Blake Prophet Against Empire*, Third edition, Princeton, New Jersey, 1977, pp. 194–7.

34 Elizabeth Langland, 'Blake's Feminist Revision of Literary Tradition in 'The SICK ROSE'', *Critical Paths Blake and the Argument of Method*, ed. Dan Miller, Mark Bracher and Donald Ault, 1987, p. 239.

35 Isaac Watts, *Divine Songs*, p. 33. Cf. Alicia Ostriker, 'Appendix A. Blake Versus Watts: Some Divine and Moral Rebuttals,' *Vision and Verse in William Blake*, pp. 212–14

36 Entry for February 1793. Manuscript Ledger of J. Swabey, Accounts with the Parish of Lambeth, 6 October 1789 to 26 October 1805, p. 17. Press Mark: P85/ MRY 1/165. London Metropolitan Archive, Corporation of London.

37 Cf. Viscomi, *Blake and the Idea of the Book*, p. 237, and *Complete Poetry and Prose*, p. 801, and *Complete Writings*, p. 888.

38 David V. Erdman, 'Dating Blake's Script; the "g" hypothesis,' *Blake Newsletter*, Vol. III, No. 1, June, 1969, pp. 8–13; 'Dating Blake's Script: a postscript, *Blake Newsletter*, Vol. III, No. 2, September, 1969, p. 42. Cf. G. E. Bentley, Jr., 'Blake's Sinister "g", from 1789–93 to ?1803,' *Blake Newsletter*, Vol. III, No. 2, September, 1969, p. 43–5, and Viscomi, *Blake and the Idea of the Book*, pp. 235–40, and 'The Evolution of *The Marriage of Heaven and Hell*,' *Huntington Library Quarterly*, Vol. 58, nos. 3 and 4, 1997, pp. 281–344, esp. pp. 301–6.

39 *Complete Poetry and Prose*, p. 852.

40 See 'Introduction,' n. 1.

41 *The Notebook of William Blake*, caption N. 100.

42 David V. Erdman, 'A Blake Epigram ,' *TLS*, 24 February, 1978, p. 234.

43 *Selected Poems*, p. 107.

44 *The Notebook of William Blake*, p. 7.

45 *Complete Poetry and Prose*, pp. 861–62.

46 Edmund Burke, *Reflections on the Revolution in France*, ed. J. G. A. Pocock, p. 66.

47 *Complete Poetry and Prose*, p. 298, *Complete Writings*, p. 146.

48 Robert F. Gleckner, 'William Blake and the Human Abstract,' *PMLA*, Vol. 76, No. 4, 1961, pp. 373–9.

49 David V. Erdman, 'Dating Blake's Script; the "g" hypothesis,' *Blake Newsletter*, Vol. III, No. 1, June, 1969, pp. 8–13; 'Dating Blake's Script: a postscript, *Blake Newsletter*, Vol. III, No. 2, September, 1969, p. 42.

50 Geoffrey Keynes, 'An Undescribed Copy of Blake's Songs of Innocence and of Experience,' *The Book Collector*, Vol. 30, No.1, Spring, 1981, p. 39.

51 Erdman, *Complete Poetry and Prose*, p. 800. Cf. Viscomi, 'The Evolution of *The Marriage of Heaven and Hell*,' *Huntington Library Quarterly*, p. 301-2, n. 28.

52 G. E. Bentley, Jr., 'Blake's Sinister "g", from 1789–93 to ?1803,' *Blake Newsletter*, Vol. III, No. 2, September, 1969, p. 43–5, and Viscomi, *Blake and the Idea of the Book*, pp. 235–40, and 'The Evolution of *The Marriage of Heaven and Hell*,' *Huntington Library Quarterly*, Vol. 58, nos. 3 and 4, 1997, pp. 281–344, esp. pp. 301–6.

53 The title-page of *Vala* is dated 1797, but the writing and revisions of *The Four Zoas* are later, extending into the period after 1800. For a summary of the dating of this MS, see *Complete Poetry and Prose*, pp. 816–18, and *Vala or The Four Zoas*, ed. G. E. Bentley, Jr., Oxford, 1963.

54 *Blake and the Idea of the Book*, p. 291.

55 *Blake and the Idea of the Book*, pp. 239, 291 and 294–302.

V. Colour-Printing *Songs of Experience*

1 *Blake Records*, p. 470.

2 *The Separate Plates of William Blake*, pp. 125–49 & 158–69.

3 J. C. Le Blon, *Coloritto; Or the Harmony of Colouring in Painting: Reduced to Mechanical Practice, under Easy Precepts, and Infallible Rules*, (n.d. *c*.1725), p. 6. British Library press mark: 561* b. 19.

4 See in particular, *Anatomie de la Couleur L'Invention de L'Estampe en Couleurs*, ed. Florian Rodari, Paris & Lausanne, 1996. See also, Joan M. Friedman, *Color Printing in England 1486-1870*, New Haven, Connecticut, 1978, pp. 3–16.

5 John Baptist Jackson, *An Essay on the Invention of Engraving and Printing in CHIARO OSCURO, as Practised By Albert Durer, Hugo Di Carpi., &c. and the*

Application of it to the Making Paper Hangings of Taste, Duration, and Elegance, 1754, pp. 7–8. British Library press mark: C.70. f12. See also, *Beyond Black and White: Chiaroscuro Prints from Indiana Collections*, ed. Adelheid M. Gealt, Bloomington, Indiana, 1989.

6 Nancy L. Pressly, *The Fuseli Circle in Rome, Early Romantic Art of the 1770s*, New Haven, Connecticut, 1979, esp. pp. 101–7.

7 J. T. Smith, *Nollekens and His Times*, II, 475–7; repr. *Blake Records*, pp. 468–70.

8 *Blake Books*, p. 68.

9 *Blake and the Idea of the Book*, pp. 250–1.

10 Martin Butlin, 'The Evolution of Blake's Large Colour Prints of 1795', *William Blake Essays for S. Foster Damon*, ed. Alvin H. Rosenfeld, Providence, Rhode Island, 1969, p. 112.

11 Anthony Blunt, *The Art of William Blake*, 1959, pp. 53–4.

12 Robert Rosenblum, *Transformations in Late Eighteenth Century Art*, Princeton, New Jersey, 1967, p. 156.

13 William Hayley, *The Life of George Romney, Esq.*, Chichester, 1809, p. 144.

14 *Transformations in Late Eighteenth Century Art*, p. 71.

15 See Philippe Bordes, 'Jacques-Louis David's Anglophilia on the Eve of the French Revolution', *The Burlington Magazine*, Vol. CXXXIV, No. 1073, August, 1992, pp. 482–90; and his, *Le Serment du Jeu de Paume de Jacque-Louis David: Le Peintre, Son Milieu et Son Temps. De 1789 a' 1792*, Paris, 1983.

16 Correspondence with the author.

17 *Nollekens and His Times*, II, 480–82; repr. *Blake Records*, p 472. Cf. Details of 'Blake's modes of preparing his ground' given by Samuel Palmer in a letter to Henry Wentworth Ackland, 29 October 1866. 'Blake's White. Get the best whitening—powder it. Mix thoroughly with water to the consistency of cream. Strain through double muslin. Spread it out upon backs of plates, white tiles are better, kept warm over basins of water until it is pretty stiff. Have ready the best carpenter's or cabinet makers' glues made in a very clean glue pot, and mix it warm with the colour: —the art lies in adding just the right portion of glue. The TEST is, that when dry upon the thumb nail or on an earthenware palette it should have so much *and no more* glue as will defend it from being scratched off with the finger nail. This, and the cleanliness of the materials are the only difficulties.' *Blake Records Supplement*, pp. 8–9.

18 *Life of William Blake*, 1863, I, 368–9. See also, *Blake Records*, p. 33 n.3.

19 *Complete Poetry and Prose*, p. 527. *Complete Writings*, p. 560.

20 *Blake Books*, p. 684.

21 Joan K. Stemmler, 'Cennino, Cumberland, Blake and Early Painting Techniques', *Blake An Illustrated Quaterly*, Vol. 17, No. 4, Spring, 1984, pp. 145–9.

22 George Cumberland, *Thoughts on Outline, Sculpture, and the System that Guided the Ancient Artists in Composing Their Figures and Groupes*, 1796, p. 47–48.

23 Geoffrey Keynes, 'Some Uncollected Authors XLIV George Cumberland 1754–1848', *The Book Collector*, pp. 38–41.

24 *Thoughts on Outline*, p. 27.

25 A. F. Maheux, 'An Analysis of the Watercolour Technique and Materials of William Blake', pp. 49–64, see esp. p. 52.

26 Robert N. Essick, 'Appendix II. Analysis of Blake's Medium in a 1795 Color-Printed Drawing', *William Blake Printmaker*, pp. 259–60.

27 Joyce Townsend, 'William Blake (1757–1827) *Moses Indignant at the Golden Calf* c.1799–1800', *Painting and Purpose A Study of Technique in British Art*, ed. Stephen Hackney, Rica Jones and Joyce Townsend, 1999, p. 68. Sarah L. Vallance, B. W. Singer, S. M. Hitchen, and J. H Townsend, 'The Development and Initial Application of a Gas Chromatograpyhic Method for the Characterization of Gum Media', *Journal of the American Institute for Conservation*, Vol. 37, 1998, pp. 294–311.

28 *Rossetti Papers*, compiled by William Michael Rossetti, 1903, pp. 16–17.

29 *Blake and the Idea of the Book*, p. 119.

30 *William Blake Printmaker*, p. 127.

31 W. Graham Robertson, *The Blake Collection of W. Graham Robertson*, described by the Collector edited with an introduction by Kerrison Preston, 1952, pp. 253–4. See also, W. Graham Robertson, 'The Colour Prints,' Alexander Gilchrist, *The Life of William Blake*, ed. W. Graham Robertson, 1907, pp. 404–12. See esp. , Martin Butlin, 'The Evolution of Blake's Large Colour Prints of 1795', *William Blake Essays for S. Foster Damon*, ed. Alvin H. Rosenfeld, Providence, Rhode Island, 1969, pp. 109–16, and 'The Physicality of William Blake: The Large Color Prints of "1795,"' *William Blake and His Circle, Papers Delivered at a Huntington Symposium*, San Marino, California, 1989, pp. 1–17. See also, Martin Butlin and Ted Gott, *William Blake in the Collection of the National Gallery of Victoria*, Melbourne, 1989, p. 111, and Butlin's review of Joseph Viscomi, *Blake and the Idea of the Book*, *The Burlington Magazine*, Vol. CXXXVII, No.1103, February 1995, p. 123. See also, Ruthven Todd, 'The Techniques of William Blake's Illuminated Printing', *The Print Collector's Quarterly*, Vol. 29, November, 1948, pp. 25–37, esp. 28–9; repr. in Robert N. Essick, *The Visionary Hand, Essays for the Study of William Blake's Art and Aesthetics*, pp. 20–44, esp. p. 29.

32 Robert N. Essick, *The Works of William Blake in the Huntington Collections*, San Marino, California, 1985, pp. 156–62.

33 At the Yale Center for British Art, Theresa Fairchild, Head of Paper Conservation, helped me with my analyses of Blake's colour-printed illuminated books including *Songs* Copy F, where the problem of lead white pigment is apparent on several plates including 'The Angel'. At the Pierpont Morgan Library, New York, Deborah Evetts and Reba F. Snyder confirmed the likelihood of decayed lead white pigments in plates of *The Marriage of Heaven and Hell*, Copy F. The same condition is apparent in plates of Copy E in the Fitzwilliam Museum.

34 Correspondence with the author. See, V. Daniels and D. Thickett, 'The Reversion of Blackened Lead White on Paper: Analytical Appendix by T. Baird and N. H. Tennent,' Institute of Paper Conservation Conference Papers, Manchester, 1992.

35 Blackening of lead white has been found on the title-page and 'several other plates' in Copy E of *The First Book of Urizen*, that appeared at auction at Sotheby's New York 23 April 1999, a problem that has not been noticed in copies A, C, D, F and J, also colour-printed in 1794. It is suggested that this was due to these plates being retouched when the copy was later bound and interleaved with tissue guards in *c.*1841, when on plate 21 'some fragments of [tissue] paper' became attached to a 'patch of very dark brown coloring.' The plates of these six copies share the same colours of ink used in the first printing in monochrome. In some cases, they also share very similar palettes of colour used in the second, colour-printing, but in other cases the palettes are clearly distinctive. The fact that blackened lead white is only apparent in this copy could be explained if the plates of these six copies were not colour-printed per-plate together, as these differences suggest. If these plates were amongst the first to be colour-printed, and the decay manifested itself before the plates left Blake's hands, they could also have been separated out because of the fault. See Robert N. Essick, 'Blake in the Marketplace, 1999,' and G. E. Bentley, Jr., 'William Blake and His Circle: A Checklist of Publications and Discoveries in 1999,' *Blake An Illustrated Quarterly*, Vol. 33, No. 4, Spring, 2000, pp. 100–02 and pp. 141–3.

36 I am grateful to Stephen Lloyd of the Scottish National Portrait Gallery, Edinburgh, for advice regarding Richard Cosway's innovative miniature painting techniques.

37 *Complete Poetry and Prose*, p. 531. *Complete Writings*, p. 566.

38 BL Add. MS 22,950, fol. 16ᵛ.

39 *Blake Books*, pp. 356–7. See Blake's letter to Dawson Turner, 9 June 1818, *Complete Poetry and Prose*, p. 771. *Complete Writings*, pp. 867–68.

40 *Separate Plates*, pp. 132 & 135–6. The context of Macklin's Poet's Gallery, and of Blake's independent ventures as a printmaker of others and his own works, is described in Timothy Clayton, 'Part III 1770–1802,' *The English Print 1688–1802*, 1997, pp. 209–282.

41 Ozias Humphry obtained from Blake *Songs of Experience*, *Songs* Copy H, and copies of the large and small colour-printed books of designs. George Cumberland obtained another of the first, colour-printed copies of *Songs of Experience*, *Songs* Copy F.

42 Reproduced in colour facsimile in Essick, *Separate Plates*, Plates 2 and 3. Cf. Plates 3 and 4.

43 Martin Butlin and Ted Gott, *William Blake in the Collection of the National Gallery of Victoria*, Melbourne, 1989, pp. 111–12. Cf. Gerald Bentley, Jr., 'The Shadow of Los: Embossing in Blake's "Book of Urizen"', *Art Bulletin of Victoria* [Melbourne], No. 30, 1989, pp. 18–23.

44 *A Catalogue of the Gifts of Lessing J. Rosenwald to the Library of Congress, 1943-1975*, Washington, D. C., 1977, Number 1811 A. See also the experimental printmaking carried out on plate 78 in the same group of plates.

45 *A Catalogue of the Gifts of Lessing J. Rosenwald to the Library of Congress, 1943-1975*, Number 1810. In Copy D, see the title-page and plates 13 [plate 16 in Copy C], 18 [plate 15 in Copy C], 32 [plate 29 in Copy C] and 37 [plate 33 in Copy C].

46 Cf. Robert N. Essick, 'New Information on Blake's Illuminated Books,' *Blake An Illustrated Quarterly*, Vol. 15, No. 1, Summer, 1981, pp. 8–9.

VI. *Songs of Innocence and of Experience*

1 Copy Z is reproduced in colour facsimile in the Tokyo exhibition catalogue *William Blake*, National Museum of Western Art, Tokyo, 1990, pp. 70–8. I am grateful to Detlef W. Dörrbecker for supplying me with information about this copy.

2 *Complete Poetry and Prose*, pp. 692–3, *Complete Writings*, pp. 207–8.

3 *Blake and the Idea of the Book*, pp. 239, 291 and 294–302.

4 *Complete Poetry and Prose*, p. 771, *Complete Writings*, p. 867–8.

5 *Blake Books*, pp. 379–80.

Conclusion

1 John Jackson, *A Treatise on Wood Engraving, Historical and Practical*, pp. 716–17.

2 Nancy Bogen, 'Blake on "The Ohio"', *Notes and Queries*, Vol. XV, No.1, January 1968, pp. 19–20.

3 See, E. C. Black, 'John Reeves and the Defense of the Constitution,' *The Association*, 1963, pp. 233–74.

4 William Holland is present amongst the prisoners depicted in Richard Newton, 'Promenade in the State Side of Newgate,' published by Holland 5 October 1793, reproduced in Phillips, 'Blake and Terror,' *The Library*, 1994, Plate 8. See Simon Turner, 'English Political

Graphic Satire in the 1790s: The Case of Richard Newton'. *M.A.* Dissertation, History of Art Department, University College London, 1996. See also, Iain McCalman, 'Newgate in Revolution: Radical Enthusiasm and Romantic Counterculture,' *Eighteenth-Century Life*, Vol. 22, February, 1998, pp. 95–110.

5 See Michael Phillips, 'Blake and the Terror 1792–93,' *The Library*, December 1994, pp. 263–97. See also, David Bindman, *The Shadow of the Guillotine Britain and the French Revolution*, 1989, esp. pp. 102–43.

6 See Michael Phillips, 'Flames in the Night Sky: Blake, Paine and the Meeting of the Society of Loyal Britons, Lambeth, October 10th, 1793,' Colloque 'La Violence et ses Representations,' *Bulletin de la Societe d'Etudes Anglo-Americaines des XVIIe et XVIIIe siecle*, No. 44, June, 1997, pp. 93–110.

7 William Blake, *The Urizen Books*, ed. David Worrall, 1995, citing Joseph Viscomi, p. 144.

8 Printing the blocks of text that form these plates could have been facilitated by using a frisket, which could also have been used to mask the 'Chorus' on the last plate of Copy M, Plate 27, leaving the final statement unqualified: 'Empire is no more! And now the Lion and the Wolf shall cease.' Blake's purpose in producing Copy M is made clear by comparing it with the second separately printed copy of *A Song of Liberty, The Marriage of Heaven and Hell*, Copy L. Copy L is printed on a substantially larger, quarto-size sheet measuring 215 × 345 mm. (Copy M measures 197 × 244 mm.) It is also folded in half, but with the first plate printed on the first side thus continuing the sequence of plates of *The Marriage of Heaven and Hell* without a break. In relation to Copy M, the generous inner margins present in Copy L clearly show that it was intended for binding. Copies L and M are discussed and illustrated in Robin Hamlyn and Michael Phillips, *William Blake*, Tate Britain Exhibition Catalogue, 2000, and Phillips, 'Blake and the Terror 1792–93,' *The Library*, Sixth Series, Vol. 16, No. 4, December 1994, pp. 290–94, Plates 9 and 10.

9 James Northcote's *Le triomphe de la Liberte en l'elargissment de la Bastille, dedie a la Nation Françoise*, engraved, colour-printed *à la poupée* and finished in water colour and body colour by James Gillray, priced '25/-' is in the private collection of Andrew Edmunds. It is discussed and illustrated in *William Blake*, Tate Britain Exhibition Catalogue, 2000.

10 Godwin's MS Diary is on loan to the Bodleian Library, Oxford, and quoted here by kind permission of Lord Abinger. Pressmark Dep. E. 201, Vol. VI, fol. 3v.

11 Quoted in Dumas Malone, *The Public Life of Thomas Cooper: 1783-1839*, 1926, p. 53, and Gerald p. Tyson, *Joseph Johnson: A Liberal Publisher*, 1979, p. 124. For further discussion regarding this point, see Mark Philp, *Godwin's Political Justice*, 1986, pp. 65–6 and 103–7.

12 Copies C, D, E, F, G, H, I, K, L and R of *America a Prophecy* were printed together monochrome on Edmeads & Pine wove paper in blue, blue green or olive. See, *Blake Books*, pp. 88, and *Blake and the Idea of the Book*, pp. 264–65. There is no record of any of these copies being sold before 1800, apart from Copy F recorded as first owned by George Cumberland and Copy H by Ozias Humphry, both close friends of Blake at the time of first issue. Copy D was still in Blake's possession in December 1825 when he first met Henry Crabb Robinson, to whom he later presented the copy. Copy K is recorded as having been Benjamin West's copy, another friend and supporter. *Blake Books*, pp. 100–06, and Robert N. Essick, 'The Resurrection of *America* Copy R,' *Blake An Illustrated Quarterly*, Vol. 21, No. 4, Spring, 1988, pp. 138–42. *Blake Records*, p. 309. Geoffrey Keynes and Edwin Wolf 2nd, *William Blake's Illuminated Books A Census*, New York, 1953, p. 46. For Benjamin West's support of Blake, see *Blake Records, passim*. See also, William Blake, *The Continental Prophecies, Blake's Illuminated Books*, Volume 4, ed. D. W. Dorrbecker, 1995, pp. 212–13.

COLOUR PLATES

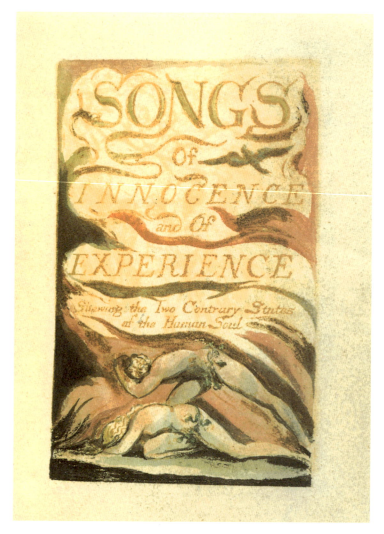

PLATE 1 General title-page, *Songs of Innocence and of Experience*, 1794,
Songs Copy D. Printed monochrome in yellow ochre, finished in watercolour.
Plate size 112 × 70 mm. Private collection.

gap quere ary. they prayd or forfats & my's every minute, to get
good humour said Miss Gittipin pray Mr Obtuse Angle sing us
a Song then he sung

 Upon a holy thursday their innocent faces clean
 The children walking two & two in grey & blue & green
 Grey headed beadles walkd before with wands as white as snow
 Till into the high dome of Pauls they like thames waters flow

 O what a multitude they seemd these flowers of London town
 Seated in companies they sit with radiance all their own
 The hum of multitudes were there but multitudes of lambs
 ~~Thousands of little girls & boys raising their innocent hands~~

 Then like a mighty wind they raise to heaven the voice of song
 Or like harmonious thunderings the seats of heaven among
 Beneath them sit the reverend men the guardeens of the poor
 Then cherish pity lest you drive an angel from your door

After this they all sat silent for a quarter of an hour.
said it puts me in Mind of my mothers song

 When the tongues of children are heard on the green
 And laughing is heard on the hill
 My heart is at rest within my breast
 And every thing else is still

 Then come home my children the sun is gone down
 And the dews of night arise
 Come home leave off play & let us away
 Till the morning appears in the skies

PLATE 2 *An Island in the Moon* MS (*c.*1782–85), folio 7ᵛ. 310 × 185 mm. Reproduced by permission of the Syndics of the
Fitzwilliam Museum, Cambridge.

No No let us play for it is yet day
And we cannot go to sleep ~~the the the the~~
~~the the the the the the the the the the~~
Besides in the sky the little birds fly
And the meadows are coverd with sheep

Well Well go & play till the light fades away
And then go home to bed
The little ones leaped & shouted & laughd
And all the hills ecchoed
Then ~~the the the the the the the the~~ Sing Qud

O father father where are you going
O do not walk so fast
O speak father speak to your little boy
Or else I shall be lost

The night it was dark & no father was there
And the child was wet with dew
The mire was deep & the child did weep
And away the vapour flew

Here nobody could sing any longer. till Tilly Lally pluckd up a
spirit & he sung.
I I say you Joe
Throw us the ball
Ive a good mind to go
And leave you all
I never saw saw such a bowler
To bowl the ball in a ~~turd~~ tansey
And to clean it with my handkercher
Without saying a word

That Bells a foolish fellow
~~the the the the the the~~
He has given me a black eye
He does not know how to handle a bat

PLATE 3 *An Island in the Moon* MS (*c.*1782–85), folio 8[r]. 310 × 185 mm. Reproduced by permission of the Syndics of the
Fitzwilliam Museum, Cambridge.

A flower was offered to me
Such a flower as may never bore
But I said I've a pretty rose tree
And I passed the sweet flower oer

Then I went to my pretty rose tree
To tend it by day & by night
But my rose turnd away with jealousy
And her thorns were my only delight

Never seek to tell thy love
Love that never told can be
For the gentle wind does move
silently invisibly

I told my love I told my love
I told her all my heart
Trembling cold in ghastly fears
Ah she did depart

Soon as she was gone from me
A traveller came by
Silently invisibly O was no deny
He took her with a sigh

Love seeketh not itself to please
Nor for itself hath any care
But for another gives its ease
And builds a heaven in hells despair

So sang a little clod of clay
Trodden with the cattles feet
But a pebble of the brook
Warbled out these metres meet

Love seeketh only self to please
To bind another to its delight
Joys in anothers loss of ease
And builds a hell in heavens despite

I laid me down upon a bank
Where love lay sleeping
I heard among the rushes dank
Weeping weeping

Then I went to the heath & the wild
To the thistles & thorns of the waste
And they told me how they were beguild
Driven out & compeld to be chaste

I went to the garden of love
And I saw what I never had seen
A chapel was built in the midst
Where I used to play on the green

And the gates of the chapel were shut
And thou shalt not writ over the door
And I turnd to the garden of love
That so many sweet flowers bore

And I saw it was filled with graves
And tomb stones where flowers should be
And priests in black gowns were walking their rounds
And binding with briars my joys & desires

I saw a chapel all of gold
That none did dare to enter in
And many weeping stood without
Weeping mourning worshipping

I saw a serpent rise between
The white pillars of the door
And he forcd & forcd & forcd
Till he broke the pearly
 Down the golden hinges tore

And along the pavement sweet
Set with pearls & rubies bright
All his slimy length he drew
Till upon the altar white

Vomiting his poison out
On the bread & on the wine
So I turnd into a sty
And laid me down among the swine

I asked a thief to steal me a peach
And he turned up his eyes
I asked a little lady to lie her down
And Holy & meek she cries

As soon as I went an angel came
And he winked at the thief
And smiled at the dame
And without one word spoken said
Had a peach from the tree
And ... & stole And still as a maid
& Enjoyd the lady

I heard an Angel singing
When the day was springing
Mercy Pity & Peace
Is the worlds release

Thus he sang all day
Over the new mown hay
Till the sun went down
And haycocks looked brown

I heard a Devil curse
Over the heath & the furze
Mercy could be no more
If there was nobody poor

And pity no more could be
If all were as happy as we
At his curse the sun went down
And the heavens gave a frown

Down pourd the heavy rain
Over the new reapd grain
...
And Mercy Pity & Peace And the poor increase
... Mercy Pity Peace
By Misery to increase
And Miseries increase Mercy Pity Peace
Mercy Pity Peace

A cradle song
3 Sleep Sleep in thy sleep little sorrows sit & weep
4 Thou wert ever scene keep ...
1 Sleep Sleep beauty bright
Dreaming oer the joys of night

3 As thy softest limbs I feel
Smiles as of the morning steal
Oer thy cheek & oer thy breast
Where thy little heart does rest

1 O the cunning wiles that creep
In thy little heart asleep
When thy little heart does wake
Then the dreadful lightnings break

2 Sweet Babe in thy face
Soft desires I can trace
Secret joys & secret smiles
... little pretty infant wiles

3 From thy cheeks & from thy eye
Oer the youthful harvests nigh
Infant wiles & ... smiles
Heaven & Earth of peace beguiles

Christian forbearance
I was angry with my friend
I told my wrath my wrath did end
I was angry with my foe
I told it not my wrath did grow

And I waterd it in fears
Night & morning with my tears
And I sunned it with smiles
And with soft deceitful wiles

And it grew by day & night
Till it bore an apple bright
And ...
And my foe beheld it shine
And he knew that it was mine

And into my garden stole
When the night had veild the pole
In the morning glad I see
My foe outstretched beneath the tree

PLATE 5 *Manuscript Notebook*, Add. MS 49,460, Folio 58ᵛ. 196 × 157 mm. N. 114. Reproduced by permission of the British Library Board.

I feard the fury of my wind
Would blight all blossoms fair & true
And my sun it shind & shewd
And my wind it never blew

But a blossom fair or true
Was not found on any tree
For all blossoms grew & grew
Fruitless false tho fair to see

Why should I care for the men of thames
Or the cheating waves of charterd streams
Or shrink at the little blast of fear
That the hireling blows into my ear

Tho born on the cheating banks of Thames
Tho his waters bathed my infant limbs
The Ohio shall wash his stains from me
I was born a slave but I go to be free

Infant Sorrow
My mother groand my father wept
Into the dangerous world I leapt
Helpless naked piping loud
Like a fiend hid in a cloud

Struggling in my fathers hands
Striving against my swaddling bands
Bound & weary I thought best
To sulk upon my mothers breast

And I soothed day after day
Till upon the ground I stray
And I smild night after night
Seeking only for delight

But upon the ...
...
And I saw before me shine
Clusters of the ... vine
and many a lovely flower & tree
Stretchd their blossoms out to me

Silent Silent Night
Quench the holy light
Of thy torches bright

For possessd of Day
Thousand spirits stray
That sweet joys betray

Why should joys be sweet
Used with deceit
Nor with sorrows meet

But an honest joy
Does itself destroy
For a harlot coy

O lapwing thou fliest around the heath
Nor seest the net that is spread beneath
Why dost thou not fly among the corn fields
They cannot spread nets where a harvest yields

My father then with holy book
In his hands a ... book
Pronounce curses on my head
And bound me in a mirtle shade

...
...
...

Like a serpent in the night
They embrace ...
Like a ... in the day
Underneath the vine they lay

So I smote them & their gore
... the roots my mirtle bore
But the time of youth is fled
And grey hairs are on my head

When I saw that rage was vain
And to sulk would nothing gain
I began to soothe & smile

PLATE 6 *Manuscript Notebook*, Add. MS 49,460, Folio 58. 196 × 157 mm. N. 113. Reproduced by permission of the British Library Board.

PLATE 7 *Manuscript Notebook*, Add. MS 49,460, Folio 57ᵛ. 196 × 157 mm. N. 112. Reproduced by permission of the British Library Board.

Thou hast a lap full of seed
And this is a fine country
Why dost thou not cast thy seed
And live in it merrily

Shall I
cast it on the sand
And turn it into fruitful land
For on no other ground
Can I sow my seed
Without tearing up
Some stinking weed

Earths Answer

Earth raisd up her head
From the darkness dread & drear
Her eyes fled light fled
Stony dread!
And her locks coverd with grey despair

Prisond on watry shore
Starry jealousy does keep my den
Cold & hoar
Weepy over
Their the father of the ancient men

Selfish father of men
Cruel jealous selfish fear
Can delight
Chaind in night
The virgins of youth & morning bear

Break this heavy chain
That does close my bones around
Selfish vain
Eternal bane
That free love with bondage bound

2 I now seek a weary
Underneath my myrtle lie
Like to dying upon the ground
Underneath my myrtle bound

Does spring hide its delight joy
When buds & blossoms grow
Does the sower sow
Sow by night
Or the plowman in darkness plow

in a myrtle shade

1 Why should I be bound to thee
O my lovely myrtle tree
Love free love cannot be bound
To any tree that grows on ground

3 Oft my myrtle sighd in vain
To behold my heavy chain
Oft my father bound in self
And clayd at our simplicity

So I smote him & his gore
Staind the roots my myrtle bore
But the time soon spread in fire
And my hands are on my head

PLATE 8 *Manuscript Notebook*, Add. MS 49,460, Folio 57. 196 × 157 mm. N. 111. Reproduced by permission of the British Library Board.

PLATE 9 *Manuscript Notebook*, Add. MS 49,460, Folio 56ᵛ. 196 × 157 mm. N. 110. Reproduced by permission of the British Library Board.

Burnt in distant deeps or skies
The cruel fire of thine eye
Could heart descend or wings aspire
What the hand dare seize the fire

5. And did he laugh his work to see
 what
4 God he who made the lamb make thee
1 When the stars threw down their spears
2 And waterd heaven with their tears

Tyger Tyger burning bright
In the forests of the night
What immortal hand & eye
Dare frame thy fearful symmetry

And what shoulder & what art
Could twist the sinews of thy heart
And when thy heart began to beat
What dread hand & what dread feet

When the stars threw down their spears
And waterd heaven with their tears
Did he smile his work to see
Did he who made the lamb make thee

Tyger Tyger burning bright
In the forests of the night
What immortal hand & eye
Dare frame thy fearful symmetry

Manuscript poems (Blake's Notebook, in the author's hand):



The human Image

Pity could be no more
If we did not make somebody poor
And Mercy no more could be
If all were as happy as we

And mutual fear brings Peace
Till the selfish loves increase
Then Cruelty knits a snare
And spreads his baits with care

He sits down with holy fears
And waters the ground with tears
Then humility takes its root
Underneath his foot

Soon spreads the dismal shade
Of Mystery over his head
And the caterpillar & fly
Feed on the Mystery

And it bears the fruit of deceit
Ruddy & sweet to eat
And the raven his nest has made
In its thickest shade

The Gods of the Earth & Sea
Sought thro nature to find this tree
But their search was all in vain
Till they sought in the human brain
They said this mystery never shall cease
The priest promotes ... & the soldier peace



Love to faults is always blind
Always is to joy inclind
Always wingd & unconfind
And breaks all chains from every mind

There souls of men are bought & sold
And cradled infancy ... for gold
And youth to slaughter houses led
And ... for a bit of bread

As I wanderd the forest
The green leaves among
I heard a ... flower
Singing a song
I slept in the Earth

The sick rose

O rose thou art sick
The invisible worm
That flies in the night
In the howling storm

Hath found out thy bed
Of crimson joy
And her dark secret love
Does thy life destroy

I walked abroad in a snowy day
I askd the soft snow with me to play
She playd & she melted in all her prime
And ... a dreadful crime

Remove away that ... church
Remove away that marriage hearse
Remove away that ... of blood
Youll quite remove the ancient curse

55
107

PLATE 12 *Manuscript Notebook*, Add. MS 49,460, Folio 55. 196 × 157 mm. N. 107. Reproduced by permission of the British Library Board.

... to my Myrtle ...
5 Why should I be bound to thee
6 O my lovely myrtle tree
Love free love cannot be bound
To any tree that grows on ground

1 To a lovely myrtle bound
2 Blossoms showering all around
... upon the ...
... neath my myrtle ...
3 O how sick & weary I
4 Underneath my myrtle lie

Nought loves another as itself
Nor venerates another so
Nor is it possible to Thought
A greater than itself to know
Then father how can I love you
Or any of my brothers more
I love myself ... you like the little bird
That picks up crumbs around the door

The Priest sat by and heard the child
In trembling zeal he seizd his hair
The mother followd weeping ...
...
... led him by his little coat
To show how ... priestly can
And all admird his priestly care
The weeping child could not be heard
The weeping parents wept in vain
...
...
And stripd him to his little shirt
And bound him in an iron chain

Deceit to secresy ...
To ...
... interest blue
And forge fetters for the mind
The churning serpent
A little black thing among the snow
Crying weep weep in notes of woe
Where are thy father & mother say
They are both gone up to church to pray

Merlins prophecy
The harvest shall flourish in wintry weather
When two virginities meet together
The King & the Priest must be tied in a tether
Before two virgins can meet together

you like the little bird

And standing on the altar high
Lo what a fiend is here said he
One who sets reason up for judge
Of our most holy mystery

They burnd him in a holy place
Where many had been burnd before
The weeping parents wept in vain
Are such things done on Albions shore 90

PLATE 13 *Manuscript Notebook*, Add. MS 49,460, Folio 54ᵛ. 196 × 157 mm. N. 106. Reproduced by permission of the British Library Board.

Day
The day arises in the East
Clothed in robes of blood & gold
Swords & spears & wrath increast
All around his bosom rolld
Crownd with warlike fires & raging desires

Come hither my sparrows
My little arrows
If a tear or a smile
Will a man beguile
If an amorous delay
Clouds a sunshiny day
If the step of a foot
Smites the heart to its root
Tis the marriage ring
Makes each fairy a king

So a fairy sung
From the leaves I sprung
He leapd from the spray
To flee away
But in my hat caught
He soon shall be taught
Let him laugh let him cry
Hes my butterfly For Ive pulld out the Sting
Of the marriage ring

The sword sung on the barren heath
The sickle in the fruitful field
The sword he sung a song of death
But could not make the sickle yield

Abstinence sows sand all over
The ruddy limbs & flaming hair
But Desire Gratified
Plants fruits of life & beauty there

In a wife I would desire
What in whores is always found
The lineaments of Gratified desire

But kiss him & give him both drink
& apparel

If you trap the moment before its ripe
The tears of repentance youll certainly wipe
But if once you let the ripe moment go
You can never wipe off the tears of woe

Eternity
He who binds to himself a joy
Does the winged life destroy
But he who kisses the joy as it flies
Lives in eternitys sun rise

The Kid
This little kid did play
&c

The Little Vagabond
Dear Mother Dear Mother the church is cold
But the alehouse is healthy & pleasant & warm
Besides I can tell where I am usd well
The poor parsons with wind like a blown bladder swell

But if at the church they would give us some ale
And a pleasant fire our souls to regale
Wed sing and wed pray all the live long day
Nor ever once wish from the church to stray

Then the parson might preach & drink & sing
And wed be as happy as birds in the spring
And modest dame Lurch who is always at Church
Would not have bandy children nor fasting nor birch

Then God like a father rejoicing to see
His children as pleasant & happy as he
Would have no more quarrel with the Devil or the Barrel
But kiss him & give him both drink & apparel

PLATE 14 *Manuscript Notebook*, Add. MS 49,460, Folio 54. 196 × 157 mm. N. 105. Reproduced by permission of the British Library Board.

PLATE 15 *Manuscript Notebook*, Add. MS 49,460, Folio 53ᵛ. 196 × 157 mm. N. 104. Reproduced by permission of the British Library Board.

The Question Ansierd

What is it men of women do require
The lineaments of Gratified Desire
What is it women do in men require
The lineaments of gratified Desire

Because I was happy upon the heath
And smild among the winters snow
They clothed me in the clothes of death
And taught me to sing the notes of woe

And because I am happy & dance & sing
They think they have done me no injury
And are gone to praise god & his Priest & King
Who make up a heaven of our misery
Come hither my boy tell me what thou seest there
A fool tangled in a religious snare

The countless gold of a merry heart
The rubies & pearls of a loving eye
The idle indolent never can bring to the mart
Nor the secret hoard up in his treasury

An answer to the parson
Why of the sheep do you not learn peace
Because I dont want you to shear my fleece

Holy Thursday
Is this a holy thing to see
In a rich & fruitful land
Babes reduced to misery
Fed with cold & usurous hand

Is that trembling cry a song
Can it be a song of joy
And so great a number poor
Tis a land of poverty

I dreamt a dream what can it mean
And that I was a maiden queen
Guarded by an angel mild
Witless woe was neer beguild

And I wept both night & day
And he wiped my tears away
And I wept both day & night
And hid from him my hearts delight

So he took his wings & fled
Then the morn blushd rosy red
I dried my tears & armd my fears
With ten thousand shields & spears

Soon my angel came again
I was armd he came in vain
For the time of youth was fled
And grey hairs were on my head

The look of love alarms
Because tis filld with fire
But the look of soft deceit
Shall win the lovers hire

Soft deceit & idleness
These are beauties sweetest dress

And their sun does never shine
And their fields are bleak & bare
And their ways are filld with thorns
Tis eternal winter there

But wherever the sun does shine
And wherever the rain does fall
Babe can never hunger there
Nor poverty the mind appall

1. Let the Brothels of Paris be opened
2. With many an alluring dance
3. To awake the [Physicians] thro the city
4. Said the beautiful Queen of France

9. The King awoke on his couch of gold
10. As soon as he heard these tidings told
11. Arise & come both fife & drum
12. And the [] shall cat both crout & crumb

2. Then old Nobodaddy aloft
 Farted & belchd & coughd
7. And said I love hanging & drawing & quartering
8. Every bit as well as war & slaughtering
 []
 Unless they will bring in
 The blood of ten thousand by fighting
 or [] & []

35. Then he swore a great Oath
6. To tell the people I am loth
 But If they rebel they must go to hell
 They shall have a Priest & a passing bell

The Queen of France just touchd this Globe
And the Pestilence darted from her robe
But the bloodthirsty people across the water
Will not submit to the priest & the halter
But our good Queen quite grows to the proud
There is just such a tree at Java found
And a great many suckers grow all around

Fayette Fayette thourt bought & sold
For well I see they tears
Of Pity are exchangd for those
Of selfish [slavish] fear

Fayette beside King Lewis stood
He saw him sign his hand
And soon he saw the famine rage
About the fruitful land

Fayette beheld the Queen to smile
And wink her lovely eye
And soon he saw the pestilence
From street to street to fly

Fayette beheld the King & Queen
In tears & iron bound
But mute Fayette wept tear for tear
And guarded them around

PLATE 20 *Manuscript Notebook*, Add. MS 49,460, Folio 51. 196 × 157 mm. N. 99. Reproduced by permission of the British Library Board.

Bibliography

Manuscripts

BRITISH LIBRARY

Mrs Anna Flaxman, Journal 1787–1788 'Journey to Rome,' Add. MS 39,787.

John Flaxman, Manuscript Notebooks, Add. MS. 39,781 and Add. MS. 39,784.

Ozias Humphry, Memorandum Book, Add. MS. 22,950.

BODLEIAN LIBRARY, OXFORD

William Godwin, Manuscript Diary, Vol. VI, Dep. E. 201.

LONDON METROPOLITAN ARCHIVE, CORPORATION OF LONDON

Manuscript Ledger of J. Swabey, Accounts with the Parish of Lambeth, 6 October 1789 to 26 October 1805, P85/ MRY 1/165.

Dissertations

Simon Turner, 'English Political Graphic Satire in the 1790s: The Case of Richard Newton.' M. A. Dissertation, History of Art Department, University College London, 1996.

Printed Sources

London is the place of publication unless stated otherwise.

An Account of the Institution and Regulations of the Guardians of the Asylum or House of Refuge situate in the Parish of Lambeth, in the County of Surrey, For the Reception of Orphan Girls (Printed (By Order of the Guardians) At the Logographic-Press, 1793).

Balston, James, *James Whatman, Father & Son* (Methuen, 1957).

Balston, John, *The Whatmans and Wove Paper Its Invention and Development in the West* (West Farleigh, Kent: J. N. Balston, 1998).

Becker, Cristoph and Beitragen von Hattendorff, *Johann Heinrich Fussli Das Verlorene Paradies* (Stuttgart: Staatsgalerie, 1997).

Bentley, G.E., Jr., *Blake Records* (Oxford: Clarendon Press, 1969).

—— 'Blake's Sinister "g", from 1789–93 to ?1803,' *Blake Newsletter*, III, 2 (September, 1969), 43–5.

—— 'William Blake and His Circle: A Checklist of Publications and Discoveries in 1999,' *Blake An Illustrated Quarterly*, 33, 4 (Spring, 2000), 141–3.

—— *Blake Books, Annotated Catalogues of William Blake's Writings* (Oxford: Clarendon Press, 1977).

—— *Blake Books Supplement* (Oxford: Clarendon Press, 1995).

—— *Blake Records* (Oxford: Clarendon Press, 1969).

—— *Blake Records Supplement* (Oxford: Clarendon Press, 1988).

—— 'The Shadow of Los: Embossing in Blake's "Book of Urizen"', *Art Bulletin of Victoria* [Melbourne], 30 (1989), 18–23.

Berthiau, M. and M. Boitard, *Nouveau Manuel Complet de L'Imprimeur en Taille-Douce* (Paris: A La Librairie Encyclopedique De Roret, 1831).

Bindman, David, with contributions by Aileen Dawson and Mark Jones, *The Shadow of the Guillotine Britain and the French Revolution* (British Museum Publications, 1989).

Black, Eugene Charlton, *The Association, British Extra-parliamentary Political Organization 1769–1793* (Cambridge, Massachusetts: Harvard University Press, 1963).

Blake, William, *An Island in the Moon, A Facsimile of the Manuscript Introduced, Transcribed, and Annotated*, by Michael Phillips (Cambridge: Cambridge University Press, 1986).

—— *The Continental Prophecies*, Blake's Illuminated Books, Vol. 4, ed. D. W. Dörrbecker (Tate Gallery Publications, 1995).

—— *The Urizen Books*, Blake's Illuminated Books, Vol. 6, ed. David Worrall (Tate Gallery Publications, 1995).

—— *Poems & Prophecies of William Blake*, ed. Max Plowman (J. M. Dent & Son, 1927).

—— *Selected Poems of William Blake*, ed. F. W. Bateson (Heinemann, 1957).

—— *The Complete Poetry and Prose of William Blake*, New Revised Edition, ed. David V. Erdman (Berkeley and Los Angeles: University of California Press, 1982).

—— *The Complete Writings of William Blake, With All the Variant Readings*, ed. Geoffrey Keynes (The Nonesuch Press, 1957).

—— *The Letters of William Blake with Related Documents*, 3rd edn, ed. Geoffrey Keynes (Oxford: Clarendon Press, 1980).

—— *The Notebook of William Blake A Photographic and Typographic Facsimile*, ed. David V. Erdman with the assistance of Donald K. Moore (Oxford: Clarendon Press, 1973); rev edn, 1977.

—— *The Poetical Works of William Blake*, ed. John Sampson (Oxford: Clarendon Press, 1905).

—— *Vala or The Four Zoas*, ed. G. E. Bentley, Jr. (Oxford: Clarendon Press, 1963).

Blon, J. C. Le, *Coloritto; Or the Harmony of Colouring in Painting: Reduced to Mechanical Practice, under Easy Precepts, and Infallible Rules* [1725].

Bloy, C. H., *A History of Printing Ink, Balls and Rollers, 1440–1850* (Evelyn Adams & Mackay, 1967).

Blunt, Anthony, *The Art of William Blake* (Oxford University Press, 1959).

Bogen, Nancy, 'Blake on "The Ohio"', *Notes and Queries*, XV, 1 (January 1968), 19–20.

Bordes, Philippe, 'Jacques-Louis David's Anglophilia on the Eve of the French Revolution', *The Burlington Magazine*, CXXXIV, 1073 (August, 1992), 482–90.

Le Serment du Jeu de Paume de Jacque-Louis David: Le Peintre, Son Milieu et Son Temps. De 1789 a' 1792 (Paris: Editions de la Reunion des musees nationaux, 1983).

Bower, Peter, *Turner's Papers A Study of the Manufacture, Selection and Use of his Drawings Papers 1787–1820* (Tate Gallery Publications, 1990).

Brissot de Warville, J. P., *New Travels in the United States*, trans. Joel Barlow (J. S. Jordan, 1792).

New Travels in the United States, trans. Mara Soceana Vamos and Durand Echeverria (Cambridge, Massachusetts: Harvard University Press, 1964).

Burke, Edmund, *Reflections on the Revolution in France*, ed. J. G. A. Pocock (Indianapolis, Indiana: Hackett Publishing Company, 1987).

Butlin, Martin and Gott, Ted, *William Blake in the Collection of the National Gallery of Victoria* (Melbourne: National Gallery of Victoria, 1989).

Butlin, Martin, 'The Evolution of Blake's Large Colour Prints of 1795', *William Blake Essays for S. Foster Damon*, ed. Alvin H. Rosenfeld (Providence, Rhode Island: Brown University Press, 1969), pp. 110–16.

—— 'The Physicality of William Blake: The Large Color Prints of "1795,"' *William Blake and His Circle, Papers Delivered at a Huntington Symposium* (San Marino, California: Henry E. Huntington Library and Art Gallery, 1989), pp. 1–17.

—— Review of Joseph Viscomi, *Blake and the Idea of the Book*, *The Burlington Magazine*, CXXXVII, 1103 (February, 1995), 123.

—— *The Paintings and Drawings of William Blake*, 2 vols. (Yale University Press, 1981).

Clayton, Timothy, *The English Print 1688-1802* (Yale University Press, 1997).

Cohn, Marjorie B., *Wash and Gouache A Study of the Development of the Materials of Watercolor* (Cambridge, Massachusetts: Center for Conservation and Technical Studies, Fogg Art Museum, 1977).

Connolly, Thomas E., 'The Real "Holy Thursday" of William Blake,' *Blake Studies*, 6, 2 (1975), 179–87.

Cumberland, George, 'Hints on various Modes of Printing from Autographs,' *Journal of Natural Philosophy, Chemistry, and the Arts*, XVIII (January, 1811), 56–9.

—— *Thoughts on Outline, Sculpture, and the System that Guided the Ancient Artists in Composing Their Figures and Groupes* (Printed by W. Wilson, 1796).

Daniels, V., and D. Thickett, 'The Reversion of Blackened Lead White on Paper: Analytical Appendix by T. Baird and N. H. Tennent (Manchester: Institute of Paper Conservation Conference Papers, 1992).

Davies, Keri, 'Mrs Bliss: a Blake Collector of 1794,' *Blake in the Nineties*, ed. Steve Clark and David Worrall (Basingstoke: Macmillan, 1999), pp. 212–30.

Dossie, Robert, *The Handmaid to the Arts*, 2nd edn, 2 vols (Printed for J. Nourse, 1764).

Dyson, Anthony, *Pictures to Print, The Nineteenth Century Engraving Trade*, (Farrand Press, 1984).

Encyclopedia Britannica; Or, A Dictionary of the Arts and Sciences, Compiled Upon a New Plan., 3 vols. (Edinburgh: Printed for A. Bell and C. Macfarquhar, 1771); 2nd edn, 1779; 3rd edn, 1797.

England, Martha W., 'The Satiric Blake: Apprenticeship in the Haymarket?,' *Bulletin of the New York Public Library*, LXXIII (1969), 6–18.

'Blake and the Hymns of Charles Wesley: Wesley's Hymns for Children and Blake's *Songs of Innocence and of Experience*,' *Bulletin of the New York Public Library*, LXX (1966), 7–26.

Erdman, David V., 'A Blake Epigram ,' *TLS* (24 February, 1978), 234.

—— 'Dating Blake's Script: a postscript, *Blake Newsletter*, III, 2 (September, 1969), 42.

—— 'Dating Blake's Script; the "g" hypothesis,' *Blake Newsletter*, III, 1 (June, 1969), 8–13.

—— *Blake Prophet Against Empire*, 3rd edn (Princeton, New Jersey: Princeton University Press, 1977).

Essick, Robert N., 'Blake in the Marketplace, 1999,' *Blake An Illustrated Quarterly*, 33, 4 (Spring, 2000), 100–02.

—— 'New Information on Blake's Illuminated Books,' *Blake An Illustrated Quarterly*, 15, 1 (Summer, 1981), 8–9.

—— ed., *The Visionary Hand Essays for the Study of William Blake's Art and Aesthetics* (Los Angeles: Hennessey & Ingalls, 1973).

—— *The Separate Plates of William Blake A Catalogue* (Princeton, New Jersey: Princeton University Press, 1983).

—— *The Works of William Blake in the Huntington Collections* (San Marino, California: Henry E. Huntington Library and Art Gallery, 1985).

—— *William Blake and the Language of Adam* (Oxford: Clarendon Press, 1989).

—— *William Blake Printmaker* (Princeton, New Jersey: Princeton University Press, 1980).

—— *William Blake's Relief Inventions* (Los Angeles: Printed for William & Victoria Dailey at the Press of the Pegacycle Lady, 1978).

—— 'The Resurrection of *America* Copy R,' *Blake An Illustrated Quaterly*, 21, 4 (Spring, 1988), 138–42.

European Magazine (June, 1782).

Faithhorne, William, *The Art of Graving and Etching*, 2nd edn (Printed for A. Roper, 1702).

Ferber, Michael, '"London" and its Politics,' *English Literary History*, 48, 2 (Summer, 1981), 310–38.

Friedman, Joan M., *Color Printing in England 1486-1870* (New Haven, Connecticut: Yale Center for British Art, 1978).

Gardner, Stanley, *Blake's Innocence and Experience Retraced* (The Athlone Press, 1986).

—— *The Tyger The Lamb and the Terrible Desart* (Cygnus Arts, 1998).

Gaskell, Philip, 'Notes on Eighteenth-Century British Paper', *The Library*, XII (1957), 34–42.

—— *A New Introduction to Bibliography* (Oxford: Clarendon Press, 1972).

Gay, John, *Trivia: Or, The Art of Walking the Streets of London* (Printed for Bernard Lintot, 1715).

Gealt, Adelheid M., ed., *Beyond Black and White: Chiaroscuro Prints from Indiana Collections* (Bloomington, Indiana: Indiana University Art Museum, 1989).

Gilchrist, Alexander, *Life of William Blake*, 2 vols (Macmillan, 1863).

—— *The Life of William Blake*, ed. W. Graham Robertson (John Lane The Bodley Head, 1907).

Gleckner, Robert F., 'William Blake and the Human Abstract', *PMLA*, 76, 4 (1961), 373–9.

Glen, Heather, *Vision and Disenchantment: Blake's Songs and Wordsworth's Lyrical Ballads* (Cambridge: Cambridge University Press, 1983).

Hamlyn, Robin, and Michael Phillips, *William Blake*, Tate Britain Exhibition Catalogue (Tate Gallery Publications, 2000).

Hayley, William, *The Life of George Romney, Esq.* (Chichester: Printed by J. Seagrave, 1809).

Hills, Richard L, *Papermaking in Britain 1488–1988 A Short History* (Athlone Press, 1988).

Irwin, David, *John Flaxman 1755–1826* (Studio Vista Christie's, 1979).

Jackson, John Baptist, *An Essay on the Invention of Engraving and Printing in CHIARO OSCURO, as Practised By Albert Durer, Hugo Di Carpi., &c. and the Application of it to the Making Paper Hangings of Taste, Duration, and Elegance* (Printed for A. Miller, S. Baker, B. White and L. Davis, 1754).

Jackson, John, *A Treatise on Wood Engraving, Historical and Practical* (Charles Knight and Company, 1839).

Johnson, R., *New Duty on Paper. The Paper-Maker and Stationers Assistant, Containing [. . .] The Dimensions [and] The Whole Duty as altered by the late Act of Parliament* (Sold by Debrett, Johnson, Bladon and Symonds, 1794).

Jones, M. G., *The Charity School Movement* (Cambridge: Cambridge University Press, 1964).

Keane, John, *Tom Paine A Political Life* (Little, Brown and Company, 1995).

Keynes, Geoffrey, 'An Undescribed Copy of Blake's Songs of Innocence and of Experience', *The Book Collector*, 30, 1 (Spring, 1981), 39–42.

—— 'Some Uncollected Authors XLIV George Cumberland 1754–1848', *The Book Collector*, 19, 1 (Spring 1970), 31–57.

—— and Edwin Wolf 2nd *William Blake's Illuminated Books A Census* (New York: The Grolier Club of New York, 1953).

Langland, Elizabeth, 'Blake's Feminist Revision of Literary Tradition in 'The SICK ROSE'', *Critical Paths Blake and the Argument of Method*, ed. Dan Miller, Mark Bracher and Donald Ault (Duke University Press, 1987).

Laws, Rules, and Orders, For the Government of the Westminster New Lying-In Hospital, Near Westminster Bridge Instituted in the Year 1765 (Printed by J. Smeeton, 1793).

Leader, Zachary, *Reading Blake's Songs* (Routledge & Kegan Paul, 1981).

Lee, Sidney, ed., *Dictionary of National Biography*, XVII (1909).

Locke, John, *An Essay Concerning Human Understanding* (Printed by Eliz Holt for Thomas Basset, 1690); 15th edn, 1760; 16th edn, 1768.

Lumsden, E. S., *The Art of Etching* (Seeley, Service & Company Ltd., 1925).

Maheux, A. F., 'An Analysis of the Watercolour Technique and Materials of William Blake', *Papers Presented by Conservation Students at the Eighth Annual Conference of Art Conservation Training Programmes*, May 1982 (Kingston, Ontario: Queen's University Press), pp. 49–64; in part repr. *Blake An Illustrated Quarterly*, 17, 3 (Spring. 1984), 124–29.

Malkin, Benjamin Heath, *A Father's Memoirs of His Child* (Printed by T. Bensley, 1806).

Malone, Dumas, *The Public Life of Thomas Cooper 1783-1839* (New Haven, Connecticut: Yale University Press, 1926).

McCalman, Iain, 'Newgate in Revolution: Radical Enthusiasm and Romantic Counterculture', *Eighteenth-Century Life*, 22 (February, 1998), 95–110.

Moore, Donald K., 'Blake's Notebook Versions of *Infant Sorrow*', *Bulletin of the New York Public Library*, 76 (1976), 209–19.

Newlyn, Lucy, *Paradise Lost and the Romantic Reader* (Oxford: Clarendon Press, 1993).

Nurmi, Martin K., 'Blake's Revisions of *The Tyger*', *PMLA*, LXXI (September, 1956), 669–85.

Ostriker, Alicia, *Vision and Verse in William Blake* (Madison and Milwaukee, Wisconsin: University of Wisconsin Press, 1965).

Paine, Thomas, *Rights of Man*, ed. Gregory Claeys (Indianapolis, Indiana: Hackett Publishing Company, 1992).

Paulson, Ronald, *Representations of Revolution (1789-1820)* (New Haven, Connecticut: Yale University Press, 1983).

Phillips, Michael, 'Blake and the Terror 1792–93', *The Library*, 6th ser, XVI, 4 (December 1994), 263–97.

—— 'Flames in the Night Sky: Blake, Paine and the Meeting of the Society of Loyal Britons, Lambeth, October 10th, 1793', Colloque 'La Violence et ses Representations', *Bulletin de la Societe d'Etudes Anglo-Americaines des XVIIe et XVIIIe siecle*, 44 (June, 1997), 93–110.

—— 'Printing Blake's *Songs* 1789–94', *The Library*, 6th ser, XIII, 3 (September, 1991), 205–37.

—— 'William Blake and the "Unincreasable Club" The Printing of *Poetical Sketches*', *Bulletin of the New York Public Library*, LXXX (1976), 6–18.

—— *William Blake Recherches Pour Une Biographie Six Etudes*, Preface d' Yves Bonnefoy, Traduction d' Antoine

Jaccottet (Paris: Documents et Inedits Du College De France, 1995).

—— 'William Blake's *Songs of Innocence* and *Songs of Experience* From Manuscript Draft to Illuminated Plate', *The Book Collector*, 28, 1 (Spring, 1979), 17-59.

Philp, Mark, *Godwin's Political Justice* (Duckworth, 1986).

Pinto, Vivian de Sola, 'William Blake, Isaac Watts, and Mrs Barbauld,' *The Divine Vision Studies in the Poetry and Art of William Blake*, ed. V. de Sola Pinto (Victor Gollancz Ltd., 1957), pp. 67-87.

Plowman, Max, 'Blake's "Infant Sorrow,"' *TLS* (18 November 1926), 819.

Pointon, Marcia, *Milton & English Art* (Manchester: Manchester University Press, 1970).

Pressly, Nancy L., *The Fuseli Circle in Rome, Early Romantic Art of the 1770s* (New Haven, Connecticut: Yale Center for British Art, 1979).

Robertson, W. Graham, *The Blake Collection of W. Graham Robertson*, described by the Collector edited with an introduction by Kerrison Preston (Faber and Faber Limited for The William Blake Trust, 1952).

Rodari, Florian, ed., *Anatomie de la Couleur L'Invention de L'Estampe en Couleurs* (Paris & Lausanne: Bibliotheque Nationale de France and Musee Olympique Lausanne, 1996).

Romilly, Samuel, *Memoirs of the Life of Sir Samuel Romilly, written by himself; with a selection from His Correspondence*. Edited by his Sons, 3 vols. (John Murray, 1840).

Rosenblum, Robert, *Transformations in Late Eighteenth Century Art* (Princeton, New Jersey: Princeton University Press, 1967).

Rosenwald, Lessing J, *A Catalogue of the Gifts of Lessing J. Rosenwald to the Library of Congress, 1943-1975* (Washington, D. C.: Library of Congress, 1977).

Rossetti, William Michael, *Rossetti Papers* (Sands & Co., 1903).

Schiff, Gert, ed.,*William Blake*, Tokyo Exhibition Catalogue (Tokyo: National Museum of Western Art, 1990).

Smith, John Thomas, *A Book For A Rainy Day: Or, Recollections of the Events of the Last Sixty-Six Years*, 2nd edn (Richard Bentley, 1845).

Stanger, Charles, *Remarks on the Necessity and Means of Suppressing Contagious Fever in the Metropolis* (Printed and Sold by W. Phillips, 1802).

Stemmler, Joan K., 'Cennino, Cumberland, Blake and Early Painting Techniques', *Blake An Illustrated Quaterly*, 17, 4 (Spring, 1984), 145-9.

Swift, Jonathan, 'Description of the Morning', *The Tatler*, No. 9 (Thursday April 28 to Saturday April 30, 1709) and 'Description of a City Shower', *The Tatler*, No. 238 (Saturday October 14 to Tuesday October 17, 1710).

Thelwall, John, *The Peripatetic; or, Sketches of the Heart, of Nature and Society in a Series of Politico-Sentimental Journals* (Printed for the Author, 1793); repr (New York: Garland Publications, 1978).

Thompson, E. P., 'London', *Interpreting Blake*, ed. Michael Phillips (Cambridge: Cambridge University Press, 1978), pp. 5-31.

Todd, Ruthven, ' "Poisonous Blues," and Other Pigments', *Blake An Illustrated Quarterly*, 14, 1 (Summer, 1980), 31-2.

—— 'The Techniques of William Blake's Illuminated Printing', *The Print Collector's Quarterly*, 29 (November, 1948), 25-37.

Townsend, Joyce H., 'William Blake (1757-1827) *Moses Indignant at the Golden Calf* c. 1799-1800,' *Painting and Purpose A Study of Technique in British Art*, ed. Stephen Hackney, Rica Jones and Joyce Townsend (Tate Gallery Publications, 1999), pp. 66-9.

Tyson, Gerald P., *Joseph Johnson: A Liberal Publisher* (Iowa City, Iowa: University of Iowa Press, 1979).

Vallance, Sarah L., Singer, B. W., Hitchen, S. M., and Townsend, J. H, 'The Development and Initial Application of a Gas Chromatograpyhic Method for the Characterization of Gum Media', *Journal of the American Institute for Conservation*, 37, (1998), 294-311

Valuable Secrets Concerning Arts and Trades: Or, Approved Directions, from the best Artists (Dublin: Printed by James Williams, 1778).

Viscomi, Joseph, *The Art of William Blake's Illuminated Prints* (Manchester: Manchester Etching Workshop, 1983).

—— 'The Evolution of *The Marriage of Heaven and Hell*,' *Huntington Library Quarterly*, 58, 3 and 4 (1997), 281-344.

—— 'The Myth of Commissioned Illuminated Books: George Romney, Isaac D'Israeli, and "ONE HUNDRED AND SIXTY designs . . . of Blake's."' *Blake An Illustrated Quarterly*, 23, 2 (Fall, 1989), 48-74.

—— *Blake and the Idea of the Book* (Princeton, New Jersey: Princeton University Press, 1993).

Walpole, Horace, *The Yale Edition of Horace Walpole's Correspondence*, ed. W. S. Lewis, Vol. 42 (Yale University Press, 1980).

Watts, Isaac, *Divine Songs Attempted in Easy Language for the Use of Children* (Printed for M. Lawrence, 1715); facsimile edn, ed. J. H. P. Pafford (Oxford: Oxford University Press, 1971).

Wicksteed, Joseph, *Blake's Innocence and Experience A Study of the Songs and Manuscripts* (J. M. Dent & Son Ltd., 1928).

Willan, Robert, *Reports on the Diseases in London, Particularly During the Years 1796, 97, 98, 99, and 1800* (R. Phillips, 1801).

Blake Index

A Figure in illustration is indicated by italic, primary account by bold lettering.

General Index

A Figure in illustration is indicated by italic lettering.